Image © Aveline Stokart

One tree planted for every book sold

OUR PLEDGE

From 2020, 3dtotal Publishing has pledged to plant one tree for every book sold by partnering with and donating the appropriate amounts to re-foresting charities. This is one of the first steps in our ambition to become a carbon neutral company with carbon neutral publications, giving our customers the knowledge that by buying from 3dtotal Publishing, we are working together to balance the environmental damage caused by the publishing, shipping, and retail industries.

3dtotalPublishing

Image © Izzy Burton

beginner's guide to digital painting in
Procreate
how to create art on an iPad

3dtotalPublishing

3dtotalPublishing

Correspondence: publishing@3dtotal.com
Website: www.3dtotal.com

Beginner's Guide to Digital Painting in Procreate: How to Create Art on an iPad. Book © 2020, 3dtotal Publishing. All rights reserved. No part of this book can be reproduced in any form or by any means, without the prior written consent of the publisher. All artwork, unless stated otherwise, is copyright © 2020 3dtotal Publishing or the featured artists. All artwork that is not copyright of 3dtotal Publishing or the featured artists is marked accordingly.

iPad is a trademark of Apple Inc.

Every effort has been made to ensure the credits and contact information listed are present and correct. In the case of any errors that have occurred, the publisher respectfully directs readers to the www.3dtotalpublishing.com website for any updated information and/or corrections.

First published in the United Kingdom, 2020, by 3dtotal Publishing.

Address: 3dtotal.com Ltd, 29 Foregate Street, Worcester, WR1 1DS, United Kingdom.

Reprinted in 2020 by 3dtotal Publishing

Soft cover ISBN: 978-1-912843-14-5
Printing and binding: Gutenberg Press Ltd (Malta) www.gutenberg.com.mt

Visit www.3dtotalpublishing.com for a complete list of available book titles.

Managing Director: Tom Greenway
Studio Manager: Simon Morse
Assistant Manager: Melanie Robinson
Lead Designer: Fiona Tarbet
Publishing Manager: Jenny Fox-Proverbs
Editor: Philippa Barker
Designer: Joseph Cartwright

Front cover artwork
Clockwise starting top left: © Aveline Stokart; © Simone Grünewald; © Sam Nassour; © Dominik Mayer; © Samuel Inkiläinen; © Nicholas Kole; © Max Ulichney
Center: © Izzy Burton

Back cover artwork © Izzy Burton

Image © Nicholas Kole

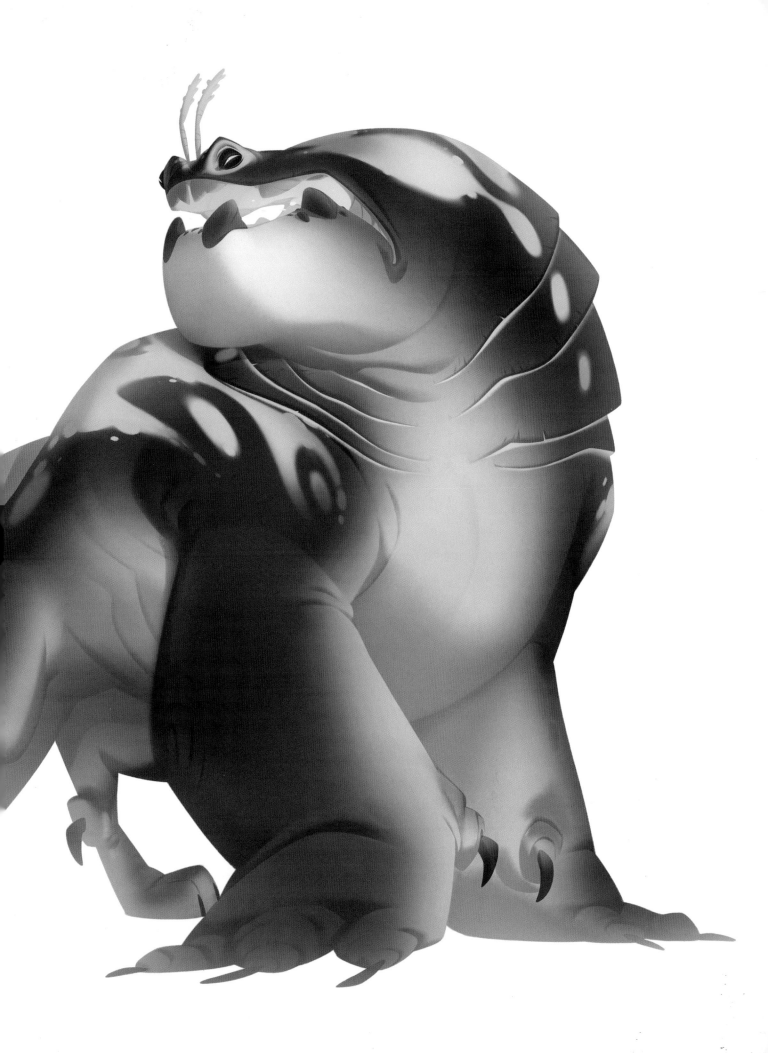

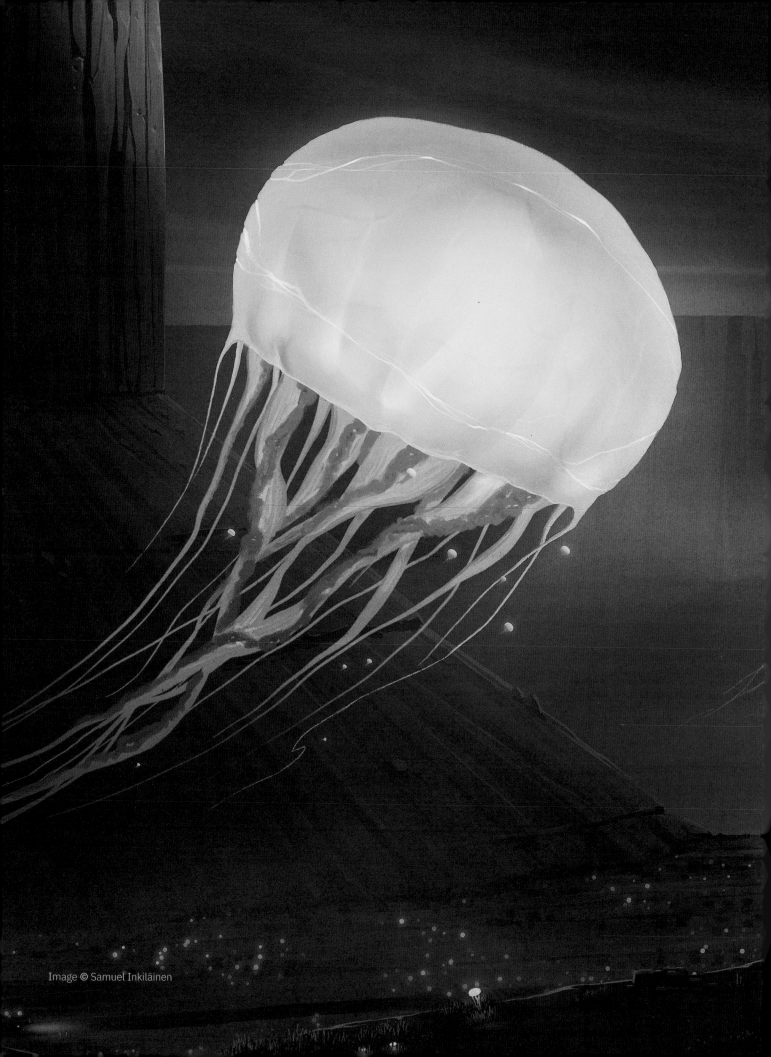

Image © Samuel Inkiläinen

CONTENTS

INTRODUCTION

BY LUCAS PEINADOR

Welcome to Procreate! It doesn't matter if you're new to the world of digital painting, or are a battle-scarred user of Photoshop or other digital painting software – this book has you covered.

Let's begin by explaining that Procreate is a digital painting and drawing app designed specifically for the iPad and Apple Pencil. (It is also available on the iPhone as Procreate Pocket.) The company behind Procreate – Savage Interactive – is extremely involved in the artist community and welcomes questions and suggestions from CG (computer graphics) creatives. The result is an inspired piece of software that is incredibly intuitive for digital painters.

With easy-access menus and responsive gesture control, you have all the tools you need to create amazing artwork at your finger tips. Not only is it an affordable option for anyone with an iPad, it has fast become a widely used app in the illustration and entertainment industries.

The hardware Procreate utilizes makes it ideal for painting on the go – paint at home, on the bus, or plein air. The exclusivity to Apple means no extra clutter from busy desktop software and no compatibility issues with your hardware. Procreate is available in the App Store for a one-time payment.

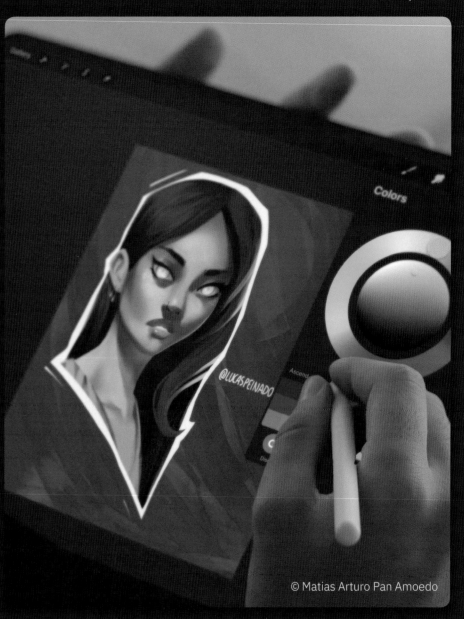

▼ Paint on the go with Procreate on your iPad

© Matias Arturo Pan Amoedo

CHOOSE YOUR TOOL

Procreate can be used with either the Apple Pencil or a third-party stylus. The preferred tool of professional-level artists, the Apple Pencil will give you optimal results, as it has advanced pressure and tilt functions designed to produce a wide range of brushstrokes and effects that mimic traditional painting. While a third-party stylus can still be used well, if you want to get the most from Procreate you may wish to buy the Apple Pencil as soon as you feel ready to invest.

WHAT IS DIGITAL PAINTING?

For newcomers to CG, we want to give a brief introduction to the concept of digital painting to help prepare you for your first experience working on screen. While digital painting, especially when using bespoke software such as Procreate, bears many similarities to painting in traditional media, the workflow can be quite different. Perhaps most noticeably, images are usually built up in layers, and you can choose how those layers interact with each other. For example, you may want one layer to influence another as if you were layering paint; you may want another to work independently as if you were masking an area off. This gives you the ability to isolate individual sections and stages of the painting when working, saving you time and allowing you to focus on the creative side.

Using Procreate, you can also create your own brushes, manipulate shapes, and easily make image adjustments at the touch of a button, all of which offer flexibility and speed that you may not come across when using traditional media. Plus, you have a limitless array of tools and colors all in one place! This is ideal when working in a hectic industry environment, as well as when you are out and about – there are no messy brushes to clean and no concerns about damaged paper.

While working on screen may seem daunting at first, the intuitive Procreate setup makes the process approachable and enjoyable. Familiarity with the app and plenty of practice are the key to success, so turn over to find out how to get the most out of this book and your journey into digital painting.

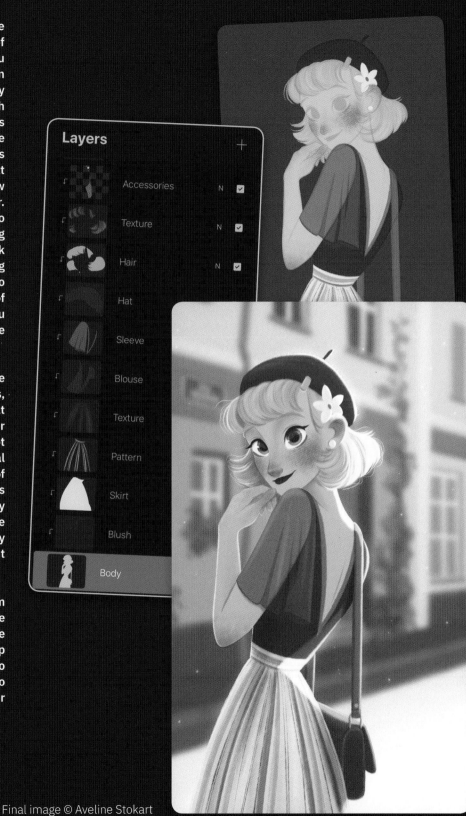

Final image © Aveline Stokart

HOW TO USE THIS BOOK

Working with talented industry professionals, we have put together a book that is tailored to creative minds new to Procreate. We recommend you begin by reading the introductory chapters. *Getting Started* will provide a brief overview of the interface and explain how to create and organize your files. Following on from this *Gestures*, *Brushes*, *Color*, *Layers*, *Selections*, *Transform*, *Adjustments*, **and** *Actions* will explore the many tools Procreate has to offer.

Each chapter will guide you through the basics of how to use Procreate, covering the various gestures, tools, and techniques needed to paint digitally and how you can integrate them into your own personal workflow. Read each chapter carefully and experiment with the different tools as you go for maximum benefit.

Once you have read the introductory chapters and have a good grasp of the basics, work your way through each of the eight *Projects*. These cover a range of themes, styles, and approaches, and will guide you step-by-step through how to create artwork in Procreate. At the start of each project you will find a list of *learning objectives* comprising the creative techniques you will learn as you work through the steps.

Throughout the introductory chapters and projects there are *artist tip boxes*, providing helpful nuggets of advice and creative insights.

Toward the end of the book there is also a useful *Glossary* and *Tool Directory* to refer back to as needed.

Chapter title

Sub-headings

Introduction

Learning objectives

Image captions

Supporting images

Artist tip boxes

 All images © Lucas Peinador

Project introduction Project title

Step-by-step instructions

Image captions

Downloadable
resources icon

Learning objectives

Step-by-step images

DOWNLOADABLE RESOURCES

The artists behind this book have supplied a range of *downloadable resources* at www.3dtotalpublishing.com/resources to aid your learning. A full list of downloadable resources is available at the end of this book (see page 208). These include the custom brushes used in the projects, along with time-lapse videos and line art. Be sure to download these before you start the projects. Where downloadable resources are available, there will be an arrow icon at the start of the chapter.

▶ Look out for the downloadable resources icon

PAGE 208

TOUCHSCREEN GESTURES

As mentioned, Procreate uses a range of gestures to carry out certain actions. For example, to undo an action you can tap the screen with two fingers. To help you learn and make the most of gestures quickly, we use the following notations in the book to indicate what is required.

**Touch and hold
the screen with
one finger**

**Touch and hold
the screen with
two fingers**

Swipe

**Swipe while
holding down
your finger**

GETTING STARTED

You've now had an overview of what this book holds in store – so what's next? It's time to explore all the tools this intuitive software has to offer, so prepare to tap, swipe, and paint your way through all the features.

This section will take you all the way back to the beginning, where you'll discover that there are lots of useful options for creating a new canvas. From there you'll discover all kinds of functions and techniques to maximise your creativity,

from how to organize your work and use the quick-and-clever gestures, to everything you need to know about brushes, color, layers, effects, and more. You'll even learn how to customize the app for a tailored experience.

So grab your ipad and work your way through this section for the ultimate hands-on training, then refer back whenever you need to. You'll soon be on your way to creating amazing digital art.

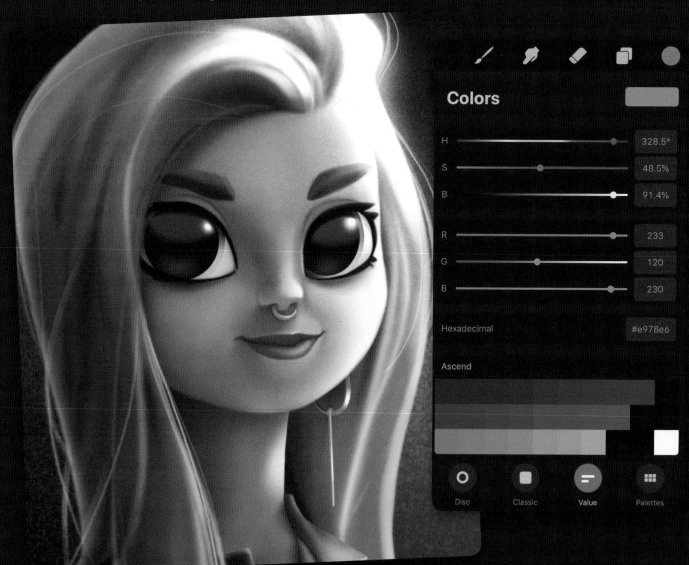

All images © Lucas Peinador

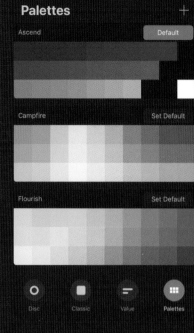

Palettes

Ascend — Default

Campfire — Set Default

Flourish — Set Default

Disc Classic Value Palettes

Tank Downhill

Bang

raits 2018
orks

Studies
20 artworks

THE USER INTERFACE

In this chapter you will learn how to:

- navigate the main elements of the user interface;

- navigate between the gallery and canvas screens.

Procreate's user interface (UI) is the means through which you interact with the software, composed of menus, icons, and buttons. The first screen you see in Procreate's user interface is your gallery, where you can create and organize your files. You will see some example artworks provided by Procreate.

Tapping on the Procreate logo will allow you to check the version of your software. Procreate releases regular updates, at no extra cost, that ensure the software is optimized.

In the upper right-hand corner of your gallery you will see options to select files, import new files from your device or from your Photos, and create new blank canvases with custom sizes.

If you tap on any of the sample artworks, or create a new one, you will be sent to your canvas screen. This is where you will spend most of your time in the app.

If you have screen rotation unlocked in your iPad, you can draw in either portrait or landscape mode and the interface will adapt to your device.

▼ Procreate's gallery showcases all of your canvases

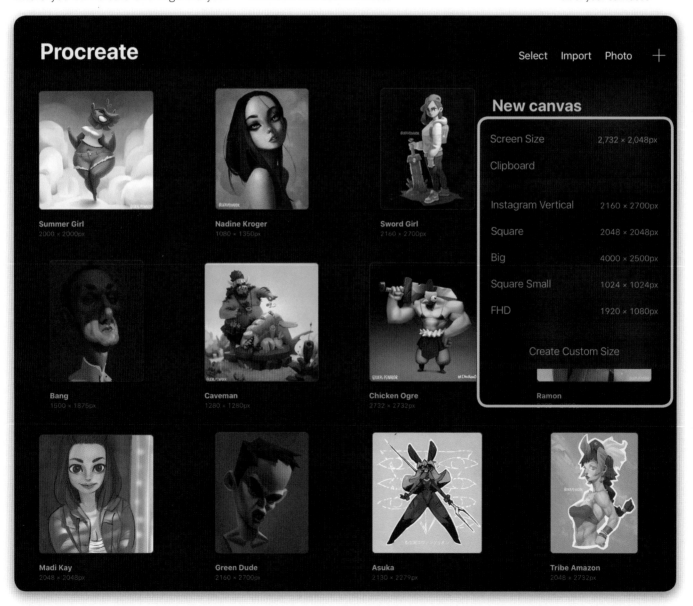

| Procreate | | | Select | Import | Photo | + |

New canvas

Screen Size	2,732 × 2,048px
Clipboard	
Instagram Vertical	2160 × 2700px
Square	2048 × 2048px
Big	4000 × 2500px
Square Small	1024 × 1024px
FHD	1920 × 1080px

Create Custom Size

Summer Girl
2000 × 2000px

Nadine Kroger
1080 × 1350px

Sword Girl
2160 × 2700px

Bang
1500 × 1875px

Caveman
1280 × 1280px

Chicken Ogre
2732 × 2732px

Ramon

Madi Kay
2048 × 2048px

Green Dude
2160 × 2700px

Asuka
2130 × 2279px

Tribe Amazon
2048 × 2732px

All images © Lucas Peinador

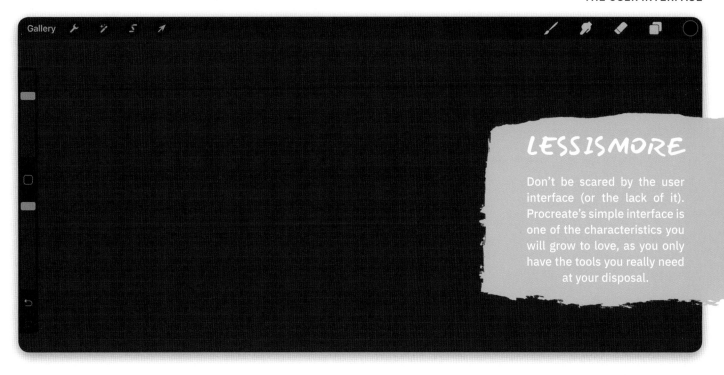

LESSISMORE

Don't be scared by the user interface (or the lack of it). Procreate's simple interface is one of the characteristics you will grow to love, as you only have the tools you really need at your disposal.

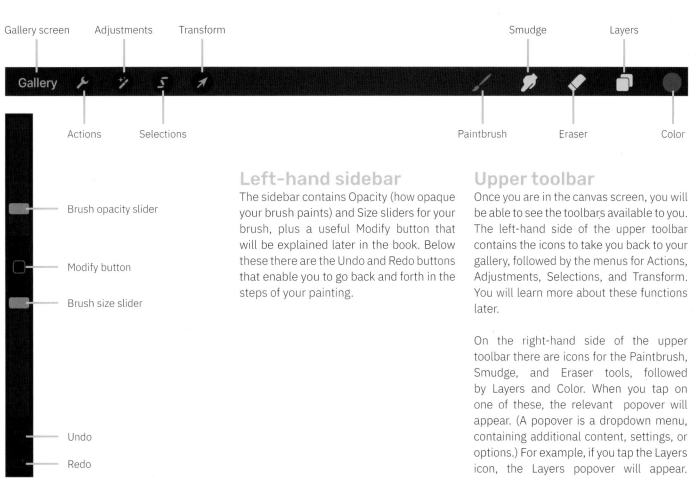

Left-hand sidebar

The sidebar contains Opacity (how opaque your brush paints) and Size sliders for your brush, plus a useful Modify button that will be explained later in the book. Below these there are the Undo and Redo buttons that enable you to go back and forth in the steps of your painting.

Upper toolbar

Once you are in the canvas screen, you will be able to see the toolbars available to you. The left-hand side of the upper toolbar contains the icons to take you back to your gallery, followed by the menus for Actions, Adjustments, Selections, and Transform. You will learn more about these functions later.

On the right-hand side of the upper toolbar there are icons for the Paintbrush, Smudge, and Eraser tools, followed by Layers and Color. When you tap on one of these, the relevant popover will appear. (A popover is a dropdown menu, containing additional content, settings, or options.) For example, if you tap the Layers icon, the Layers popover will appear.

▲ All the tools you need to paint can be found in your canvas screen

SETTING UP

Now you are familiar with the basic Procreate interface we can look more closely at how to set up a new canvas to work on, and how to organize your gallery.

In this chapter you will learn how to:

- create a new canvas;

- delete, duplicate, and share a file from your gallery;

- choose which file type to work with;

- rearrange and group your files into stacks;

- speed up your navigation by previewing gallery files without opening them;

- select multiple files to carry out bulk actions.

CREATE A NEW CANVAS

Preset size

There are several ways to create a new canvas in Procreate. To create a blank canvas, tap the + icon in the top right-hand corner of the gallery screen. This will bring up a dropdown menu of several different sizes.

To create a canvas based on one of these predetermined sizes, simply tap on your selection. This will immediately send you to the canvas view inside that file.

Custom size

Alternatively, you can create your own custom size. This will allow you to edit the width and height of your canvas, select the density of pixels and the Color mode, and rename it. Once you tap Create, you will be sent to your canvas. This custom size will

then appear as an option the next time you create a new canvas.

Import files and photos

If you tap Import you will be sent to the file browser in your iPad where you can import files from your iPad documents, your iCloud, or Google Drive. Tapping Photo will allow you to import files from your device's photos, which is useful if you want to open a screenshot or a picture taken with your device.

A quick way of using these two options is to simply drag and drop files from these windows into your gallery in Procreate. A new canvas will be created for each file that you drop there.

Nadine Kroger
1080 × 1350px

Caveman
1280 × 1280px

▼ Tap the + icon to open a new canvas

Select Import Photo +

New canvas

Screen Size 2,732 × 2,048px

Clipboard

Instagram Vertical 2160 × 2700px

Square 2048 × 2048px

Big 4000 × 2500px

Square Small 1024 × 1024px

FHD 1920 × 1080px

Create Custom Size

Sword Girl
2160 × 2700px

Chicken Ogre
2732 × 2732px

New canvas

Screen Size 2,732 × 2,048px

Clipboard

Instagram Vertical 2160 × 2700px

Square 2048 × 2048px

Big 4000 × 2500px

Square Small 1024 × 1024px

FHD 1920 × 1080px

Create Custom Size

▲ Save your most frequently used
canvas sizes for future use

CREATE YOUR OWN PRESETS

While Procreate will automatically save any custom sizes you make, it can still be helpful to plan ahead and create and name a few presets of your most frequently used resolutions. This will save you time whenever you start a new painting, especially if you often find yourself working with the same size canvas.

DELETE, DUPLICATE, AND SHARE

Deleting, duplicating, and sharing your files is easily done. Swiping left with your finger over one of your files on the gallery screen will bring up three options.

Delete
Delete will erase your file. Take care to back up your files often, as there is no way to recover a deleted file.

Duplicate
Duplicate will create a copy of your file. This is a useful option if you want to implement some drastic changes to your artwork, or if you want to preserve different versions of it.

Share
Finally, Share will allow you to export your artwork in several formats. These formats will be covered in the next section.

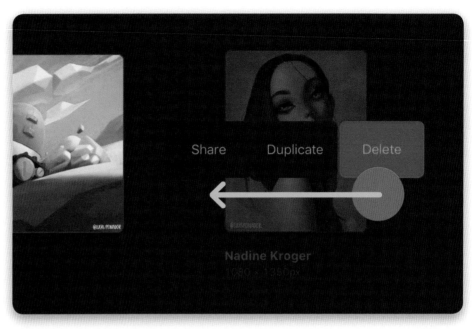

▲ Share, duplicate, and delete files by swiping to the left

FILE SUPPORT

Procreate has become increasingly open towards different file formats, from its native PROCREATE format to the indispensable PSD of Photoshop. Let's take a look at some of the formats available to you and why you may wish to choose one over another.

PROCREATE
As PROCREATE is the local format of your app, you should export in this file type if you intend to open a file in Procreate again. As well as supporting layers, a unique feature of this format is that it records a time-lapse video of your artwork. (This feature will be covered in **Actions** on page 66.)

PSD & TIFF
Besides PROCREATE, only PSD and TIFF support layers. Use either of these formats

if you want to preserve the layer information and edit the files in another software.

PDF
PDF is a good option if you intend to print your images.

JPEG and PNG
JPEG and PNG are excellent formats if you wish to share files digitally. JPEG doesn't support transparency, while PNG does, so if you need a transparent background, use the latter.

Time-lapse videos
Another great reason to use Procreate is the ease with which you can export time-lapse videos directly from your files. This tool will interpret the layers of your file as frames of an animation. You can select the

speed at which it plays and whether you want to export the file at full resolution or for quick loading on the web. You can export files as:

- Animated GIF for wide browser support but lower quality.

- Animated PNG for better quality but smaller browser support.

- Animated MP4 if you want to export a video instead of a loopable animation and you don't need transparency.

 All images © Lucas Peinador

▼ The image format menu provides different options for exporting your artwork

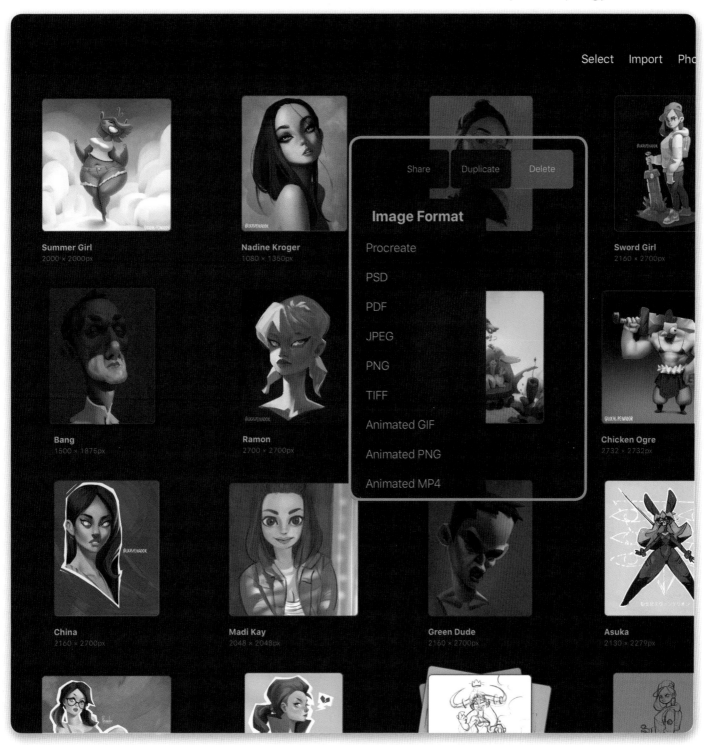

After creating a few artworks, your gallery may start to feel a little cluttered. Fortunately, organizing your files in Procreate is easy. You can rearrange and rename your files, and create stacks directly in gallery view.

Rearranging stacks

To rearrange, simply touch and hold one of the files and reposition it.

If you drop one file over another, this will form a stack, or a group of files. This is an excellent way to keep your gallery organized and to find your files faster.

The best thing about stacks is that you can reorganize them as if they were single files, and move files in and out of a stack.

Renaming files

An important part of keeping your gallery organized is renaming your files and stacks. Simply tap the name of the file or stack to summon the keyboard and type a new name.

▼ Touch, hold, and drag an image to reposition it – drop it over another image to create a stack

Nadine Kroger
1080 × 1350px

Maymay 3
1200 × 1200px

Ramon
2700 × 2700px

Caveman
1280 × 1280px

China
2160 × 2700px

Madi Kay
2048 × 2048px

Green Dude
2160 × 2700px

 All images © Lucas Peinador

PREVIEW

Preview mode allows you to view your artworks full-screen without having to open them first. This is great if you want to present your files as a portfolio, for example, but you don't want to export every single image. You can do this directly in your gallery view.

Using two fingers to zoom in on one of your files will open a preview of that artwork. You can then swipe left or right to see a slideshow of all of the files in your gallery. A great way to use this feature is to first create a stack of the files you wish to view, and then open the Preview. This slideshow will only swipe through the files inside of the selected stack.

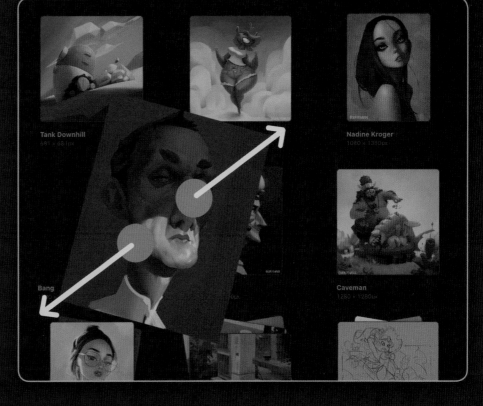

▶ Preview an image without opening it by zooming in on it

ORGANIZE YOUR GALLERY

▼ Organizing your artworks into stacks allows you to locate them easily

Keep your gallery organized with a "work-in-progress" stack, a "studies" stack for still-life paintings, and a "life-drawing" stack for sessions with live models.

You could also organize your gallery into "sketches" and "finished paintings". Use this feature to stay organized and find your artworks quickly and easily.

SELECT

| Select | Import | Photo | + |

If you want to carry out the same action across multiple files, you can use the Select button. This can be found at the top right of your gallery. After tapping it, you can select multiple files and carry out bulk actions such as:

- stacking,
- previewing,
- sharing,
- duplicating,
- deleting.

This feature also enables you to quickly create stacks of several files, or complete a backup of your entire gallery online or on another device.

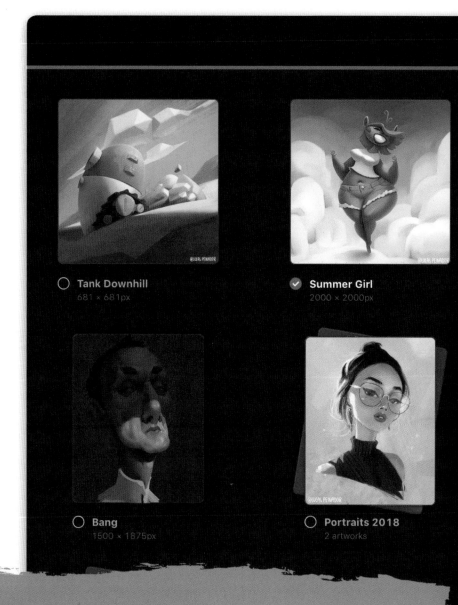

ROTATE YOUR FILES

One of the nifty tricks Procreate allows is changing the orientation of a file directly from the gallery. For example, if you were to paint a portrait image then return to the gallery view while the orientation of the painting was landscape, you would see the preview of your painting wrongly oriented. While in the gallery view, use two fingers to select your artwork and rotate it. Your artwork will then snap to a horizontal or vertical position. This option is useful to you if wish to change the orientation of your documents quickly without going into the canvas view.

▲ The Select tool allows you to rotate files in gallery view

 All images © Lucas Peinador

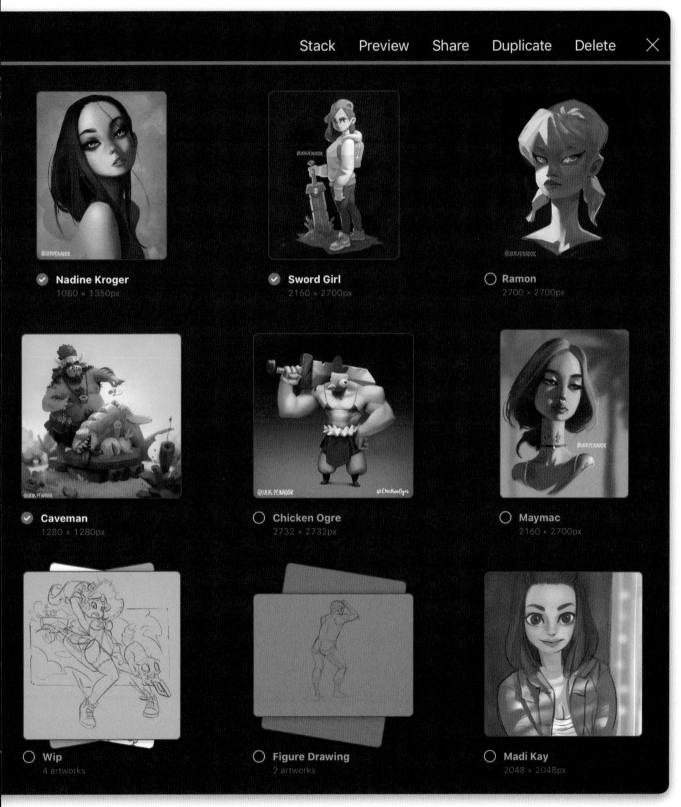

Stack　Preview　Share　Duplicate　Delete

Nadine Kroger
1080 × 1350px

Sword Girl
2160 × 2700px

Ramon
2700 × 2700px

Caveman
1280 × 1280px

Chicken Ogre
2732 × 2732px

Maymac
2160 × 2700px

Wip
4 artworks

Figure Drawing
2 artworks

Madi Kay
2048 × 2048px

▲ Use the Select tool to perform bulk actions on your files

GESTURES

Now we have covered the gallery, let's take a look at the canvas view.

As mentioned in the *The user interface* (page 14), one of the features that makes Procreate stand out from other software is its minimalistic interface. Through the use of gestures, it is able to be a fully featured digital painting application without dozens of menus crowding in front of your drawing.

Gestures are essential when working in Procreate. This chapter will cover them one at a time.

The Gesture Control Panel lets you customize gestures, which can help speed up your workflow. This will be covered in *Actions* (page 66).

In this chapter you will learn how to:

- navigate through Procreate;

- use gestures to speed up your workflow;

- undo and redo using gestures and the buttons on the sidebar;

- summon the menu to copy and paste elements in your canvas;

- use gestures to clear a layer;

- use gestures to return to full-screen view.

GESTURES AND NAVIGATION

The most basic gestures in Procreate are the ones used to navigate your canvas. These include how to zoom in and out, and how you move your canvas around the screen. All of these are extremely intuitive to use.

Zoom in and out
To zoom in or out, simply hold down two fingers and slide/pinch them in or out.

Rotate the canvas
Similar to the zoom gesture, keep your fingers held down on the canvas and rotate them. The canvas will rotate as it follows your motion.

Move the canvas
A similar gesture can be used to move the canvas around the screen. This time hold two fingers down on the canvas and drag to where you want to move the canvas to.

▶ Gestures are simple and intuitive

With these simple gestures, you can reposition your artwork as intuitively as if you were working on a piece of paper.

Full-screen view
Another gesture that proves useful when working on a painting is the quick pinch. This gesture snaps your canvas to full

screen view on your iPad. This is helpful when you wish to zoom in on details of your artwork, then want to quickly see the whole piece again. To do the quick pinch gesture, put two fingers on the screen and quickly pinch inwards, lifting your fingers off the screen.

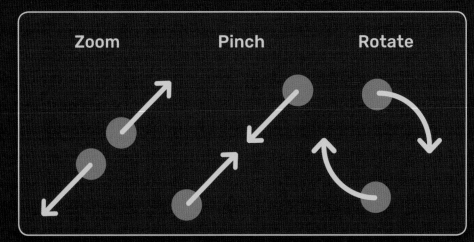

Zoom Pinch Rotate

All images © Lucas Peinador

UNDO AND REDO

Undo and Redo are essential commands n any digital painting software. Undo lets you go back a step in your painting and Redo a step forward. As you won't be using a keyboard with your iPad (though you could if you wish, using the keys of the keyboard to control several of the gestures), both can be carried out using gestures.

Undo
To undo, tap your canvas with two fingers.

Redo
To redo, tap with three.

Multiple steps
If you want to undo or redo several steps, hold your fingers down instead of tapping.

Alternatively, Undo and Redo are also included as arrow buttons at the bottom of the left-hand sidebar.

▼ Tap with two fingers to undo a step, or three fingers to redo i

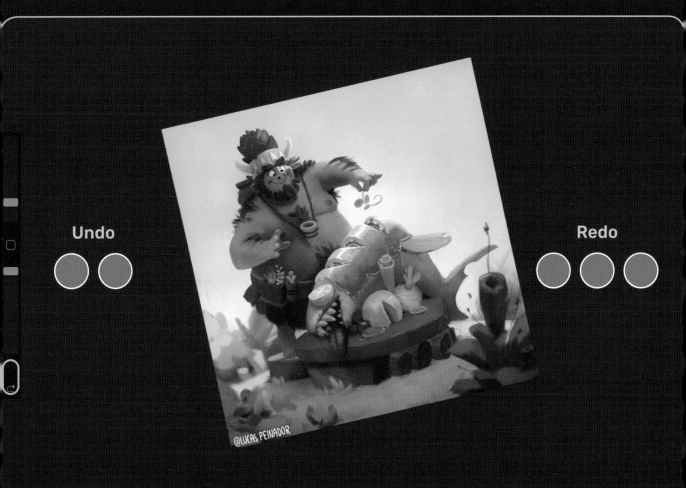

Undo

Redo

@LUCAS PEINADOR

COPY PASTE MENU

If you use three fingers to make a short, quick downward stroke on the canvas, the Copy Paste menu will appear. This menu allows you to copy, cut, or paste parts of your painting.

Copy

Copy duplicates whatever you have selected in your current layer. (How to make selections is covered in *Selections* on page 50, and layers are covered in *Layers* on page 42.) If you don't have anything selected, you will copy everything in your current layer. You can then use Paste to place what you have copied. You can do this from a different file, or even into another application.

Cut

Cut works in the same way, but instead of creating a copy of your layer, you remove the selected element and are able to paste it anywhere you like.

Paste

As you will usually want to paste onto another layer immediately after you have copied or cut, the buttons that do both actions are included in the menu.

Copy All

The Copy All option makes a copy of everything that is visible in your file, regardless of the layers.

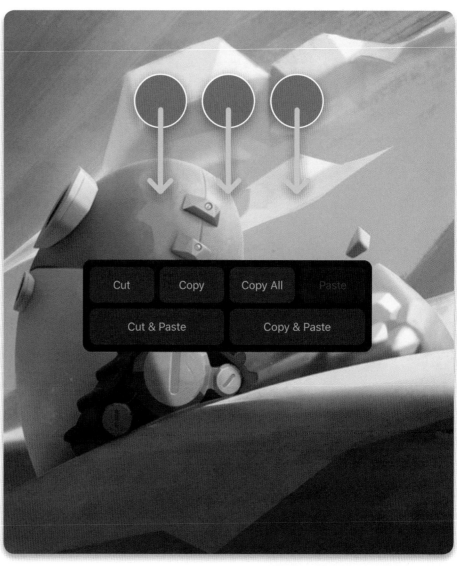

▲ To open the Copy Paste menu, slide three fingers downward on the screen

COPY ALL LAYERS

The Copy All command allows you to copy the contents of all your layers, pasting them onto a single flat new layer. (Your original layers will remain unchanged.) This is useful if you want to share quick work-in-progress images, or to capture a flattened copy of your progress that you can look back on later. An alternative to this is to create a group of layers, duplicate the group, and continue working on the new group. This serves the same purpose as saving them through Copy All, but preserves the layers; just be mindful of the number of layers in your file.

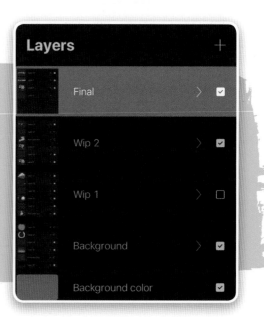

All images © Lucas Peinador

OTHER USEFUL GESTURES

Clear layer

If you want to clear a layer of everything that has been painted on it, place three fingers on the screen and slide them from side to side. This gesture can be used in combination with Selections to erase large parts of a painting without using the Eraser tool.

▶ Slide three fingers from side to side to clear a layer

Hide the interface

Tap the screen once with four fingers to hide the interface. If you want to summon it back, simply repeat the action. This is useful if you want to draw free of distractions, or you if you want to present your work.

▶ Tap with four fingers anywhere on the screen to hide the interface

BRUSHES

Procreate comes with three useful tools: Paintbrush, Eraser, and Smudge. The Paintbrush is your main painting and drawing tool and is the tool you will likely use the most. Once you have paint on your canvas, Smudge allows you to blend it, and the Eraser to erase sections of the painting (or the entire thing).

Believe it or not, these are the only tools you will need to paint in Procreate because the three of them share the same brush library. You can use the same brush with all three to create similar brushstrokes.

In this chapter you will learn how to:

- approach the Paintbrush, Eraser, and Smudge tools;
- explore the brushes Procreate comes with;
- rearrange your brushes;
- create a new set of your favorite brushes;
- share brushes;
- import brushes from your device;
- create and modify brushes;
- enable QuickShape and use it to your advantage.

THE BRUSH LIBRARY

If you select either the Paintbrush, Eraser, or Smudge, and tap the icon again, this will summon the brush library. This is a menu listing sets of brushes on the left and individual brushes on the right.

Procreate has brush sets for everything you might need from the outset, including: calligraphy, textures, abstract, inking, painting, sketching, and many more. Each brush set includes a selection of brushes relevant to that category. There are enough that you will find what you need, but not so many that you will feel lost. Here are some of the most useful brushes to get started:

Sketching brush set
Here you have pencils, crayons, and other dry media. Try the 6B Pencil – this is great for doodles and for practicing drawing gestures.

Painting brush set
In the Painting set you can find square and oriental brushes to simulate acrylics or watercolor. Try the Nikko Rull – this brush has some texture, but not so much that you can't control it.

Airbrushing brush set
The airbrushes are simple round brushes that increase in size and opacity with the pressure of your pencil. Keep a Soft and Hard Airbrush to hand, as these will prove useful in many paintings.

Touchups brush set
Touchups is a category useful for portrait painters. Here you find skin and hair brushes. If you wish to add some texture, try the Noise Brush from the Touchups set.

Before starting a project, explore all of the brushes in the brush library. Take some time to doodle and experiment with a few of them.

▲ Procreate's brush library comes with everything you need to get started

All images © Lucas Peinador

YOUR BRUSHES

After experimenting with the brushes, you may have discovered a few favorites that you would like to keep in a single set.

Creating a new brush set

To create a new brush set, drag the column of brush categories down until you see a + icon at the top. Tap the + icon to create a new set. Rename the set something like "Favorites." Once you have done this, you can then tap on the set again to rename, delete, share, or duplicate it.

Adding brushes to a set

Add brushes into your new brush set by finding the brush you wish to transfer, then selecting, holding, and dragging it into your new set. Wait until the set blinks and opens, and then release the brush into the library.

Moving and duplicating brushes

If the brush was a default brush, it will still appear in its original default set. However, if you transfer a brush from one custom set to another custom set, you will move it instead of copying it. To have a brush in two custom sets, you must duplicate it first.

▲ Create a new brush set by sliding the list of brush sets down and tapping the + icon

REARRANGING BRUSHES

After adding several brushes to a set, you can rearrange them by selecting, holding, and dragging them up or down the list. Grouping similar brushes together will help you to find them faster and make your time spent working in Procreate more enjoyable.

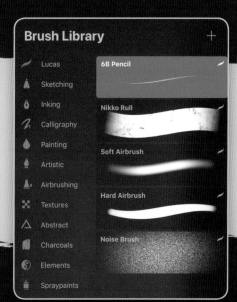

▶ Group and rearrange your favorite brushes for easy access

SIZE AND OPACITY

Controlling the size and opacity of your brush is essential when working in Procreate, or any other digital painting software. Size lets you control how big or small the marks made by your Paintbrush, Eraser, or Smudge tool are on the canvas, while opacity controls how opaque or transparent these marks are. Each brush

can be edited so its size and opacity are determined by default; however, there are useful sliders to adjust them while you work.

The size and opacity sliders are on the left-hand sidebar of the interface. Unless you have enabled full-screen mode and

hidden the sidebar, they are always there. (See *The user interface* on page 14 for a labelled diagram of the sidebar.) The upper slider controls the size of your brush and the lower one the opacity of your brush. The controls are positioned so that you can manipulate them with your non-drawing hand.

▲ Experiment with the size and opacity of your brush as you paint

▲ Brush opacity slider

▲ Brush size slider

PAINTING WITH A STYLUS

You can use your finger or a stylus (the Apple Pencil is recommended) to use the Paintbrush, Eraser, and Smudge. If you're wondering why you need a to buy a plastic stick to paint with, the answer is that a stylus (the Apple Pencil especially) allows the software to recognize both pressure and tilt. If you press harder or softer, or tilt your stylus, the digital brushes will immediately react to the change, helping to simulate a more realistic feeling of drawing and painting.

 All images © Lucas Peinador

There are a couple of tricks to adjust the sliders to meet your needs.

Right-hand interface

If you are left-handed, you can invert the position of the sliders. To do this, tap the Actions icon (the wrench icon in the upper left-hand corner), then select Prefs, and activate Right-hand interface.

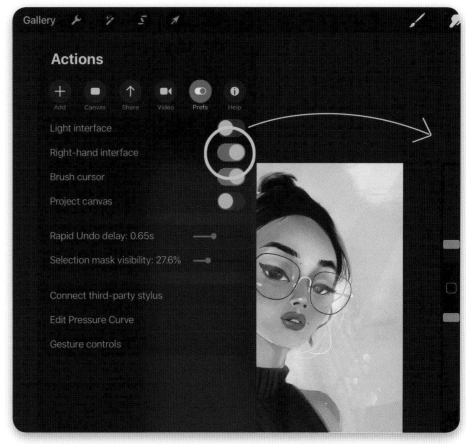

Changing to Right-hand interface allows you to manipulate the sliders with your right hand

Repositioning the bar

To reposition the bar higher or lower, hold down the Modify button (the little square in its center) and drag away from the border of the screen, and then slide up or down. This is useful when adjusting the bar to fit with the natural position you hold your iPad in.

Fine control

When you require more precision when moving the sliders, another trick is to enable fine control. Hold your finger down on the slider and drag it away from the bar, then move it up or down to adjust the brush size or opacity with more precision. You will notice that the slider moves slower than if you simply slide up or down as usual. This trick works for any slider you find in Procreate.

Experiment with the size and opacity of various brushes, seeing the different kind of brushstrokes and effects you can create.

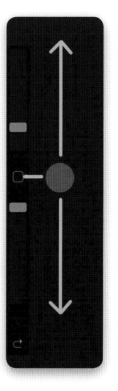

For fine control, reposition the left-hand sidebar by dragging it away from the edge, and then moving the sliders up or down

SHARING YOUR BRUSHES

Once you have created some custom brush sets of your own, you may wish to share them or back them up either online or on your device. To do this, tap the brush set you want to share and select Share, then choose where you want to export your brush set to.

You can also share individual brushes. Slide left on the brush you wish to share to summon a menu with three options: Share, Duplicate, and Delete.

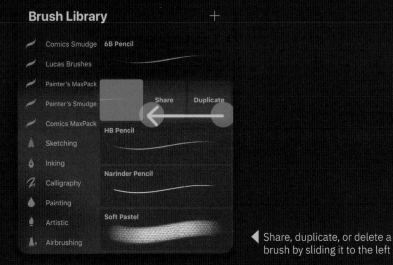

Share, duplicate, or delete a brush by sliding it to the left

HOW TO IMPORT BRUSHES

If you want to import one of the brushes or brush sets that you saved before, or if you find a brush online that you want to try, there is a simple way to import these into your brush library. Open both Procreate and the folder where the brush is stored. Next, drag and drop the brush you want to import into Procreate's brush library. If it is a single brush, drop it into the right-hand column, and if it is a set, drop it in the left-hand column.

Easily import brushes by dragging and dropping from your device

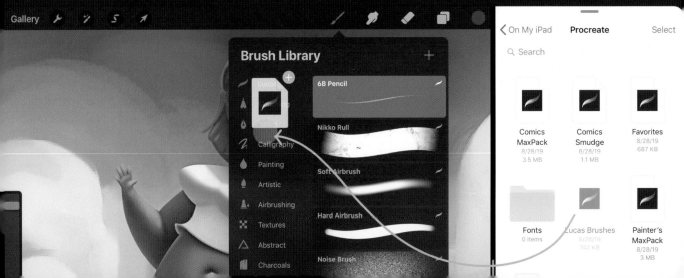

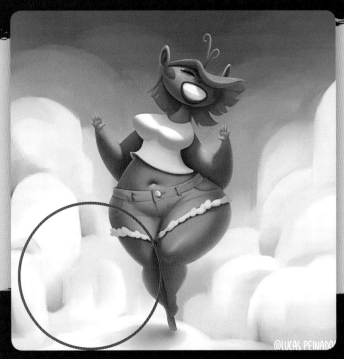

GRADIENTS

If you want to create a gradient effect, you can do this by working with a large soft airbrush. To create this brush, navigate to the Airbrushing brush set in your default brush library. Select the Soft Airbrush, then tap on it again to edit its settings. Go to the General section and make sure the Max slider is all the way to the right. Use this brush to create big soft gradients on your canvas.

@LUCAS PEINADO

▶ Implement a gradient effect using a large soft airbrush

CREATE A NEW BRUSH

Even after creating your set of favorite brushes, you may still feel like there is a brush you are missing. If you can't find the ideal brush, the solution is to create it. Fortunately, Procreate's brush customization is extremely powerful and provides all the options necessary to build whatever unique brush you might need.

Creating a new brush

To create a new brush, tap the + icon in your brush library. You can name your brush and select a shape and grain for it. Imagine the shape as the form of the brush's tip and the grain as the texture it leaves on the page. Tap on Swap from Pro Library to select a shape and grain from the ones already included in Procreate. After selecting a shape and a grain, you have created your own brush. Next it is time to customize it.

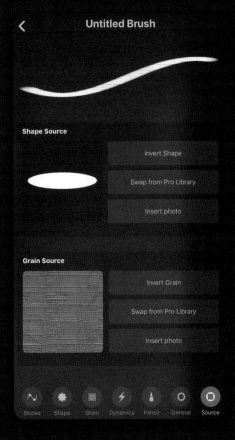

◀ Create a new brush using the Sources in your Pro Library

Brush customization

The number of brush customization options can seem a little overwhelming at first. Here are some of the more important settings to experiment with.

Test all your brush settings as you go along by scribbling in the brushstroke preview area.

Grain

Just as the Shape menu controls the shape of the brush, this menu controls the grain.

Movement controls how the grain is applied with each stroke. 0% will stamp the grain, whereas 100% will continuously apply the grain through your stroke.

Scale will determine the size of the grain in your stroke, while Zoom determines if the grain scale follows the size of your brush or is independent.

Shape

The Shape menu allows you to customize how the rotation of the brush shape reacts. Use a flat brush to better test this setting.

Scatter determines how much the brush shape rotates with each stroke.

Rotation affects how the shape follows the direction of your stroke. 0% will leave the rotation static. 100% will make your brush follow your strokes.

Randomized makes the rotation of your stroke different every time, and Azimuth makes the direction of your brush follow the tilt of your brush.

General

The General menu lets you rename your custom brush. Stamp Preview will show the stamp in your library, instead of the brushstroke. Preview makes the preview in your library bigger or smaller, without affecting your brush.

Blend Mode will ensure the brush paints with the chosen blend mode. Orient to Screen will make your brush follow your iPad's orientation. Smudge will determine how hard your brush drags paint when used with the Smudge tool.

Finally, Size Limits will determine the maximum and minimum size your brush can reach with your slider.

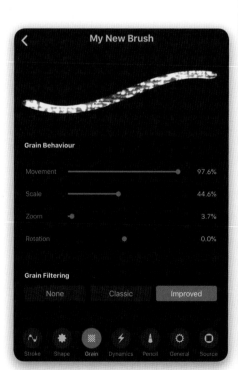

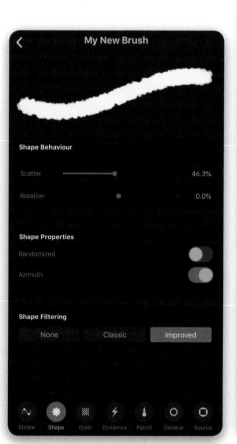

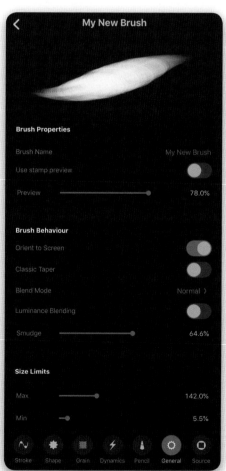

▲ Experiment with the various menu settings and sliders to customize your brush

 All images © Lucas Peinador

Dynamics

This menu offers three modes for your brush.

Normal is the default mode and applies a steady and consistent level of color.

Glazed is translucent and can be built up with multiple strokes to reach full color, as if you are glazing with watercolors.

Wet Mix simulates a wet media effect. You can set it up to drag paint in your canvas, or even set how much paint the brush contains each stroke. This is a good mode if you want to simulate techniques like oil or acrylic paints.

Stroke

Spacing will control how dense your brush is. Increasing the value will give the brush a dotted line effect.

StreamLine produces smoother lines. Maximize the slider to create the smoothest line, which is perfect for inking a drawing or drawing calligraphy.

Jitter will make your brush scattered, which is ideal for creating brushes that simulate clouds or vegetation.

Pencil

The Apple Pencil Pressure menu lets you increase the **Size** and **Opacity** to make the brush bigger and more opaque when you press harder with your Apple Pencil or stylus. (See page 8 for the difference between the Apple Pencil and a third party stylus.)

If you want your brush to react when you tilt your stylus, start by setting an angle. The bigger the angle, the more quickly the brush will recognize the tilt. For example, you can set your brush to become more transparent the more you incline your stylus by increasing the sliders in **Angle** and **Opacity**.

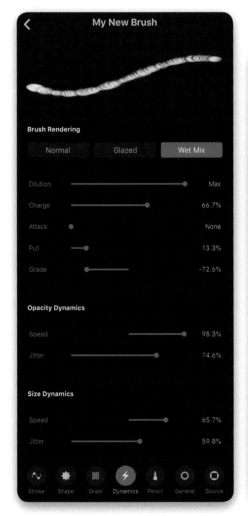

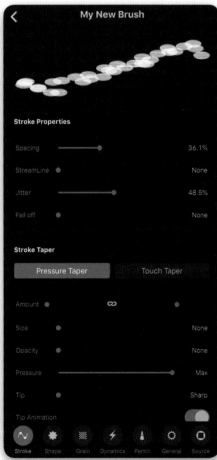

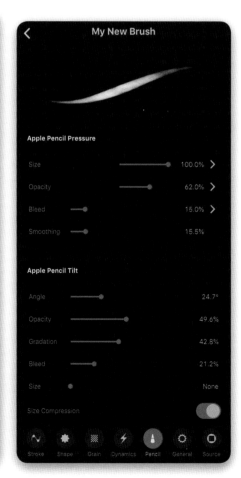

QUICKSHAPE

QuickShape provides an easy way to transform your lines and shapes after you have created them. The best way to understand this is to try it yourself.

Straight lines

Draw a straight line, then hold your stylus at the end of your line and watch Procreate transform it into a perfectly straight one. Next, lift your stylus off the screen and tap Edit Shape, which is a button at the top of the screen. This will allow you to move and edit your line after its creation, using the round blue handles that appear at either end.

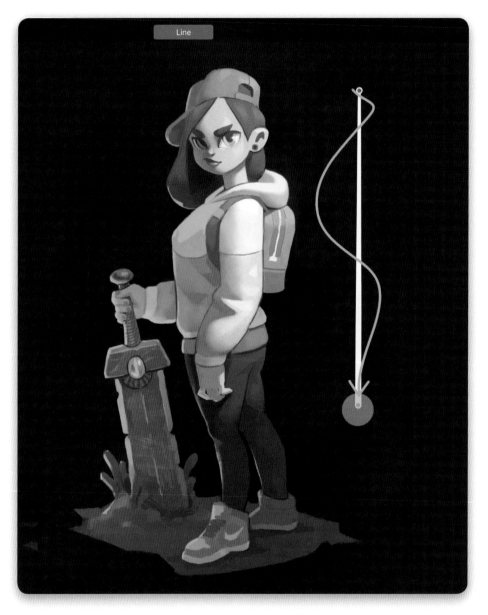

▷ Draw a line and hold it
 to activate QuickShape

 All images © Lucas Peinador

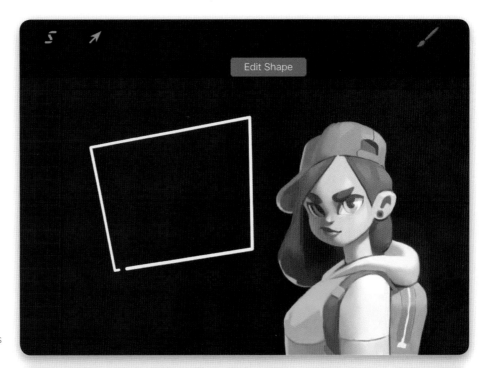

▷ Edit your Quickshapes after you create them

Shapes

As well as simple straight lines, QuickShape can be used with ellipses, quadrilaterals, or shapes made out of several straight lines. Simply draw each line one at a time. After releasing a line, you can edit its position using the blue handles at the ends. This allows you to achieve clean edges and precise shapes for subjects such as machinery, weapons, and buildings.

Snapping

To create a perfect circle using QuickShape, draw an ellipse and hold until you enable QuickShape. Instead of lifting your stylus off the screen, place a finger on the screen and you will see your ellipse turn into a perfect circle. This is called snapping and also works with squares and to snap lines to fixed degrees. When you hit Edit Shape after the circle is complete, you will notice four round handles appear. Tapping and dragging on these will allow you to squash, stretch and rotate your circle

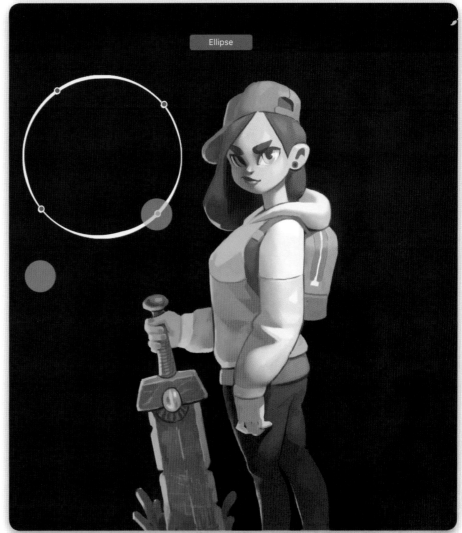

▷ Snap your QuickShape by holding another finger on the screen

COLOR

Procreate comes with four color modes, allowing you to choose the one that best fits your workflow. These are:

◆ Disc
◆ Classic
◆ Value
◆ Palettes

Find them by tapping on the the circular color swatch icon in the upper right-hand corner of the interface. The four color modes are listed across the bottom of the Color popover that appears.

The next few pages will guide you through some of their characteristics

and why you may prefer to use one mode over another, or switch between color modes while painting. For example, you could use Disc for the majority of the painting, then switch to Value once the general palette has been established and you require more precise results. Experiment with each of them to find your favorite.

In this chapter you will learn how to:

● use the Disc color mode to select colors;

● use the Classic color mode to select colors;

● use the Value color mode to select colors;

● use RGB and HSB sliders;

● create and modify the palettes in different color modes;

● share and import palettes.

DISC

Let's start with the first mode available to you: the disc. This mode is perhaps the most intuitive, as it allows you to control the hue, value, and saturation, all at the same time, in a clearly presented chromatic circle.

Hue
Select a hue, such as red or blue, using the outside ring of the circle.

Saturation and value
To make your hue lighter or darker, change the saturation and value using the inner circle. If you require more precision, simply zoom in on the inner circle to expand it. To return, pinch to zoom out.

Pure colors
But what if you want to select pure white or pure black, or a pure color? Procreate includes an ingenious solution to this problem. There are nine points in your circle to which you can snap if you double-tap around any of them.

Palettes
You also have access to a palette of square swatches below the circle if you prefer to select and save colors that way instead. Palettes are available in every color mode and allow you to save your favorite colors for quick access. Find out more about palettes on page 41.

▼ Double-tapping on the disc snaps to the closest points

Colors

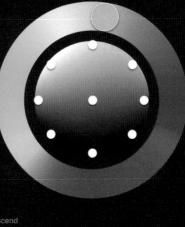

Ascend

Disc Classic Value Palettes

Hue

Veterans of digital painting will be familiar with this mode. Instead of a ring, the hue is controlled using the first slider.

Saturation and value

Saturation and value are controlled with the square, but there is also the option to fine-tune them separately using the two lower sliders.

Pure colors

Unlike the Disc mode, there is no need for snapping because the corners of the square include black, white, and pure color.

Overall, this is a good color mode to use if you prefer the precise control provided by the sliders, but still wish to see a visual representation of the selected color.

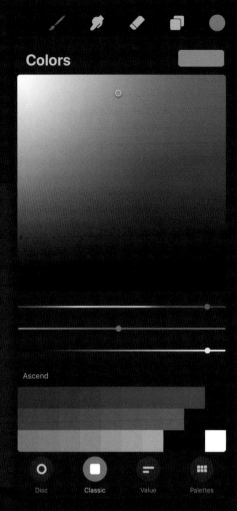

▶ Adjust the sliders to alter color in Classic mode

EYEDROPPER

The Eyedropper lets you pick colors from your canvas quickly and easily, and is an essential tool for a digital painter. The Eyedropper ring will appear, which you can drag around the canvas to select an area to sample from. The bottom half of the ring will show your currently active color, while the top half will show the new color that's pinpointed by the crosshairs of the Eyedropper.

By default, you can tap the Modify button to bring up the Eyedropper, but there are many other ways to access this tool. Go to **Actions > Prefs > Gesture controls > Eyedropper** and try some of the different tap, touch, and combination gestures until you find something you're comfortable with.

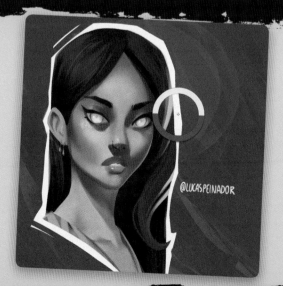

@LUCASPEINADOR

VALUE

The Value color mode has six sliders that provide greater control when selecting a color.

Hue, saturation, and value

The three upper sliders are the same as Classic mode – Hue, Saturation, and Value – however, Value color mode shows the percentage of the slider you are selecting. This allows you to accurately select 50% gray, for example.

RGB

The three lower sliders allow you to control the amount of red, green, and blue in your selected color. This function can be used to select and mix colors.

Hexadecimal code

Alternatively, if you need to use a specific color, requested by a client for example, you can select it by entering the hexadecimal code (or hex code as it is commonly referred to).

▶ Allowing you to select the exact percentage, Value mode provides a more technical approach

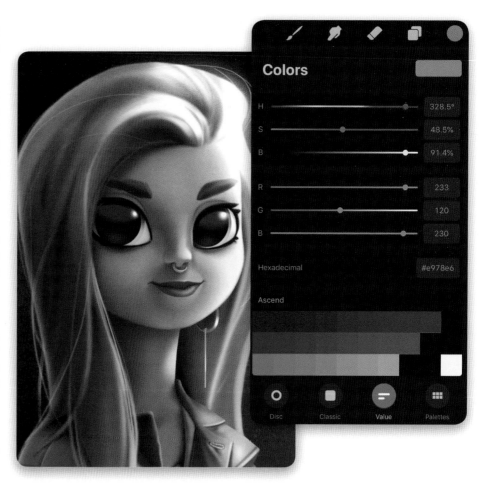

COLORDROP

The ColorDrop provides an easy way to fill the canvas with a single color. Drag the color dot from the top right-hand corner of your interface and drop it onto your canvas – this will fill your canvas with your selected color. Doing this on a layer with a closed shape will only let you fill either inside or outside of the shape.

 All images © Lucas Peinador

PALETTES

If you prefer to work with a defined set of colors, you may wish to use Palettes mode. As palettes can be used within all the other color modes, this mode is sometimes viewed as a complement to the other modes rather than an independent one.

Creating and filling a palette

Tap the + icon in the top right of the Palettes popover to create a new palette, then tap on an empty square to place a swatch of the color you have selected. To delete one of the swatches, hold and release it to bring up the Delete option. Creating a whole new palette from scratch can only be done in the Palettes mode, but once created it will be visible in all the other color modes. You will be able to add new colors to it, or to any of the existing default palettes.

To edit or add to a palette in another color mode, tap on one of the empty squares at the end of the respective palette to add a new square with your current color.

Replace an existing swatch by selecting and holding it until the Set/Delete option pops up, then select Set.

Rename and save

After creating a palette, tapping the Default button will set it to appear under your other color modes. Sliding left on one of the palettes will provide you with the option to share or delete the palette. You can also rename your palettes to help stay organized.

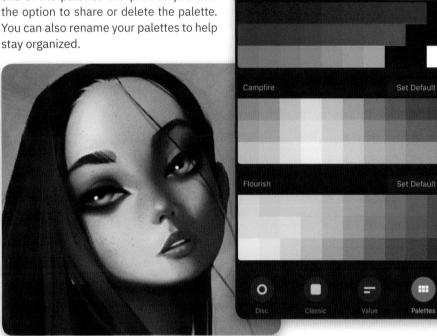

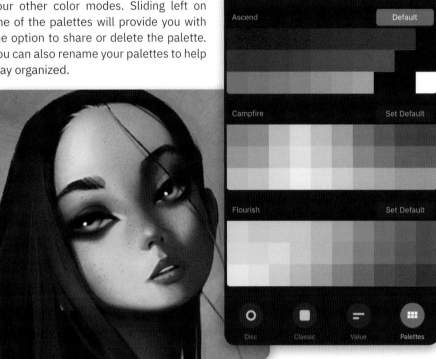

▼ Palettes mode lets you create your own color palettes to work from

新世紀エヴァンゲリオン

Before

After

LAYERS

Layers are a vital tool for any digital artist and are one of the main reasons why so many artists love painting digitally.

Think of layers like transparent sheets on which you can paint independently. This provides a huge amount of flexibility, as you can paint on one layer without fear of altering what you have painted on other layers. You can reorganize them, plus test out major changes without repercussions.

In this chapter you will learn how to:

- use layers to your advantage;
- create a new layer;
- toggle the visibility of a layer on and off;
- organize and merge layers;
- lock, duplicate, and delete layers;
- alter a layer's opacity;
- use Alpha Lock;
- use layer blend modes;
- access additional layer options;
- use layer masks and clipping masks.

LAYER BASICS

The Layers popover
The icon to open the Layers popover is second from the right in the top right-hand corner of the interface. Tap on it with your finger or stylus to open it.

Layer 1
When you create a new file, you will see two layers. One is the background color layer and the other is Layer 1. Every file in Procreate creates these two layers by default. On the left-hand side of every layer you will see a thumbnail preview of what is painted on that layer.

Background color layer
If you want to change the background color, tap on the background color layer and select the color you want to set. If you want to work with a transparent background and later export your image with transparency, tap on the checkbox of this layer to hide it.

Visibility
You can turn the visibility of any layer on or off by tapping its checkbox. This is a useful action. For example, if you want to be able to see the layer you are working on more clearly, it may help to hide another layer.

Creating new layers
Tap on the + icon in the top right of the

Layers popover to create a new layer. Every artist uses layers differently; some create new layers for everything, while others avoid having more than two or three. If you are new to digital painting, keep the number of layers to a minimum to begin with, and only create new ones when you want to paint something that could ruin what you have on your canvas already.

Experiment with using layers and painting brushstrokes on different layers to build up an image.

Layer limit
Procreate sets a limit on the number of layers you can create. This number depends on the size of your file, that is, in megabytes; the larger the file, the fewer layers you can create. This number can be viewed when creating the file and will be covered later in this chapter.

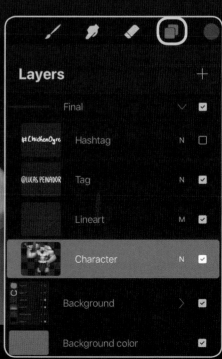

▲ Layers are essential for any digital artist

LAYER ORGANIZATION

Moving and grouping individual layers

Start by moving layers up and down in the layer hierarchy. Moving a layer up will make what you painted on it appear on top of the other layers. To move a layer, hold and drag it up or down the list in the Layers popover.

If you release the layer on top of another layer it will create a group of layers. Groups are an excellent way to keep layers organized. A group acts like a folder, containing two or more layers that can be moved together but edited individually.

Find out how to delete individual layers on the next page.

Selecting multiple layers

To select multiple layers at once, select each layer, slide it to the right, then release. (The selected layers will be highlighted in blue.) This will allow you to drag and drop them like individual layers, or tap the Delete or Group commands that appear at the top right.

Merging layers

Merging layers is a good way to keep them organized when you don't need to work on separate elements, or when you wish to apply an adjustment to the whole image at the end of the process, when you've finished painting and just want to make some final touches.

Merging, also known as flattening, layers means compressing two or more individual layers into one flat layer. This means they can longer be individually edited, so only do this if you are 100% sure. Merging is different from grouping layers, where each individual layer is still available to edit within the group, which acts like a folder.

Merge layers by pinching them together in the Layers popover. This can be done with any number of layers.

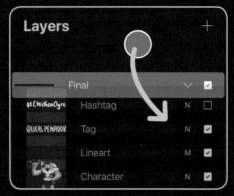

▲ Drag and drop a layer to reposition it

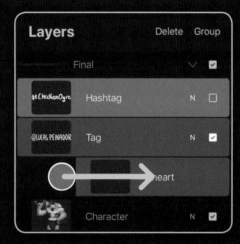

▲ Slide one finger to the right to select a layer or a group

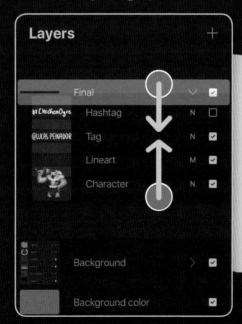

▲ Pinch layers together to merge them

ORGANIZE YOUR LAYERS

Keeping your layers organized is necessary to maintain a streamlined workflow. Messy or confusing layers will mean you will not be able to find things in your own files.

ARE YOU SURE?

Unless you Undo the merge straightaway, this action cannot be undone. Therefore it's important to be sure you want to merge and flatten your layers, or you may find it difficult to make adjustments or corrections to those areas later.

LOCK, DUPLICATE, AND DELETE

If you slide a layer to the left, three options will appear: Lock, Duplicate, and Delete.

Delete

Delete will remove the layer. A layer can be restored if you tap Undo immediately afterwards, but if not there is no way of reinstating it.

Duplicate

Duplicate will create a copy of your layer. This will appear below your original layer with the same name, so ensure you rename the duplicated layer straightaway to avoid confusion.

Lock

Accidentally painting on the wrong layer can be very frustrating, especially when you have been working for a long time then realize all of your hard work is in the wrong place. The lock function provides a solution to this problem. You can toggle lock on or off on any layer.

Locking a layer will prevent you from manipulating it in any way, including painting on it or deleting it. If you want to unlock the layer, slide the layer to the left again and the Unlock button will appear.

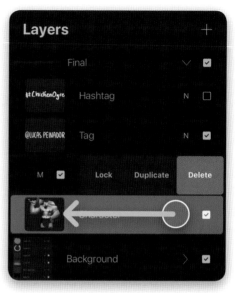

▲ Lock, duplicate, or delete layers by sliding to the left

OPACITY AND ALPHA LOCK

Alpha Lock and opacity are included together in this section because both are controlled with two-finger gestures from the Layers popover. Both are extremely useful when working with layers.

Opacity

Opacity controls the overall opacity of a layer's entire contents. For example, if you wish to paint a gradient of light on a layer, you can fine-tune how strong this gradient is with the opacity setting of the layer. Or, when you have drawn a sketch on a layer and are ready to move on to the final line art, you can lower the opacity of your sketch and use it as a guide as you draw cleaner and more final lines on top. These are two examples, but you can integrate it into your workflow in your own way.

To control the opacity of a layer, tap the layer in the Layers popover with two fingers and then slide left or right on the screen to adjust the visibility.

▲ Tap the layer with two fingers to open the opacity control

 All images © Lucas Peinador

Alpha Lock

Alpha Lock is another very useful option that is unique to digital painting. Once activated, it only allows you to paint on the parts of your illustration that are already painted on, preventing you from painting outside of the desired shape. For example, it could be used to paint texture on an object, such as the art tools in this image. You would paint the subject on an isolated layer, Alpha Lock it, and then paint on top of it with a texture brush. Once you have tried Alpha Lock, you will see the numerous ways you can integrate it into your work.

To enable Alpha Lock on a layer, slide the layer to the right with two fingers. A checkered pattern will then appear on the transparent parts of your layer's thumbnail.

Alpha Lock your layer by sliding to the right with two fingers

ALPHA LOCK

After painting the silhouette of your object, turn Alpha lock on to paint the shadow or details inside that silhouette. Working this way will keep your painting clean and organized.

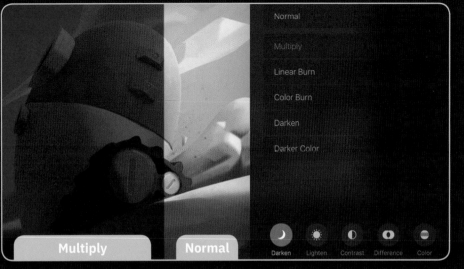

Darken

Darken mode boosts your colors, resulting in a darker blend.

Multiply is the most commonly used mode in this category. It multiplies the value of your color with the colors of the layers below, which is great for creating shadows. Pure white cannot be multiplied and darkened by this mode, so becomes transparent instead. This is valuable if your line art is on a white layer and you would like to color on layers underneath it.

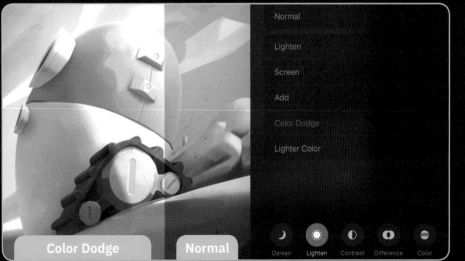

Lighten

Lighten mode does the opposite of Darken, blending your colors to achieve a lighter combination.

Use **Screen** when adding a source of light to your painting, or **Color Dodge** if you want to increase saturation and highlights.

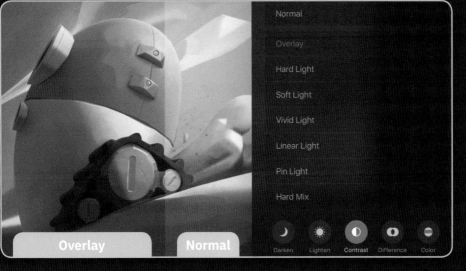

Contrast

Contrast creates a combination of Darken and Lighten. The result is always increased contrast between the light and dark parts of the image.

Overlay is the most frequently used mode; it can be used to glaze a color, changing the mood of an entire painting.

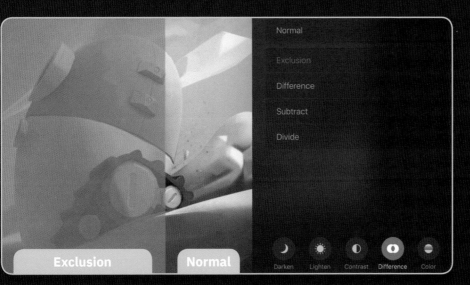

Difference

The **Difference** options combine or invert the colors to create a photographic negative type of effect. This is a good mode to use if you are looking for experimental results.

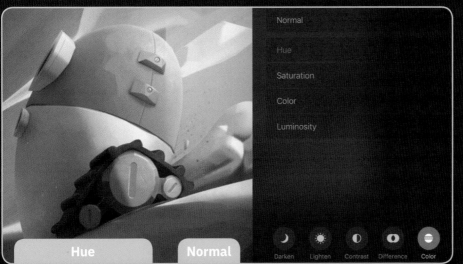

Color

The **Color** modes allow you to influence how the hue, saturation, and value of your layers interact independently of each other.

Both **Hue** and **Color** are often used to add hue to grayscale images. Experiment with the different modes to see how they can alter an image.

EXTRA OPTIONS

There is an extra menu of options for layers. What is displayed in this menu will depend on the type of layer selected. Procreate will only show options that are relevant to that layer.

Tap on your selected layer to open the menu.

Rename is self-explanatory, but it is useful to know where this option is.

Select will make a selection of the contents on the layer. (Selections will be covered in depth in the next chapter.)

Copy copies the contents of the selected layer.

Fill Layer will fill the layer with color.

Clear will clear the layer of its contents.

Alpha Lock locks the empty pixels of the layer, meaning you can only paint on what has already been painted on the layer (as shown on page 45).

Clipping Mask makes the current layer the clipping mask of the layer below. (Clipping masks will be covered in the next section.)

Mask will hide what's on your layer (and will be covered in more detail in the next section).

Invert inverts the colors of your layer.

Reference makes this the layer that dictates where ColorDrop applies color on other layers.

Combine combines the current layer and the one below it into a group.

Merge merges the selected layer with the layer immediately below it.

Flatten is an option for groups. It merges the group of layers into one single layer.

Edit Text opens the text editor and is an option for text layers only.

Rasterize is also an option for text layers, transforming the text characters into pixels.

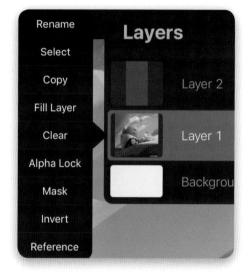

▲ Tap on your selected layer to open an extra menu of layer options

MASK

How to use a mask

The mask is a simple yet very useful tool if you are able to integrate it into your workflow. If you tap a layer, then tap Mask, a white layer will be created on top of your selected layer. This is your mask. If you paint black on the mask, it will hide what's painted on your layer, while white will show it again. Using gray will partly hide what's painted on your layer. In the image on the right you can see that the black and gray strokes on the Layer Mask partially hide the dark blue layer, revealing the aqua layer underneath.

Masks are powerful as they allow a non-destructive workflow. Instead of erasing and losing the information on your layer, a mask will simply hide it, meaning it is still at your disposal if you need it again.

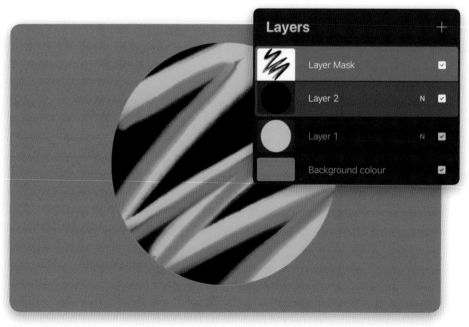

▲ Masks are an excellent way to erase in a non-destructive way

 All images © Lucas Peinador

CLIPPING MASK

Clipping masks may sound similar to masks, but they have more in common with Alpha Lock. While Alpha Lock only allows you to paint on the already painted pixels of a layer, clipping masks allow you to do the same, but on a different layer.

For example: paint a circle on an isolated layer (using QuickShape to create the circle shape, and ColorDrop to fill it with color). This layer will determine where you are able to paint within the clipping mask, as you cannot paint where the layer is transparent.

Next, create a new layer above this one and set it as a clipping mask by navigating to the extra Layer Options menu and tapping Clipping Mask. You will see that the new layer has an arrow on the left-hand side pointing downward; this indicates that the new layer is now clipped to the original circle layer. Whatever you paint on this layer will now only show where the circle is on the original layer, as if you're painting within a stencil.

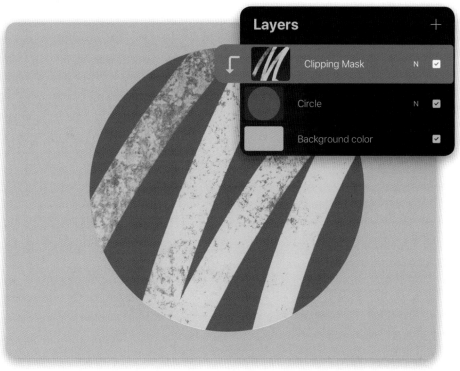

▲ Keep your workflow efficient with clipping masks

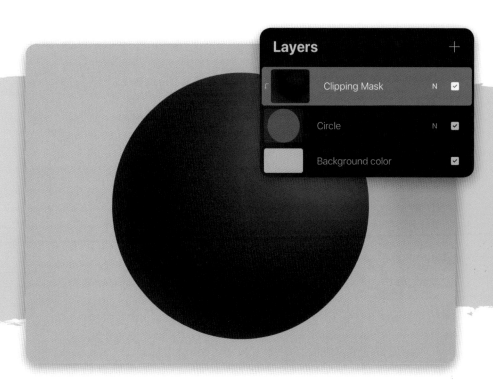

CLIPPING MASKS

Use clipping masks when painting shadows on a layer. Create a base shadow with the shape or silhouette of the object, then create a new layer and clip it, then paint the shadow. This will allow you to control the shadow separately from the color of the object.

SELECTIONS

Selections are used to control where you want to paint or what elements you want to transform. (The Transform tool will be covered in *Transform* on page 54.)

The Selection menu can be found by tapping on the S icon in the top left of your interface. After tapping on the Selection icon, a menu will appear at the bottom of your screen. Here you can choose the Selection mode, as well as from a number of Selection modifiers.

After selecting an area of an image, you will only be able to modify that section, therefore keeping the rest of your canvas intact. The best way to understand this is to try it out for yourself – experiment using an image from the downloadable resources provided.

In this chapter you will learn how to:

● use selections to enhance your creative process;

● clear a selection and summon the previous selection back;

● use Automatic Selection;

● use Freehand Selection;

● use Rectangle and Ellipse Selections;

● add, remove, invert, duplicate, feather, and clear selections.

AUTOMATIC SELECTION

The first Selection mode is Automatic Selection. This mode selects a range of similar colors, depending on where you tap your finger on the screen. If you want to expand the range of this selection, known as the selection threshold, slide your finger to the right. If you want to reduce the selection threshold, slide it to the left. As you tap or slide to select areas, they will be highlighted in solid color. Once you have obtained your preferred selection, simply tap on a tool and a diagonal stripe

pattern will appear. This pattern confirms what areas have been selected. If you wish to go back and modify your selection, hold the Selection icon for a moment until the menu reappears.

Automatic Selection proves most useful when you have merged your layers but find you want to alter an area of your painting that has similar colors; for example, the hair of a character or the sky of a landscape.

It is essential to understand that selections only work on your currently selected layer. This is especially important with Automatic Selection, where the areas you are able to select are dictated by the content of your current layer.

▼ Use Automatic Selections to separate objects with high contrast

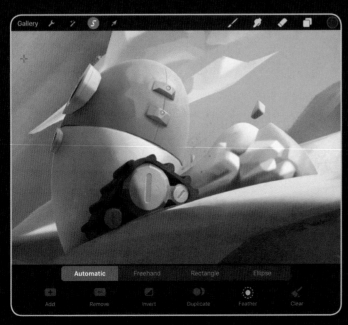
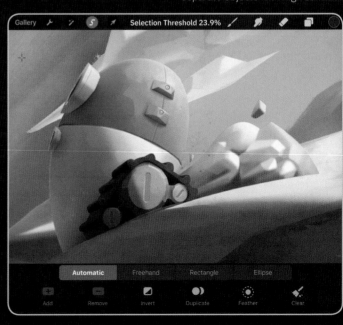

 All images © Lucas Peinador

FREEHAND SELECTION

Freehand Selection is simple to use and is an important tool in a digital artist's toolkit. After selecting Freehand from the Selection mode menu, drag your finger or stylus to create your preferred selection.

Alternatively, you can tap the screen to place a dot, then tap again to draw a dashed line. Continue tapping in this way to draw a polygonal shape around what you wish to select. Once you are happy with your selection, tap your initial dot again to finish the selection. If you continue drawing shapes, this will add the selections together.

You can also combine both methods to achieve the selection you want.

▼ Freehand Selection allows you to be as precise as you want

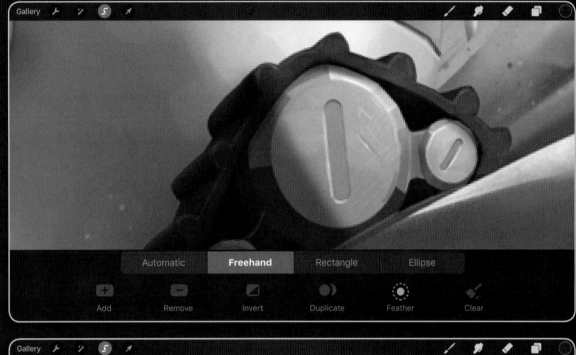

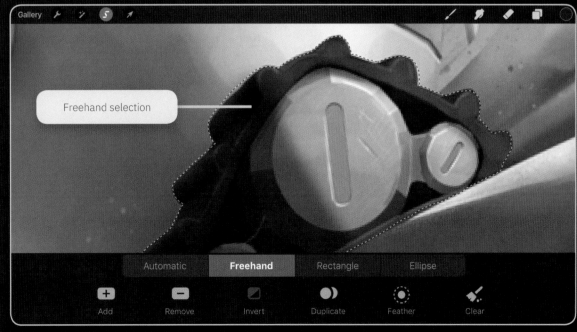

Freehand selection

RECTANGLE AND ELLIPSE SELECTIONS

Shape Selections are useful for a variety of reasons, from using them to paint circular masks, to selecting a crop of your canvas to paste elsewhere. Simply tap either Rectangle or Ellipse and proceed to drag your desired shape. An added advantage is that you can snap your ellipses to perfect circles by placing another finger on the screen while dragging the Ellipse Selection.

▼ Ellipse and Rectangle Selections enable you to create shapes faster

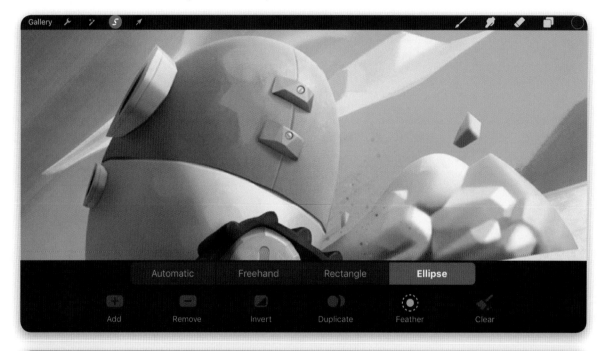

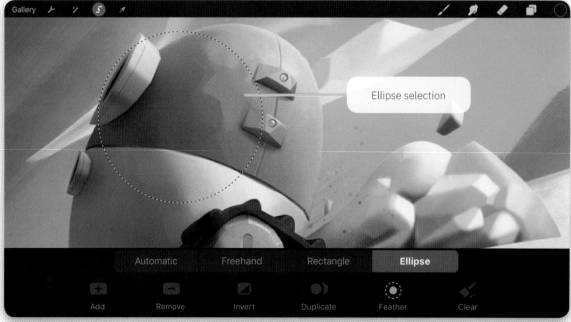

 All images © Lucas Peinador

SELECTION MODIFIERS

There are a number of selection modifiers listed below the Selection modes. The Add and Remove buttons are useful when using Freehand Selection. Add will attach the chosen area to your existing selection, while Remove will subtract the chosen area from your existing selection.

The Invert option will invert your selection. This is useful as it is sometimes easier to select the areas you don't wish to paint, then invert them, than create a selection the usual way. Duplicate will duplicate the contents of your selection onto another layer. Remember that selections only work on the layer currently selected, so be sure you are selecting the layer that contains the section you wish to duplicate.

Feather is an interesting option – useful in very specific cases – which allows you to soften the edges of your selection to create a gradient. You will see the diagonal stripe pattern soften and fade according to the degree of feather. The amount of feather determines the softness of the gradient. Clear will undo your current selection, which is useful if you would like to start again.

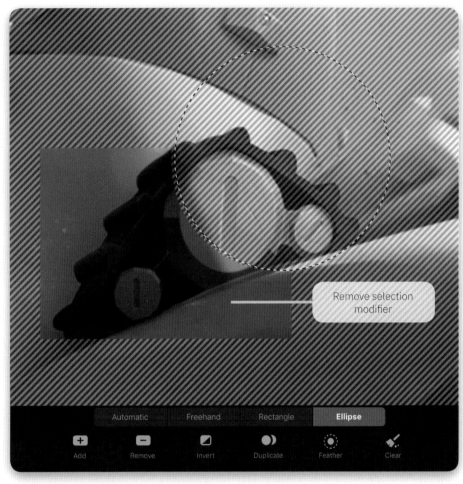

▲ Subtract an area from your current selection using Remove

SELECTION MASK VISIBILITY

If you find it difficult to work with the striped pattern, you can increase or decrease its opacity. Go to **Actions > Prefs** and adjust the Selection mask visibility slider.

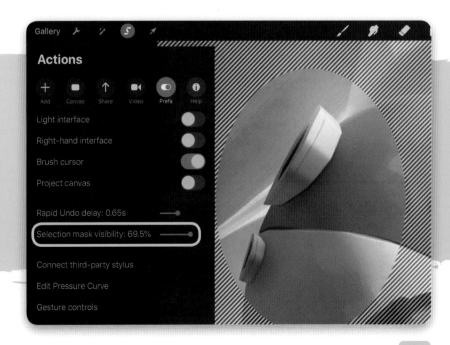

TRANSFORM

The Transform tool allows you to move, rotate, flip, distort, and warp parts of an image. Accessed by tapping the arrow icon on the upper toolbar, Transform works nicely with selections. If you have a selection active (indicated by the blue *S* icon in the top left of your screen) you will be able to transform the area of your artwork that is selected. If you don't have anything selected, Transform will affect the entire contents of a layer.

Similar to Selections, the Transform menu has several modes and options. Experiment with these, using one of the images provided in the downloadable resources.

In this chapter you will learn how to:

- use Freeform and Uniform Transform;
- use Distort and Warp;
- use Advanced Mesh;
- flip selections, rotate them, fit them to the canvas, and how to reset them;
- use Magnetics to your advantage;
- use Interpolation.

FREEFORM VERSUS UNIFORM

The difference between Freeform and Uniform Transform is most noticeable when scaling an object.

Create an object, then tap Transform to summon the controls. You will see a marquee surrounding your object. A marquee, also known as marching ants, is the dotted line that indicates the border of the area you have selected. Use the blue dots to change the shape of an object and the green dot to rotate an object. If you select the corner of that marquee, this will let you change both the width and height of your object at the same time.

Freeform
If you have Freeform selected, you will be able to squash and stretch the proportions of your object.

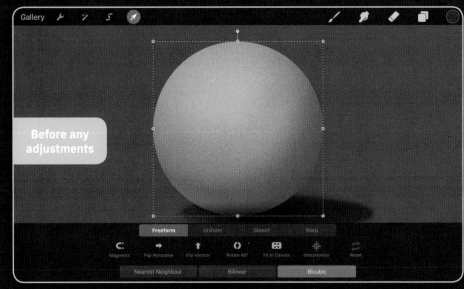

Before any adjustments

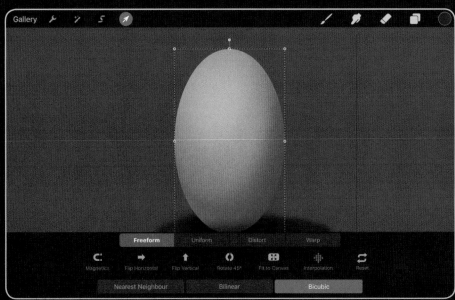

▶ Freeform Transform lets you

Uniform

Conversely, if you have Uniform selected, this will maintain the proportions of your object so that it does not get squashed or stretched.

Both Freeform and Uniform have their uses. For example, when scaling the head of a character you may wish to keep its proportions, but if you are scaling rocks in an environment, changing their height and width could help to make them look more natural.

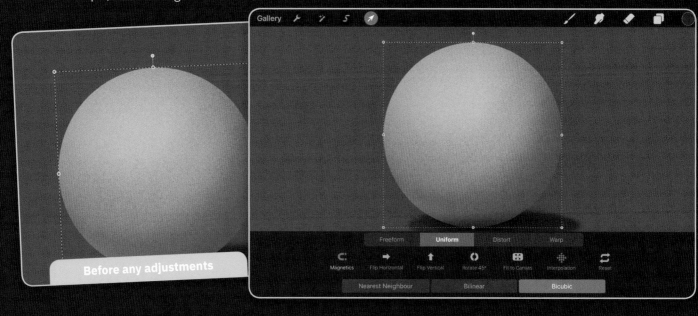

Before any adjustments

DISTORT

Distort allows you to transform the perspective of your object without constraints, similar to Freeform, except every dot on your transform marquee is independent. This allows you to create diagonal distortions and is a great way to transform textures to fit a three-dimensional object.

▶ Choose Distort when you wish to transform the perspective of your object freely

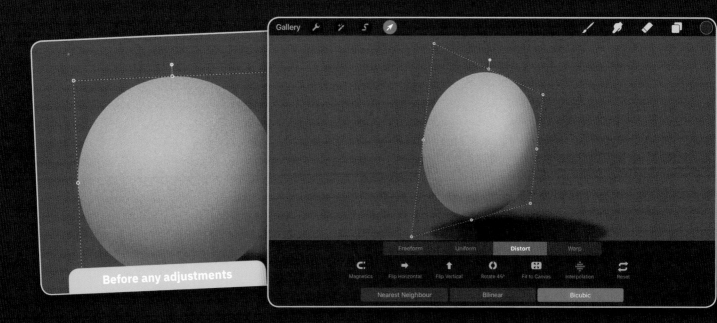

Before any adjustments

WARP

Warp bends objects as if they were painted on a piece of paper. You can move the mesh that overlays the marquee to produce different effects, or you can bend the shape over itself. You can also tap on the points around an object to move them back or forth in space.

If you want more detailed control with how your shape bends, activate Advanced Mesh, which will provide more blue nodes on your mesh.

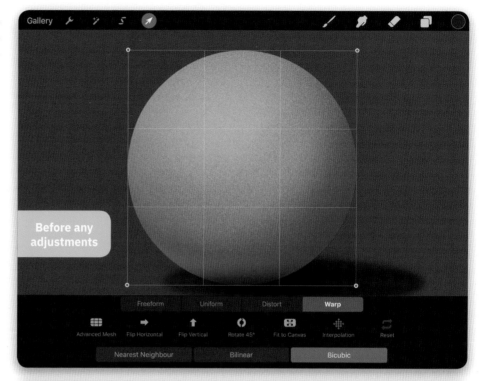

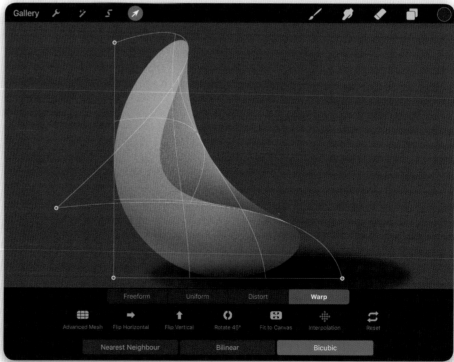

▶ Warp allows you to bend objects like sheets of paper

 All images © Lucas Peinador

TRANSFORM OPTIONS

In addition to the main Transform modes, there are also Transform options that allow you to tailor each mode in more detail. These are visible at the bottom of the screen when Transform is selected.

Magnetics

Turning Magnetics on will allow you to transform your object with fixed constraints, such as rotating it in increments of 15 degrees or scaling it in increments of 25%. This is useful if you need distinct measurements and determined axes when transforming.

Flip Horizontal and Flip Vertical

Flip Horizontal and Flip Vertical are self-explanatory. These are two very useful options if you are working with symmetrical objects.

Rotate 45°

Rotate 45° will rotate your object by 45°; however, you can perform this action plus much more with Magnetics.

Fit to Canvas

Fit to Canvas will enlarge your object until it fits to the borders of your canvas. You can fit either the height or the width, depending on whether Magnetics is turned on or off.

Interpolation

Interpolation offers three options for the pixel-level transform of your objects:

- Nearest Neighbour
- Bilinear
- Bicubic.

From former to latter, these transition from sharper to smoother. Try all three to see which one works best for you. You may find that some interpolation modes will yield cleaner-looking results than others, especially when enlarging a selection.

Reset

Redo will undo any transformations you have applied, returning the object to its original state.

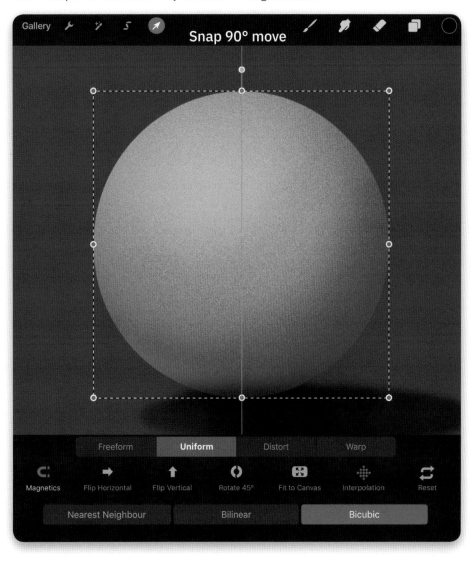

▶ Magnetics lets you move an object along straight axes

ADJUSTMENTS

The magic wand icon on the top left of the upper toolbar holds the Adjustments menu. Adjustments are effects that can be applied to an image to change how it looks. They can be applied to specific layers, but some work best when used on a whole image. Adjustments only work on the layer you have selected and can be used alongside selections. This means that if you have a portion of a layer selected and then proceed to apply an adjustment, it will only affect the selected area.

In this chapter you will learn how to:

- use adjustments to your benefit in a painting;

- use the Gaussian Blur adjustment;

- use the Motion Blur and Perspective Blur adjustments;

- use the Sharpen adjustment;

- use the Noise adjustment;

- use the Liquify adjustment;

- use the Hue, Saturation, Brightness adjustment;

- use the Color Balance adjustment;

- use the Curves adjustment;

- use the Recolor adjustment.

Gallery

Adjustments

Opacity

Gaussian Blur

Motion Blur

Perspective Blur

Sharpen

Noise

Liquify

Hue, Saturation, Brightness

Color Balance

Curves

Recolor

▶ Tap the magic wand icon to summon the Adjustments menu

GAUSSIAN BLUR

Gaussian Blur is the second option in the Adjustments menu. This extremely useful adjustment allows you to uniformly blur the selected layer. Gaussian Blur can be used for a multitude of things. For example, if you need to blur the background behind a character, or soften a gradient, the shine on a character, or the clouds in the sky. It is also extremely easy to manipulate.

Simply tap on Gaussian Blur, then slide left or right to increase or decrease the blur effect.

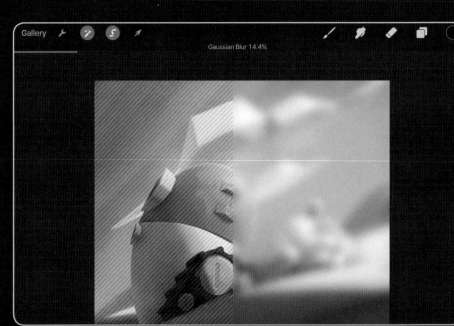

Gallery · Gaussian Blur 14.4%

▶ Gaussian Blur is extremely useful for creating distance between objects

MOTION BLUR AND PERSPECTIVE BLUR

Similar to Gaussian Blur, the Motion Blur and Perspective Blur adjustments blur an image, but in a directional fashion. Motion Blur does this in a straight line, which is useful if you want to create the illusion of an object moving parallel to the camera. Perspective Blur applies this in a radial mode, which is useful if you want to give the impression of objects moving toward the camera.

Motion Blur

To use Motion Blur, tap on the option in the Adjustments menu then drag your finger on the image. The direction in which you make the movement will determine the axis of the blur, and the distance of the slide will determine the amount of blur.

Perspective Blur

Perspective Blur is slightly different. After tapping on the option, a dot will appear on your image. This dot is the center of your radial blur and you can reposition it by dragging it. After you have positioned it, slide left or right on your image to increase or decrease the amount of blur. Alternatively, you can tap the Directional option at the bottom of the screen. This turns the radial blur into a conical one, if that better suits your needs.

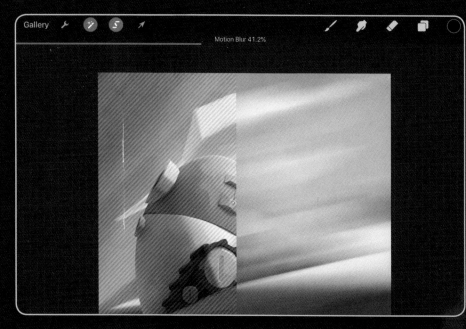

▲ Motion Blur can be used to create a sense of speed

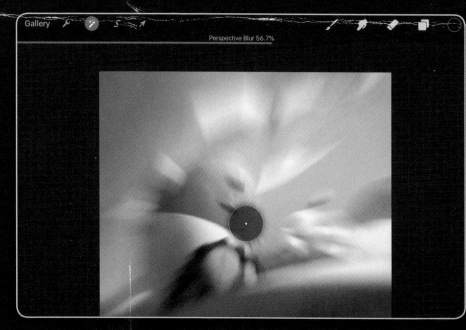

▲ Perspective Blur can also be used to give the impression of movement

59

SHARPEN

Sharpen enhances the contrast between neighboring pixels, making an image's edges more crisp and contrasting.

As with other adjustments, after tapping on Sharpen you can slide right or left to increase or decrease the strength of the effect. But be careful; while sliding all the way to the right might be tempting, overdoing Sharpen will make your image look grainy and overly processed, overpowering your handpainted details.

▽ Sharpen can be a great way to enhance detail, but don't go overboard

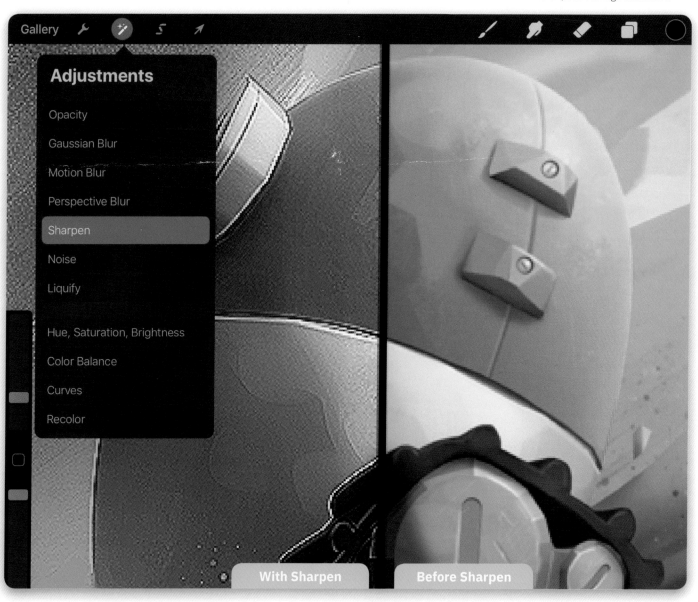

All images © Lucas Peinador

NOISE

If you study a photograph or video close up, you will see how noise is everywhere, giving the subject a subtle grain that can offer a lot of character. Digital paintings, in comparison, can sometimes feel a bit too slick, clean, and lacking in texture. To avoid this, the Noise adjustment creates a photographic look that digital paintings often lack by adding a layer of noise on top of an image.

Tap on Noise then slide to the right to add more noise, or to the left to decrease the amount of noise. As with the Sharpen filter, less is more, as overdoing the effect can look too artificial.

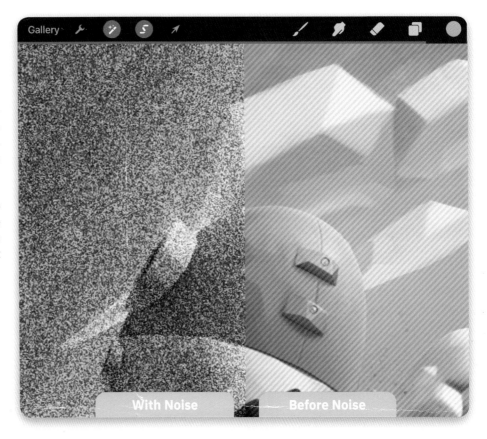

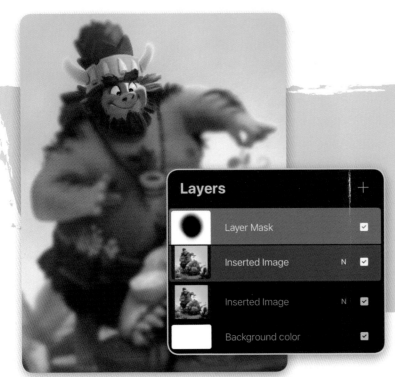

ADJUSTMENTS & MASKS

Adjustments can be tricky to fine-tune. Let's say you want to apply Gaussian Blur to your whole image except on a character's face. You could do this by applying the adjustment on a duplicated version of your artwork, then using the Mask tool to hide or show parts of the adjustment, allowing precise control over every detail.

Liquify is one of the most powerful adjustments available in Procreate. Tapping on it will summon a menu along the bottom of the screen, which contains a variety of tools and sliders.

Tools

Three of Liquify's most useful tools are Push, Pinch, and Expand. **Push** can be used to drag pixels, **Pinch** to drag the pixels to a center point, and **Expand** to push pixels away from your selection. The other tools are fun to experiment with, but may not be quite as useful. **Twirl Right**, **Twirl Left**, **Crystals**, and **Edge** will all deform an image in weird ways.

Sliders

Under the menu of tools there are sliders to change the Liquify effect. **Size** determines the size of your brush. Your Liquify brush is controlled with this slider, not the regular brush slider. **Pressure** controls the strength of the effect, similar to the Opacity slider on a regular brush. If you increase **Momentum**, Liquify will continue its path even after you lift your stylus off the screen. And finally, **Distortion** distorts the image. You can increase this slider for each tool to boost its randomness. For example, it will add waves to your Push, spikes to your Pinch, or blobs to your Expand.

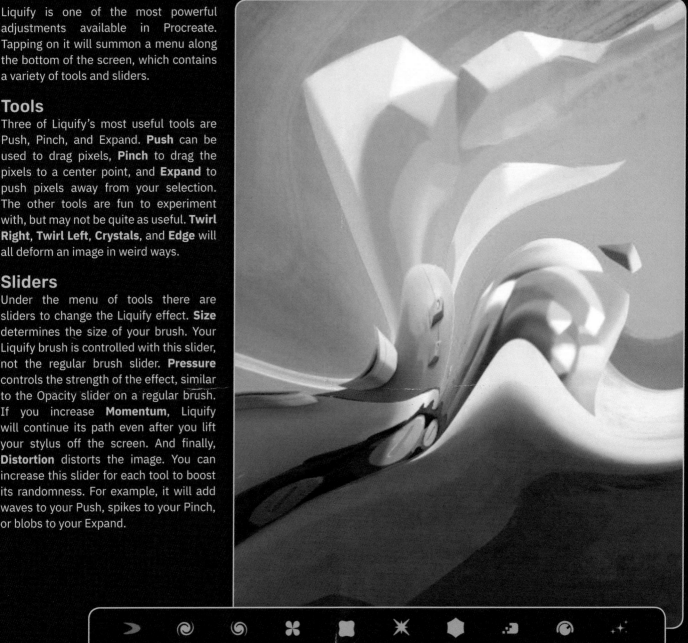

 Push
 Twirl Right
Twirl Left
 Pinch
 Expand
 Crystals
Edge
Reconstruct
Adjust
 Reset

HUE, SATURATION, BRIGHTNESS

Hue, Saturation, Brightness (HSB) is an easy-to-use adjustment that allows you to change color using three different sliders. It can be used to try out different color combinations in a painting without changing the shading on them.

Tapping on this option will summon a menu with three sliders. You also have options to reset your changes, preview a before and after, and undo or redo your last step in the adjustment.

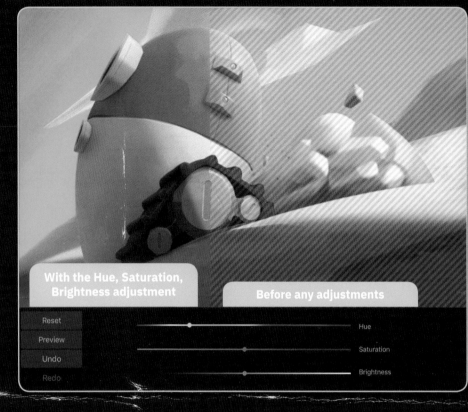

▶ Experiment with the hue, saturation, and brightness of an image

COLOR BALANCE

Imagine Color Balance as the subtle brother of HSB. Where HSB is a paint bucket, Color Balance is a paintbrush.

This adjustment allows you to individually control the amount of red, green, and blue in a painting by moving the sliders for each of the colors. You can even choose whether you wish to alter the shadows, midtones, or highlights individually.

Use Color Balance to fine-tune the colors in your overall image. For example, if you want to lower the temperature of your shadows and raise it in the highlights.

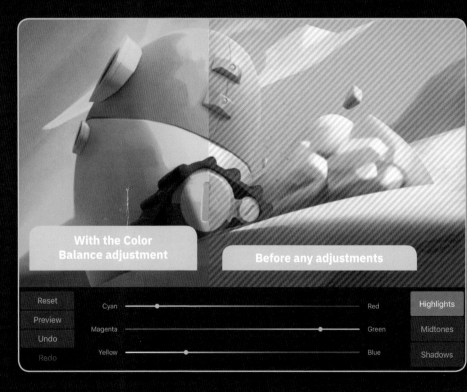

▶ Color Balance is more subtle than HSB, but by no means less useful

CURVES

Curves allow you to micro-manage the colors in your painting, making the Curves adjustment one of the most powerful in your toolkit. Though Curves may seem intimidating at first, once you understand what the curve represents you will realize it is just as simple as the other tools.

Tapping on Curves will bring up a histogram with a line through the middle. If you drag the middle of the curve, you will create a point. You can manipulate this point to affect different value ranges of your image, then drag those ranges up to making them brighter, or down to make them darker.

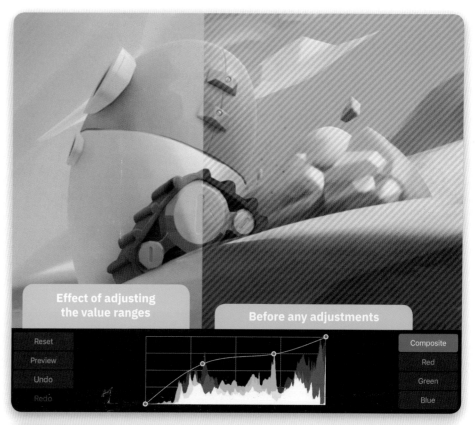

▷ Curves may seem intimidating at first, but they are no harder than other adjustments

Many artists limit their usage of Curves to modifying the overall hues and values of their painting. This is very useful by itself, but you can also modify the amount of red, green, or blue in each of the value ranges of your painting. For example, if you found that your highlights were a bit too yellow, you would tap the Blue channel in the Curves panel (since blue is the complementary color of yellow) and drag the right part of the curve up. This would increase the amount of blue in your highlights, therefore reducing the amount of yellow.

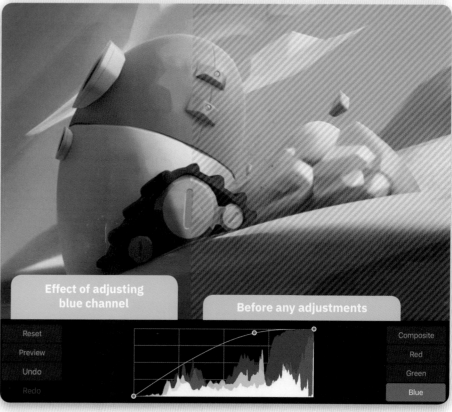

▷ Curves may seem intimidating at first, but they are no harder than other adjustments

All images © Lucas Peinador

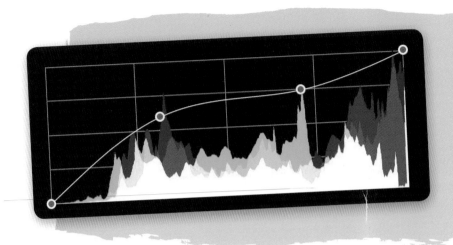

HISTOGRAMS

In Procreate, a histogram is a grapic representation of an image's colors and values. The left is the black, the right is the white, and then there is everything in between. The height of the bars in each section represent how much of that value there is in the painting.

RECOLOR

Recolor is a simple tool that can save you a lot of time if you need to implement big changes at the end of a painting.

Let's say that you have finished an illustration, have flattened the layers, applied some post-production effects, and have delivered it, when suddenly your client decides they wish to change the color of the character's skin. Instead of trying to cut or select all of the character's skin, simply choose your new color from the color palette, then go to Recolor, tap the skin of your character, and this is instantly fixed.

▼ The Recolor adjustment can save lots of time in changes

Before recolor

After recolor

Adjustments: Opacity, Gaussian Blur, Motion Blur, Perspective Blur, Sharpen, Noise, Liquify, Hue, Saturation, Brightness, Color Balance, Curves, Recolor

ACTIONS

The Actions menu can be found by tapping the wrench icon on the upper toobar. This menu contains a variety of options, from personalizing your Procreate gestures to connecting a different stylus.

In this chapter you will learn how to:

● use the Add Text tool;

● use the different options in the Canvas tab;

● use and edit Drawing Guides;

● use the Assisted Drawing mode;

● use various options in the Prefs tab to customize your experience in Procreate;

● use the gesture control panel to customize Procreate's gestures to your liking;

● use Procreate's time-lapse video and how it helps artists to share their work and learn from each other.

ADD

To open the Actions menu, tap the wrench icon in the top right-hand corner of the interface. You will see several categories, the first of which is Add.

Add contains options for:
◆ Inserting a file directly from your device.
◆ Inserting a photo from your gallery.
◆ Taking a photo with your iPad.
◆ Adding text.

Further down the menu there are the options from the Copy Paste menu, in case you prefer to access these here rather than using the gestures covered on page 26.

▲ The Add tab lists options for inserting elements, plus copying and pasting layers

All images © Lucas Peinador

Tapping on Add Text will create a text layer with the sample "Text." The color of the text is determined by what color is currently selected in the color swatch. Once you have written what you want to write, tap the Edit Style button. This will provide a variety of style options, letting you alter the font, size, opacity, style, and kerning (the space between letters), plus import your own fonts.

▶ Tap Edit Style to alter the font, size, opacity, style, and kerning of your text

▶ The Add Text tool provides a variety of stylistic options

CANVAS

The second category in the Actions menu is Canvas. Here you can view and edit the attributes of your canvas.

The Crop and Resize option allows you to modify the size of your canvas. You can crop it by dragging the rectangle around your image, or change the resolution by editing the numbers in the boxes at the bottom of the screen. You can also rotate it using the slider.

The number in the first box is the width and the second the height. Tapping the chain link icon will link them, keeping them in proportion to one another. If you want to enlarge the image, not just the canvas around it, switch Resample on. This option will automatically link width and height.

The Crop and Resize screen also displays the layer count. This is the maximum number of layers you can create in a file. The bigger the canvas, the smaller the layer count.

The Canvas tab also contains options to flip canvas vertically or horizontally. This is useful if you need to refresh your eyes and catch any mistakes. Below this is Canvas Information, where you can view details such as the file size of your image, number of layers used, canvas dimensions, and tracked time. Tracked time is useful for seeing how long a painting actually takes you to complete.

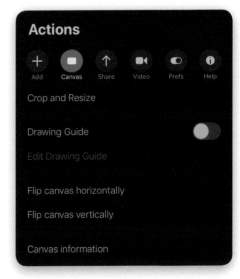

▲ Tap Canvas to edit the attributes of your canvas

◀ Crop and resize your artwork easily

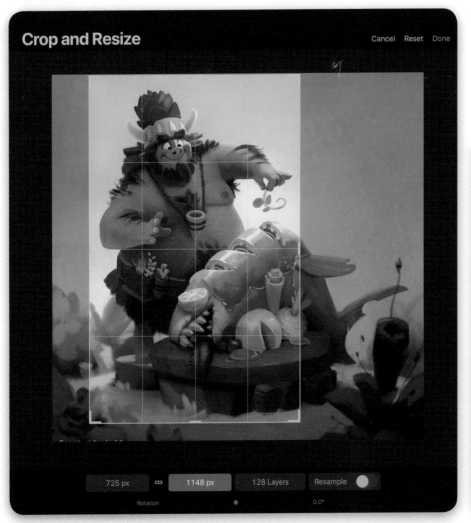

All images © Lucas Peinador

DRAWING GUIDE

The Drawing Guide is an easy way to create grids to follow while drawing. It can be switched on and off in the Canvas tab. Below that is Edit Drawing Guide. Tap this and you will be presented with a screen where you can select the type of guide, plus all of its attributes. You can choose between 2D Grid, Isometric, Perspective, and Symmetry. All are fairly straightforward and share common attributes, such as the color, thickness, and opacity of the guidelines.

Drawing Guides also allows you to snap your brushstrokes to the guidelines. This is helpful when building scenes in perspective. Do this by turning on Assisted Drawing.

2D Grid

2D Grid is a grid made up of vertical and horizontal lines equidistant from each other. You may find this grid useful if you need to divide the canvas into equal parts, or uniformly distribute objects along your canvas.

Isometric

Isometric is a grid formed of vertical and diagonal lines, the latter projected at 30 degrees. This grid can be used to draw objects that even if drawn in three dimensions appear to not foreshorten with the distance.

Perspective

Perspective is unique in allowing you to place up to three vanishing points by simply tapping on the screen, then dragging them to reposition, or tapping again to delete them.

Symmetry

Symmetry allows you to select the type of symmetry you want to use – vertical, horizontal, quadrant, or radial – and also turn the Rotational Symmetry on or off. When you turn on this last option, you will notice that your lines follow the same direction, instead of the opposite direction as usual.

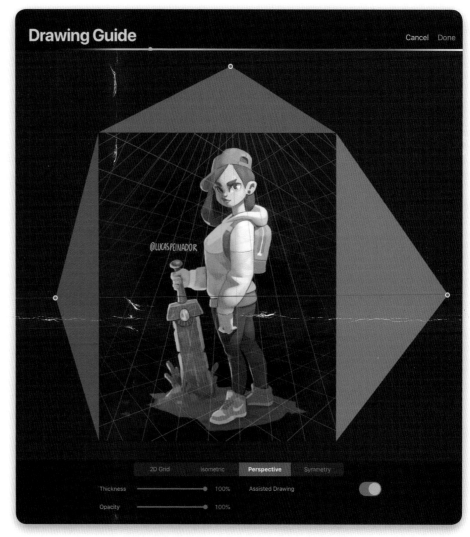

The Perspective Guide lets you create up to three vanishing points

DRAWING ASSIST

Drawing Assist is layer sensitive, meaning you can switch it on for specific layers. Do this in the Layers popover by tapping on any layer and selecting Drawing Assist. Once the layer has the option enabled, you will see "Assisted" written below the layer name.

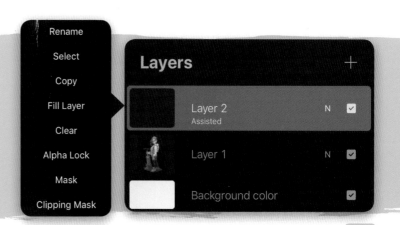

PREFS

The Prefs tab offers some useful options to customize and improve your experience in Procreate:

- If you dislike Procreate's dark interface, try the **light interface** instead.

- **Right-hand interface** allows you to switch the side of your Size and Opacity sliders so you can manipulate them with your non-dominant hand.

- **Brush cursor** can be switched on or off to show or hide the silhouette of your brush when painting.

- **Project Canvas** allows you to share your canvas, without showing the interface, when sharing your screen with another device.

- **Rapid Undo Delay** determines how long you need to hold when undoing to initiate the automatic undos.

- **Selection Mask Visibility** controls how visible the zebra pattern is when you have an active selection.

- **Connect Third-Party Stylus** is self-explanatory; you only need to use this if you don't have an Apple Pencil.

- And **Edit Pressure Curve** allows you to tweak how Procreate interprets the pressure of your strokes.

▶ The Prefs tab contains multiple useful options

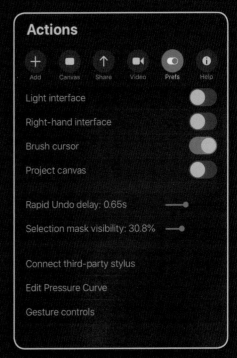

PRESSURE CURVE

We all have a natural way of holding a pencil. Some people will hold it lightly, while others squeeze it like an empty tube of toothpaste. Pressure Curve allows you to personalize this. A downward curve captures more sensitive strokes, while an upward curve is better suited to people with a strong hand.

GESTURE CONTROLS

The last option in the Prefs tab is the Gesture Controls. Here you can customize the gestures in Procreate to optimize your workflow. For example, you can switch to the Smudge tool whenever you touch the screen with your finger instead of your stylus, set a gesture for Assisted Drawing, change the way you summon the Eyedropper, or reduce the delay in which it appears.

A couple of useful customizations to try are summoning the QuickMenu with touch, and activating Layer Select with the Modify button plus touch. These two commands can accelerate your workflow when working on big projects.

Gesture control panel

Smudge	**Touch** — A finger touch will invoke Layer Select
Erase	**□ + Touch** — A finger touch while holding □ will invoke Layer Select
Assisted Drawing	**□ + Apple Pencil** — Apple Pencil while holding □ will invoke Layer Select
Eyedropper	**Touch and hold** — Holding a finger on the canvas will invoke Layer Select
QuickShape	Delay 0.20s
QuickMenu	
Full Screen	
Clear Layer	
Copy & Paste	
Layer Select	
General	

▶ Modify your gestures in the gesture control panel

VIDEO

Procreate boasts a unique feature that sets it apart from other digital painting apps on the market: the option to record a time-lapse video.

Under the Actions menu there is a tab called Video. By enabling Time-lapse Recording, Procreate will record every brushstroke or action you make in your file as a step in a video. This offers enormous advantages for any artist. Not only can you learn from your own process to improve on it, but you can also share this video with others.

To watch the video of your current file, tap Time-lapse Replay. Rewind or skip ahead in the video by sliding your finger to the left or right.

To export a video, tap on Export Time-lapse Video. Procreate offers the option to export the full-length video, or if your video is fairly lengthy, then a compressed version of 30 seconds. After choosing which option, select where you wish to store the video.

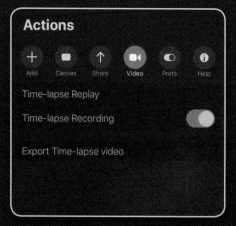

▲ Procreate records your canvas by default – use this feature to your advantage

PROJECTS

Now you know how to use Procreate, it's time to put your newfound knowledge into practice. Follow these eight detailed projects written by professional artists, demonstrating how to create a variety of digital paintings in Procreate.

The project artists have all used the Apple Pencil to complete their digital paintings. Note that if using a third party stylus, you may not be able to create exactly the same brushstroke effects the artists have achieved on the following pages. This specifically relates to the advanced pressure and tilt functions unique to the Apple Pencil. However, we have used the word 'stylus' throughout, as you will still be able to follow and complete the projects using a third party stylus.

Don't forget to download the free resources (see page 208) for each project before you start.

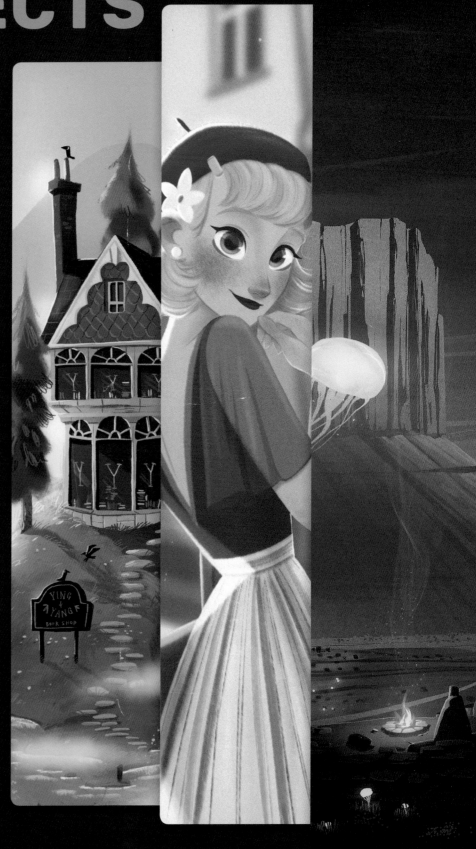

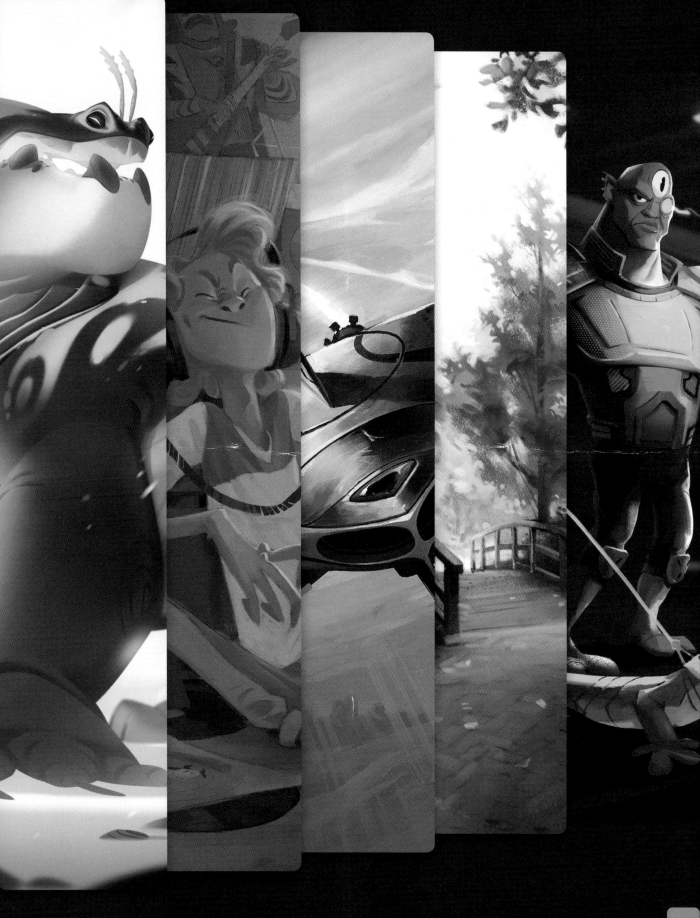

ILLUSTRATION

Izzy Burton

This project will guide you through how to create a fantasy environment illustration with an architectural element, capturing a mysterious mood to intrigue and captivate the viewer.

You will learn how to take your idea from thumbnail stage to color rough to final art, using your own photographs of architecture to help inspire your design. You will learn how to block shapes and lock their pixels so you can paint within the shapes to add texture. And you will learn how to add light and detail to your illustration to bring it to life, as well as the basics of using Procreate. These skills and techniques can be easily transferred to other types of illustration to help with future projects.

While this project uses photographic references, remember to draw on the power of your imagination too. The best thing about illustration is that you're not constrained to the real world; have fun creating a world that is inspired by this one, but with fantastical and exaggerated colors or shapes.

PAGE 208

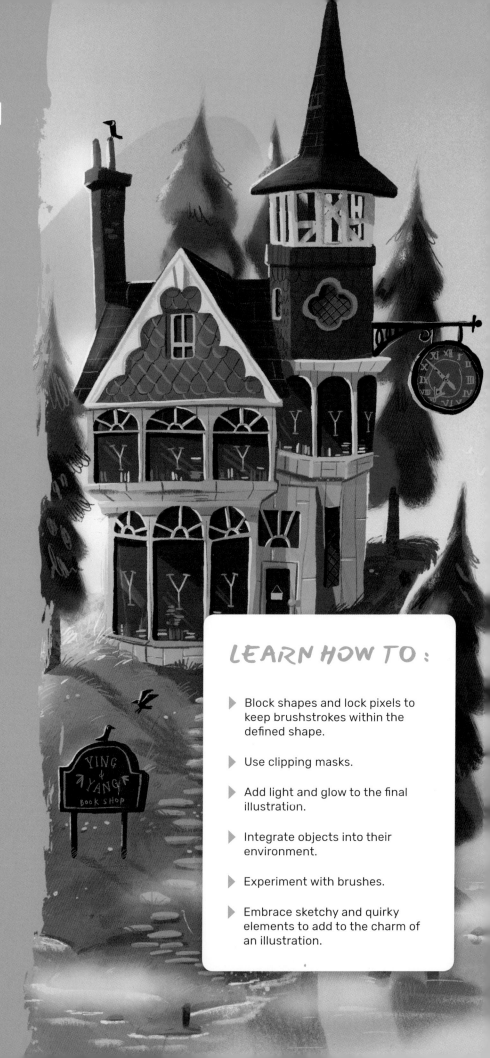

LEARN HOW TO :

▶ Block shapes and lock pixels to keep brushstrokes within the defined shape.

▶ Use clipping masks.

▶ Add light and glow to the final illustration.

▶ Integrate objects into their environment.

▶ Experiment with brushes.

▶ Embrace sketchy and quirky elements to add to the charm of an illustration.

01

Before you begin, take some time to formulate an idea and collect references to help you put the illustration together. When creating an illustration focused on architecture, take photos of architecture where you live or on a visit somewhere else. This mood board contains photos taken in Lewes, England, which has very old Tudor architecture that suits the mystical, fairytale feel that this illustration will evoke.

▶ Creating a mood board of photo references will help inspire your illustration

02

Now set up your iPad workspace. You can use the iPad split screen function to position your mood board alongside your canvas in Procreate. Swipe up from the gray bar at the bottom of the screen to open the dock. Touch and hold the Photos app, then drag and drop it onto the screen. Locate your mood board in your Photos. (The dock only shows recent apps, so if the Photos app isn't showing on your dock bar, open it separately first then go back into Procreate where it should now appear on the dock.)

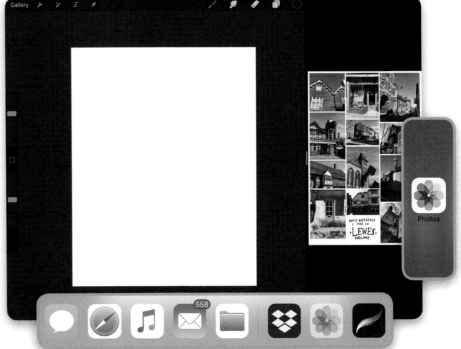

▶ Setting up your workspace

03

Use the QuickShape tool to create four storyboard panels to draw your thumbnail ideas within (see page 36). Once you have drawn the four lines of the first box, select **Transform > Uniform** and scale the box down to a quarter of the page. Next, duplicate the layer. Use the Transform tool to move the second box next to the first, then repeat the duplication until you have four boxes. Finish by merging your layers so that all four boxes are on the same layer.

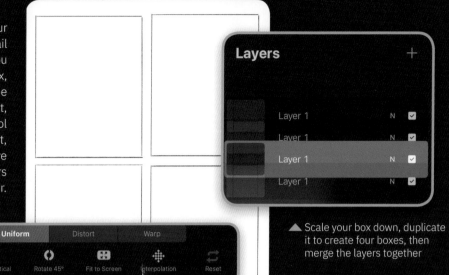

▲ Scale your box down, duplicate it to create four boxes, then merge the layers together

▶ Use the QuickShape tool to draw straight lines

04

Draw the thumbnails using the **Sketching > 6B Pencil** brush. Thumbnails should be rough, quick drawings that focus on the idea, layout, and composition rather than detail. Let yourself be loose and imaginative – this is the time to play around with your idea. Create a new layer for your drawings above your thumbnail boxes. Rename your layers to stay organized.

◀ Create a new layer for your thumbnails and rename each new layer for optimal organization

05

Use the Transform tool to scale and rotate your drawings. If you only want to scale down a section of your artwork, use **Selection > Freehand** and draw around the area you want to scale. Then use the Transform tool to scale and rotate as you wish. The 6B Pencil offers some nice shading effects when you tilt your stylus at different angles.

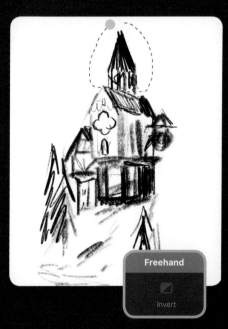

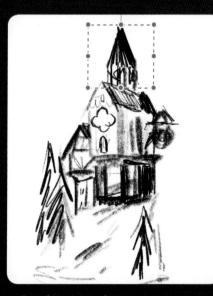

▲ Transform areas of your thumbnails with the Selection tool

ARTIST'S TIP

On an Apple Pencil (2nd generation), you can double-tap the lower section to swap between the Eraser and Paintbrush tools quickly.

▲ Finished thumbnails

06

Thumbnail two works well; however, there are elements of thumbnail three that are also good. Create a new thumbnail that combines these two. First, use the Selection tool to draw around thumbnail two, then open the Clipboard menu and select Copy & Paste. A new layer will be created called From Selection. Hide the other thumbnails by unticking the layer. Erase the area you don't like on thumbnail two. Unhide the other thumbnails and use the Selection tool to copy and paste the area you like – the turret – from thumbnail three. Use the Transform tool to move it and scale it in place. Merge the final thumbnail on its own layer and fill in any gaps by sketching.

◀ Transform areas of your thumbnails using the Selection tool

▲ Erase the area you don't like on thumbnail two

▲ Use the Selection tool to copy and paste the turret from thumbnail three

▲ Merge thumbnails by copying and pasting details together

07

Once you're happy with your thumbnail, hide the rest of the layers and scale up to fit the canvas. Select **Transform > Flip Horizontal**. This is a great way to check your perspective and make sure you haven't drawn on a slant. If your image is on a slant, tap and hold down the dots of the Transform box and then move them to skew the image. Then use Flip Horizontal to return to the original orientation.

▶ Flip your canvas horizontally to check your thumbnail is working

08

Another great way to fix issues is using **Adjustments > Liquify**. Use the Push function to move parts of your thumbnail around by dragging your stylus over areas. Experiment with the other options within Liquify to refine your thumbnail.

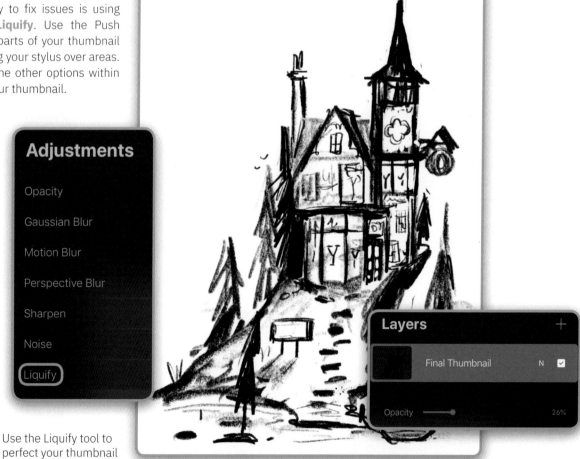

▶ Use the Liquify tool to perfect your thumbnail

09

Now it is time to draw a more detailed sketch. Start by turning down the layer opacity, then create a new layer and rename it Final Sketch. Draw on this layer, using your thumbnail as a guide. You can still be rough with this sketch as the line art won't show in your final illustration; you are simply creating a detailed enough guide for your final illustration.

▶ Reduce the opacity of your thumbnail layer and create a new sketch layer above it

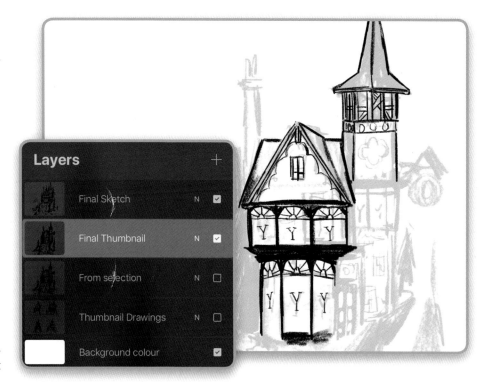

10

Use QuickShape to create a perfect circle for the clock in the same way you created straight lines earlier (see page 36). Then take your time refining your sketch; it's your map for the final illustration. It's much easier to correct things at this stage than when you've painted on multiple layers.

▶ Creating perfect shapes is easy using QuickShape

11

Creating color roughs is a good way to experiment with the mood and atmosphere you wish to create before committing yourself to the final color. Create a new layer for your first color rough. Set your sketch layer to blend mode Multiply and reduce the opacity. Fill your color layer with a base color by picking a color, then dragging and dropping the color swatch onto your canvas. (Ensure you're on the new color rough layer first.)

ARTIST'S TIP

The base color is extremely important in setting the mood of your image. Traditional painters will paint their canvas a base color so that if they miss some areas, the color revealed below isn't solid white. A purple base color could set a misty, mysterious tone, whereas a golden yellow base color will create a warmer and more inviting tone. Think about your base color before you start painting.

▼ Create a solid fill layer

12

Paint on top of this base color. You don't need to worry about layers for color roughs. Use broad, loose strokes using a brush like **Artistic > Acrylic** to lay color. Make several color roughs, creating a new layer for each one. Experiment with different times of day and types of weather, using images found online as references. Learning about light and color is all about observing the world around you, so make taking your own photo references a regular practice. Choose your favorite color rough and remove the other color rough layers.

▶ Paint with broad, loose strokes to form ideas on mood and atmosphere

13

Reduce the number of layers, ensuring you keep Final Sketch and Color Rough. Keep Color Rough above all of your final painting layers so you can turn it on and off to pick colors from. While painting, create a new layer for anything you want to be able to edit in isolation. Start with a layer for the background and paint in the sky and water. Use the Eyedropper (see page 39) to pick colors from your color rough. Block colors for the background using a brush like **Painting > Flat Brush**. Use the **Spraypaints > Splatter brush** for the clouds to create a soft, grainy effect.

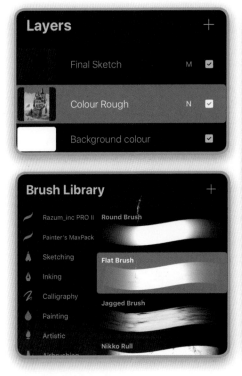

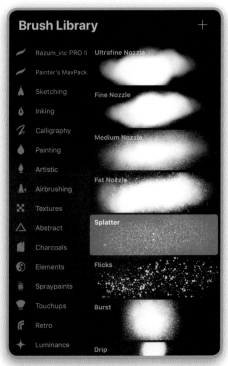

▶ Use different brushes for different effects

14

Turn your sketch layer on and off as you work to check everything is working without the sketch. Brushes like the Acrylic brush have a low opacity, allowing you to layer colors. To blend two colors, paint the two colors so they are overlapping, then color pick the central color in the overlap and paint over the overlapping lines. Keep picking the overlap color and painting over the line until the colors blend in a nice gradient. Blend the line between sea and sky to give the artwork a misty feel. Rename layers as you go.

▲
Blend colors as you define your background
▼

15

Create a new layer for the island and use the **Inking > Dry Ink** brush to block it in. Once happy with the shape, Alpha Lock the layer. Now when you paint the brushstrokes, you will stay within the shape you have already defined. Color the island grass using the **Sketching > Artist Crayon and Organic > Twig** brushes. Use the 6B Pencil for any details. Experiment with different brushes to achieve your desired effect.

▶ Block out the island and add in details

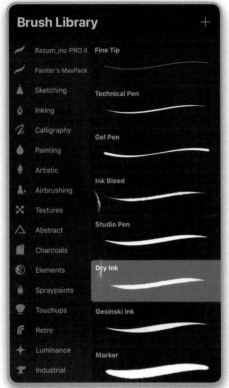

16

Create a new layer for the bookshop and block in the shape, again using the Dry Ink brush. This time just block in the outline, then drag the color swatch into your outlined shape to fill. Use Alpha Lock to lock the pixels, then start detailing your building. Create new layers for details like roof edging and windows. Use a clipping mask to ensure the layer sits directly above the bookshop layer and that these new layers adhere to the blocked building shape.

▶ Block the bookshop and use clipping masks to add details

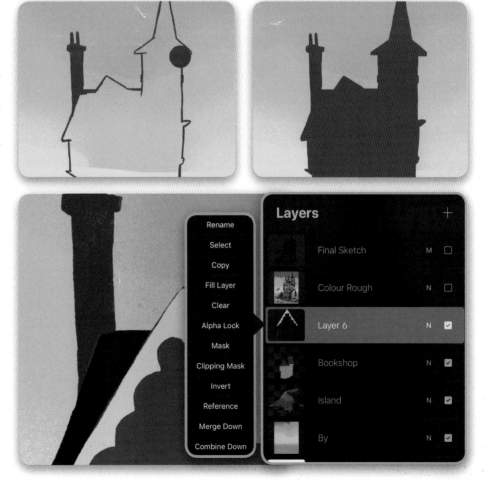

17

Add shadows and highlights, setting a light source first so all shadows fall in the same direction. Use the Dry Ink brush for harsh lines and something softer, such as the **Organic > Bamboo Brush**, to blend. Add brick and tile details in a loose, scribbly way using the 6B Pencil. Add color variance to stop colors like the wood of the shop front appearing flat by lowering the brush opacity and brushing different vibrant colors through the main color, then blending using the Smudge tool set to **Painting > Old Brush**.

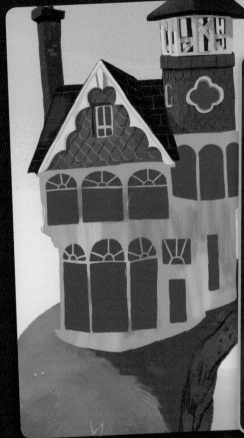

▼ Add detail and color variance for interest

18

Add book details by creating a new layer and painting simple colored rectangle shapes lined up and stacked in piles. As they're so small, they don't need to be neat. Set the blend mode to **Lighten > Lighten**, so the books look like they are behind the glass windows. Group all of your building layers together and rename the group Building. Create a new layer above the Building group and add grass details using the 6B Pencil where the building meets the grass to integrate it into the environment.

▶ Add details such as books in the windows and grass on the island

19

Add a pathway and other grass details. Create a new layer for the trees and draw their trunks using the Dry Ink brush to block again. Alpha Lock the pixels and, in a lighter color, use the **Industrial > Wasteland** brush to add texture to the trunk. Create a new layer for the branches and use the **Organic > Sable Brush** to block in abstract foliage shapes. A second branches layer will be needed for the branches that are behind the building. Move this layer under the Building group. Add leaf detail using the 6B Pencil brush.

ARTIST'S TIP

When painting, consider the color of your darkest and lightest points (your black and white points). In the real world, it's rare to see pure black or pure white. Instead of using white as your lightest point, use a pale yellow to create warmth or a pale blue to lend a coolness to your artwork. The same applies with your darkest point. This will give your artwork depth.

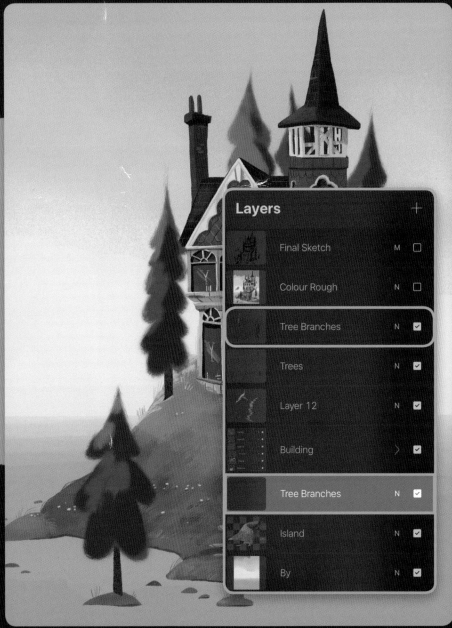

▶ Refine your painting and add more details

20

Add the clock. If the shop windows aren't contrasting enough, darken them by setting the layer to Alpha Lock, then painting black at a low brush opacity over the entire layer. Block in rocks using the Dry Ink brush, Alpha Lock, and then use the **Industrial > Rusted Decay** and **Spraypaints > Flicks** brushes to add texture in a different color. Add hills in the background and use the **Spraypaints > Medium Nozzle** brush on the base of each hill, in the same color as the background, to make them look like they are in fog.

▶ Add further details including the clock, rocks, and hills in the background

21

On a new layer, use the 6B Pencil brush in a pale blue to add ripples and spray to the water, tilting the stylus nib in places to create thicker and thinner marks. Use the 6B Pencil brush to add a highlight edge to the trees and buildings in a pale yellow, and add in any forgotten shadows. Zoom out at regular intervals to check the image is readable when small.

▶ Add in highlights, shadows, and ripples

22

Merge all of the island layers, as you will have reached the layer limit. Duplicate the Island layer then tap **Transform > Flip Vertical** and rename this new layer Reflection. Move the Reflection layer below the first Island layer and position it as a reflection in the water. Reduce the Reflection layer opacity then use a brush to correct any areas by eye and the eraser to remove any wrong reflections. Use the Selection and Transform tools to move any areas into the correct position. On a new layer above everything else, add more fog using the Spraypaints brushes and add tiny bird details using the 6B Pencil brush.

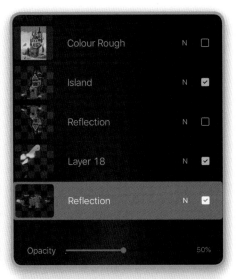

▶ Create a reflection in the water by merging and flipping the image

23

Create a new layer and set the blend mode to Overlay. Next, use one of the Spraypaints brushes in a pale yellow to paint light coming from your light source (off screen left). Adjust the layer opacity until it looks right. Add another layer set to Overlay and paint on more light, concentrating on the areas that would have the brightest highlight.

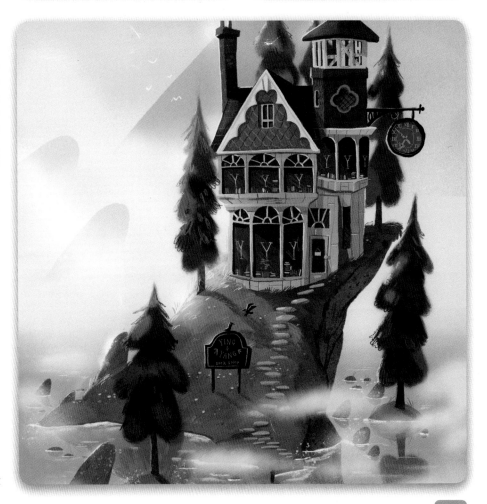

▶ Add warmth and light

Once you are happy with the image, merge all of the layers. (To save a backup before merging, duplicate the entire image in the gallery by **Select > Duplicate**.) Duplicate this flattened image and then select **Adjustments > Color Balance**. Experiment with the highlights, midtones, and shadows to create the desired look. Add more red and yellow to the highlights to create more warmth. Once you're finished, export the image to share it (see page 18).

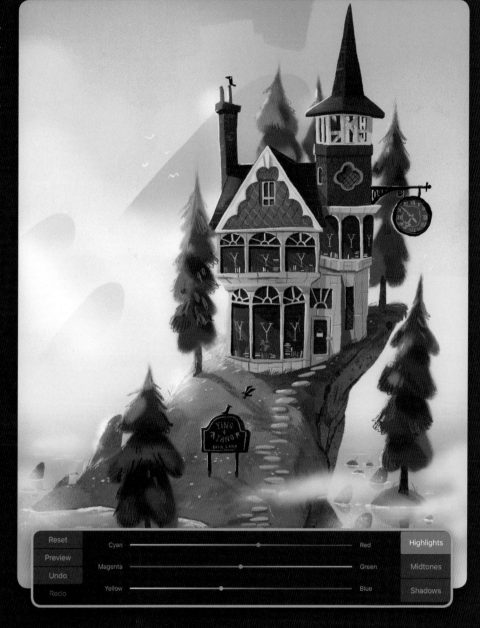

▶ Use Color Balance to adjust the final colors before saving

FINAL IMAGE

The final image is a beautifully mysterious bookshop, shrouded in fog, on a craggy island. Perhaps it's abandoned? No one knows... The illustration invites you to find out. Small details like birds bring the image to life. Use the techniques covered in this project to create different moods by changing the time of day, weather, and colors. You could also try adding in characters to tell even more of a story.

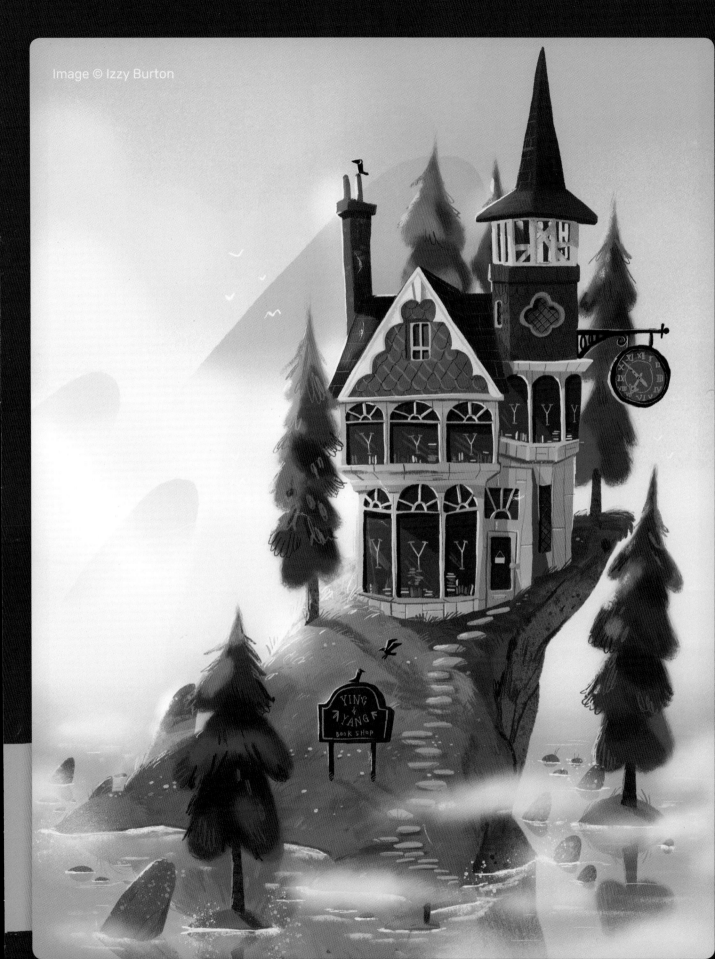

Image © Izzy Burton

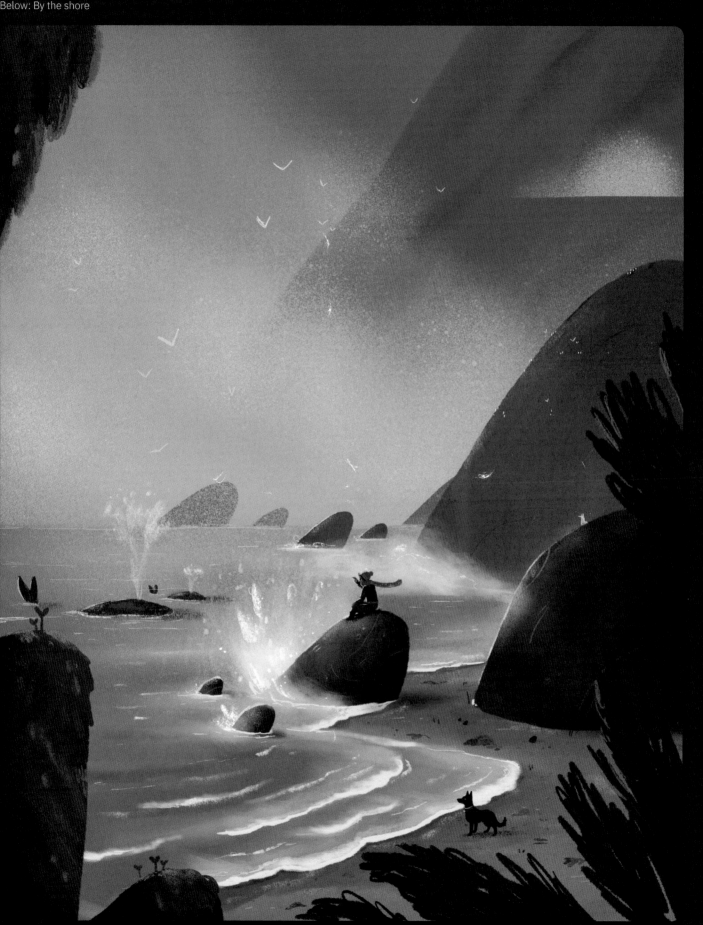

CHARACTER DESIGN

Aveline Stokart

This tutorial will teach you how to create a human character set on a simple background. The character will be a young woman, walking through the streets of Paris, and the tutorial will show you how to capture her graceful and sunny personality, with a touch of shyness, plus how to paint an atmosphere that fits her mood. The painting will convey vintage and French vibes, and will create the impression that it's a moment captured on a stroll on a sunny afternoon.

The tutorial will guide you step-by-step, from exploration sketches through to final rendering, in how to create an engaging and eye-catching final image. It will teach you how to use tools such as clipping masks and Alpha Lock to work colors, plus layer blend modes, and how to use different effects to create a warm, vibrant atmosphere.

PAGE 208

LEARN HOW TO :

▶ Organize layers for a tidy workflow.

▶ Use clipping masks and Alpha Lock to paint color.

▶ Use layer blend modes to create light and shadow.

▶ Create depth of field to focus on the subject.

▶ Add simple but useful effects to enhance the final render.

01

Begin by creating a new file in your gallery. You can choose a default format, for example, A4 (2,480 x 3,508px, 300 dpi), or tap on Create Custom Size. The resolution you choose will affect the limit of usable layers. If you choose to customize the size, keep the dpi in mind. Don't go below 300 dpi if you want to create a quality printable file.

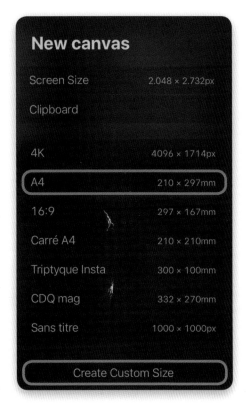

New canvas	
Screen Size	2.048 × 2.732px
Clipboard	
4K	4096 × 1714px
A4	210 × 297mm
16:9	297 × 167mm
Carré A4	210 × 210mm
Triptyque Insta	300 × 100mm
CDQ mag	332 × 270mm
Sans titre	1000 × 1000px
Create Custom Size	

▶ Create a new canvas

02

On your new canvas, sketch a variety of character attitudes using the **Inking > Ink Bleed** brush. This brush has great stroke texture, but experiment with the various brushes to find one you like. Using the left-hand sliders, decrease both the size and opacity of your brush to 35%. This setting will provide a light, thin stroke, which is important when sketching to ensure you don't get lost in lots of strong, thick lines. Start light during the drawing construction and gradually accentuate the right lines.

▼ Five character attitude sketches to explore different moods and expressions

03

Use the Selection tool to isolate your preferred sketch on a new layer. Tap **Selection > Freehand** and trace around your sketch, then tap the gray dot to complete the selection. Once the selection is active, select Copy & Paste to set your selection on a new layer, which you can call Character Sketch. The Transform tool will activate automatically, allowing you to rotate or change the size of the selection. Use Magnetics (see page 57) to keep the correct proportions of your sketch.

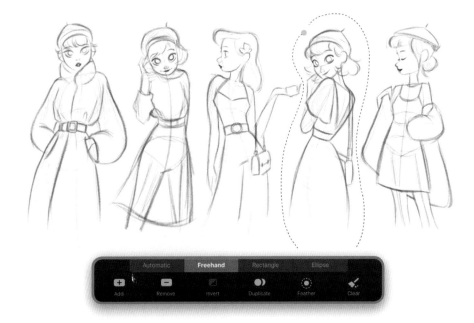

▶ The chosen character attitude sketch invites the viewer into the image

04

Naming your layers will make it easier to identify them later. Once your layers are organized, hide those you no longer need. Hide the other character sketches by unchecking them. Leave the Character Sketch layer visible and set its blend mode to Multiply. Multiply will give your lines transparency, while appearing darker when superimposed on another color.

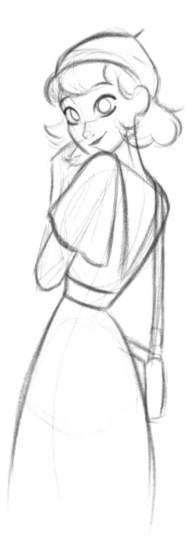

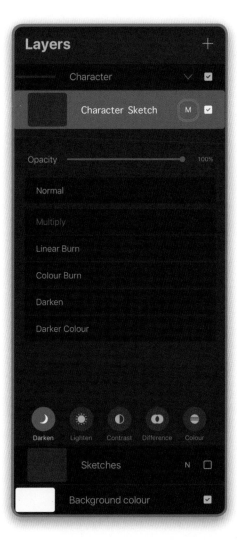

▶ The Character Sketch layer set to Multiply

05

Create a new layer, place it under your Character Sketch layer, and rename it Skin. Try using **Calligraphy > Chalk** to test out colors. This brush has a nice texture and will allow you to paint large color blocks easily. Select a color and start to create your color roughs. Don't worry about accuracy at this point, as you are just exploring. Create each element on a separate layer – this will make it easier to change one color without affecting the rest. Once you have created your first color rough, group the layers and rename it Color 1.

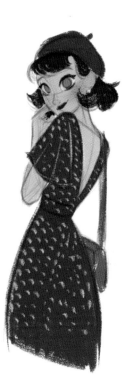

▶ Use a new layer for each element: skin, hair, outfit, and accessories

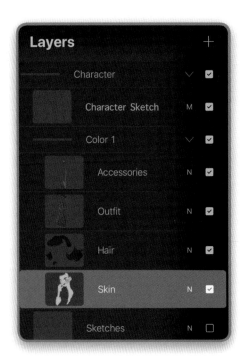

ARTIST'S TIP

When using a mood board as inspiration, split your screen to avoid flicking back and forth between screens. With Procreate open, slide the middle of the bottom edge of the screen slightly upward and the dock bar containing recent apps will appear. If your mood board is in Pinterest, tap the Pinterest app, then hold and drag it to the right or left edge of your screen. This will allow you to navigate easily through your reference images while working in Procreate, exploring your designs easily and methodically.

06

To explore other possibilities, duplicate Color 1 and rename it Color 2, then move Color 1 below. Repeat this five times to create six different exploration groups. Once complete, tap on a color group to open it and recolor the different layers. Using Alpha Lock will let you paint with another color directly inside your shape without exceeding the edges. Alternatively, you can change the colors by experimenting with the Hue, Saturation, and Brightness sliders.

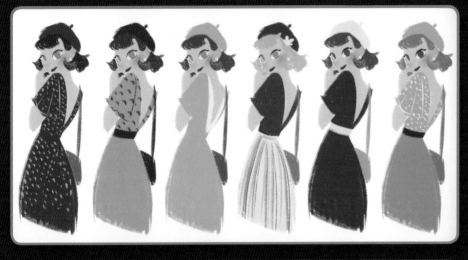

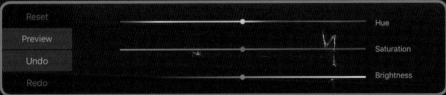

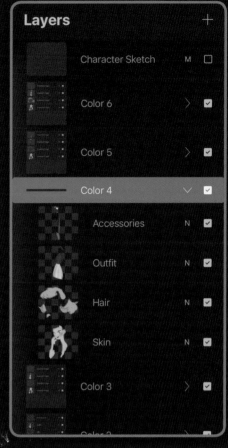

A checkered box will appear behind the layer preview when Alpha Lock is active

07

Decide on one of your color roughs, duplicate its layer group, and flatten it. This will create a new layer containing all of the elements. Now you have an idea for the character, the next stage is to set the character in a simple environment. Explore the scenery in the same file. Group all of the layers related to your character into a single group and name it Character, then mask it to create a blank space for the development of your background.

The Character layer group should include all of your color rough sketches

08

Explore ideas for your background with the same method used for the character. Start with a rough composition to give you an idea of the size you want your character to be in the scene. Draw lines with a slight perspective for more dynamism. Study photos of people walking down the street to help you. On a new layer, redraw the same sketch and develop it further, then duplicate the layer and decrease its opacity to 30%. Create a new layer on top and start detailing the background over your previous sketch.

▶ Sketch exploration for the background

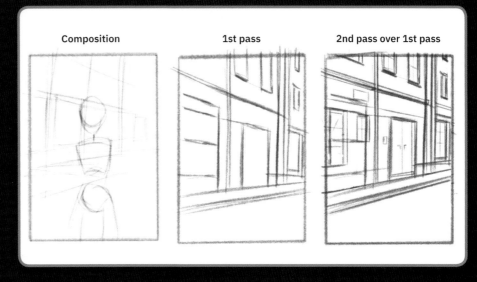

Composition 1st pass 2nd pass over 1st pass

09

When choosing colors for your background, refer to images where you like the light atmosphere. As you did for the character, set the sketch layer to Multiply and apply the colors on a layer under it. Once complete, take the flattened character color rough layer and place it above the background color rough, resizing it using Transform. This will give you an idea of how your chosen colors work together and whether you need to make any adjustments. Next, add layers to mark the areas where the light and shadows will fall. Choose a light yellow color to draw the impact of light, and on a different layer, use a warm purple color to draw the shadows. Set this layer to Multiply and reduce the opacity. Once complete, merge the character and background color rough layers.

▼ Background and character color roughs with a quick test of light and shadow

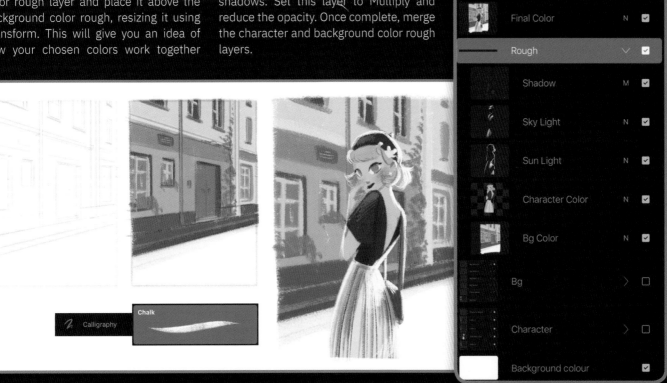

10

To begin the final piece, create a new A4 canvas then copy the layers of your final color and sketches and paste them into the new file. To do this, select the layers you wish to copy (Background Sketch, Character Sketch, and Color Rough) then hold your stylus nib down on one of the layers. The layers will bump up and follow your stylus. While holding them, tap Gallery with your other hand, then tap on the new file. With the new file open, release the stylus and the layers will automatically import into the new file.

▶ The selected layers will appear as a group when exporting to another file

11

Use Transform to arrange your sketches on your canvas. Resize and position your background sketch and character sketch so the character's eyes rest on the top third of the composition. Decrease the size of your final color rough and place it in the corner of the screen as a thumbnail to refer back to as needed. This will keep your color palette at your fingertips, allowing you to use the Eyedropper to select your chosen colors.

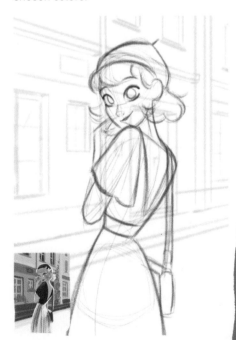

▲ The resized background sketch and character sketch, with the final color rough as a thumbnail

12

You can now clean up your sketch. Hide the background and decrease the opacity of the character sketch to 35%. Create a new layer above your character sketch, select the Ink Bleed brush and start drawing over your sketch. Repeat this step as many times as necessary to refine your sketch. Once you are happy with the refined image on your clean-up layer, hide or delete the character sketch layer. Set your clean-up layer to Multiply, then you're ready to start painting.

▶ Set the clean-up layer to Multiply above the character sketch

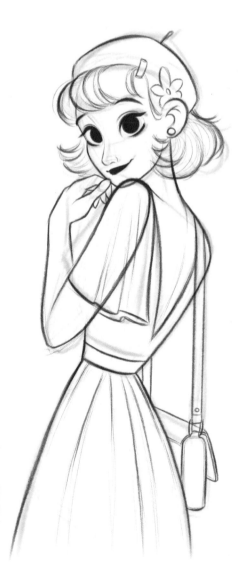

ARTIST'S TIP

The eraser can be used with the same texture as your brush. Tap and hold the eraser until it bounces slightly and turns blue. This lets you know it is active and will have the same texture as the brush you were using.

13

Hide your character sketch layer and decrease the clean-up layer opacity to 20%. Create a new layer, place it under your clean-up layer, and rename it Body. Turn the default canvas background gray by tapping the default background layer and selecting gray from the color square. This will allow your colors to stand out and will help you to see them more clearly. Using a red color for your sketch and line art can warm up the image when colors are applied under it, especially skin colors. Avoid using black, as this can create a muddy effect that weighs down the overall image.

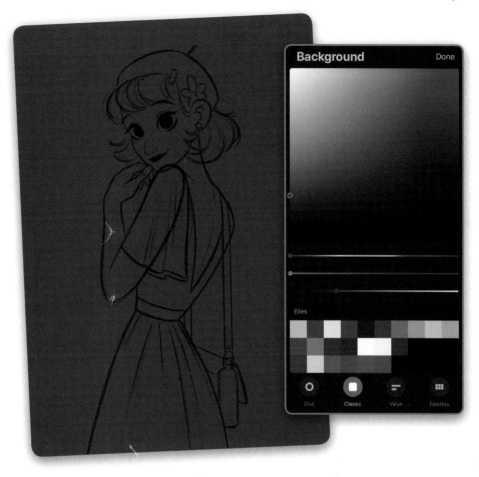

▶ The clean-up layer set on a gray background

14

Use the Eyedropper to select the skin color from the final color rough thumbnail. The color swatch in the top right will automatically change to the selected color. Use the Ink Bleed brush to draw the silhouette of the whole character in the skin color. Once your outline is drawn, make sure there are no holes in it. If there are any holes when you fill your shape, the color will fill the whole canvas instead. To fill the shape, drag and drop the color swatch inside of the outline. If a thin white line persists near the outline, simply retrace over it.

▶ Use the Eyedropper to sample from your color rough

16

Repeat the process for the skirt, hair, hat, accessories, blush, and so on. Choose a vibrant red for the blush and use the **Spraypaints > Flicks** brush to apply it, reducing the size to between 3% and 5%. This will warm up your character's complexion and provide the skin with a nice texture. Set the blush layer to Multiply. To give the sleeve a transparent look, decrease the sleeve layer opacity to 75%. Use the **Artistic > Wet Acrylic** brush to create shades in the hair. Decrease the size of the brush to 10%, then create a new layer and paint with a very light yellow shade to create a strand effect.

Spraypaints

Artistic

▶ The color layers make up all of the flat colors of the character

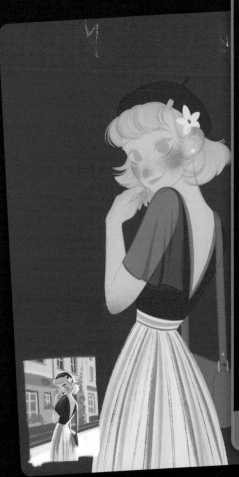

Layers +

Accessories	N	☑
Texture	N	☑
Hair	N	☑
Hat	N	☑
Sleeve	N	☑
Blouse	N	☑
Texture	M	☑
Pattern	N	☑
Skirt	N	☑
Blush	M	☑
Body	N	☑

17

To paint the face, create a new layer group separate from the others. Create a layer for the whites of the eyes, then add a layer above this for the irises and clip it to the whites of the eyes. This will allow you to reposition the irises if needed. Above this, add new layers for the eyelashes, eyebrows, and mouth. Group together the layers that make up the face and name it Face. Finally, on top of the character layer group, use a pinkish color to redraw lines to better define the different elements and ensure they don't fade away when you hide the clean-up layer and set it to Multiply.

▶ Add lines to define the neck, eyelids, nose, fingers, inside of the ear, and bag edges

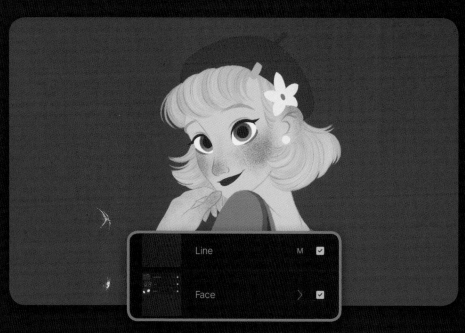

18

Once you have finished painting the character, use the same process to paint the background. First, group all of the character elements, then hide the character group. Next, create a new layer below your character group and start to paint using the Eyedropper to pick the colors from your final color rough. The

Chalk brush can be used to create color blocks more easily. While you can paint everything in your background on the same layer, separating your elements onto different layers will provide you with more freedom when editing them. Don't worry too much about accuracy here, as the background will be blurred and out of focus.

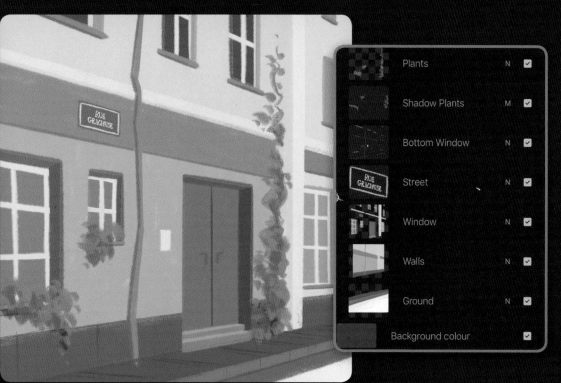

◀ Use different layers to color the street

19

To create the out-of-focus effect, duplicate your background layer (if you have several background layers, create a group, duplicate it, and flatten it) then apply **Adjustments > Gaussian Blur**. Set the strength of the blur to 17% to create a depth of field effect.

▶ Control the strength of the Gaussian Blur by sliding from left to right

20

To light your scene, unhide your character group and create a new layer above it. Set it to Multiply and use a warm purple color to paint in shadows. Never use black, as this will make your colors appear muddy. Select **Smudge > Ink Bleed**, adjusting the brush size to 80–100% and the opacity to 10–20%. Use this to soften the outlines of the shadows by slightly smudging the edges.

▶ The character set against the blurred background

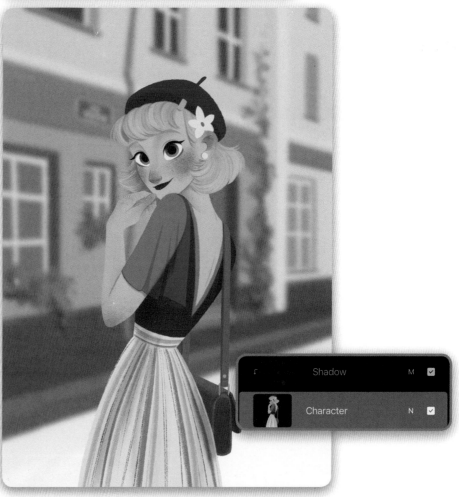

21

To add sunlight, create a new layer and, using a light yellow color, paint where the sunlight will hit the character. Set the blend mode to Overlay to contrast and saturate the colors. To add highlights, create a new layer above this and accentuate some areas using the same light yellow color. Next, add sky light. This is very soft but it will give your light more consistency. On a new layer, add a bit of light blue on the top of the character's hat, nose, and hand, set the blend mode to Screen, and decrease the opacity to 55%.

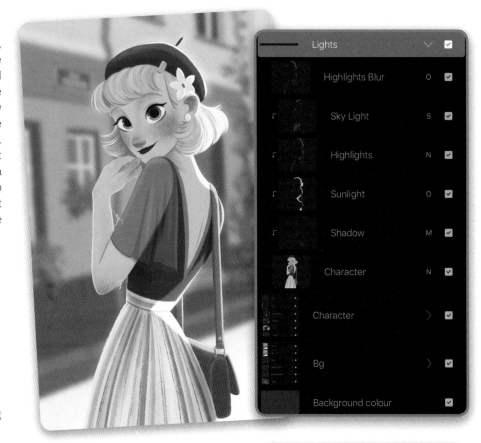

▶ After duplicating and flattening the character group, use clipping masks to add light and shadow

22

To add some atmosphere, duplicate the highlight layer and set it to Overlay. Apply Gaussian Blur at 20% to create a soft glow over the character. At this stage you can add a few more details. On a new layer, use a white color to create a reflection in the eyes and set its blend mode to Add, with 13% opacity. Use this white color to create fine hairs, as well as small dust particles by creating disparate points. Duplicate the dust layer and blur it slightly to give the particles a nice glowing effect.

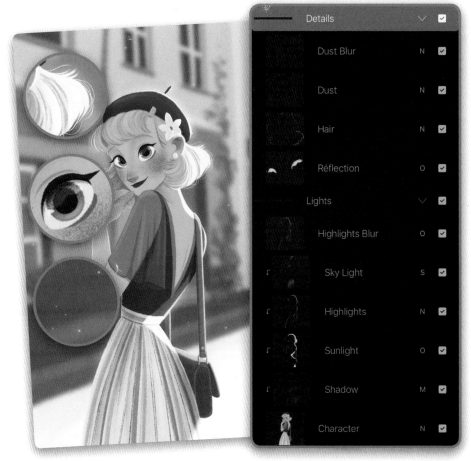

▶ Close-ups of the fine details

23

Finally, apply some color adjustments to warm up the atmosphere. To ensure the adjustments affect the whole image, the image needs to be flattened in one layer on top of everything. To do this, summon the Copy Paste menu and select **Copy all > Paste**. (If the Paste button remains frozen, simply redo the manipulation and the Paste button should be available.) Now the whole image is flattened on one layer, you can adjust the curves. Lower the center dot slightly downward in Composite to add contrast, then slightly increase the red to warm up the overall image.

▲ The Composite will affect all of the colors in the image

24

For the final effects, duplicate your final image layer. Use **Adjustments > Perspective Blur** to create a slight impression of motion. Move the cursor in the center of your character's face and set the blur strength to 5%. This is almost invisible, but will add a dynamic vibe to the character's eyes. Add **Adjustments > Noise** set to 13%. If you want to add some color fringe VHS effect, duplicate the layer, set its blend mode to Color, and move the image a few millimeters. Finally, using **Airbrushing > Soft brush** with a large brush size, paint a soft orange halo on a new layer set to blend mode Add and decrease the opacity to 30%. Once you are happy with how your image looks, you can export and share it (see page 18).

▶ The render of the final image

FINAL IMAGE

Having completed this tutorial, you are now able to create a character, set them on a background, and create a complementary atmosphere. You have learned how to create a warm, bright, and vibrant mood to enhance your character and help draw viewers into the image. Next time, try creating a variety of different characters, each with strong personalities or emotions, and create a background that matches their mood. Think about what colors can be used to illustrate mood if the character is scared, sad, or in love.

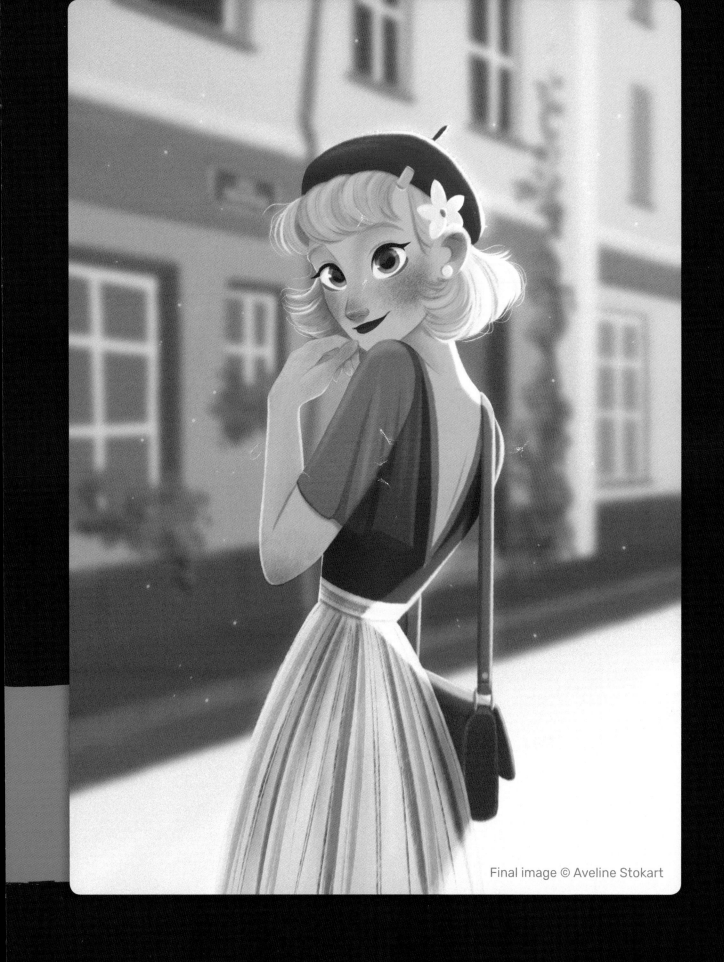

Final image © Aveline Stokart

 All images © Aveline Stokart

Above: Library girl

FANTASY LANDSCAPE
Samuel Inkiläinen

This tutorial will guide you through digitally painting a fantasy desert landscape with steep cliff faces and huge, peacefully floating jellyfish. It will take you through the painting process from start to finish, teaching you how to start small before gradually increasing in size and complexity to prevent the project from feeling overwhelming.

The tutorial will start with searching for reference images and creating quick study sketches to warm up and familiarize yourself with the subject matter. It will then take you through the thumbnailing phase where you can separate color from the composition and values to keep things as simple as possible. After trying out different color schemes and refining the thumbnail sketch, you will dive into the actual painting with a better sense of direction and a colored sketch to guide you on your way.

The tutorial will also cover how to create your own custom brushes to complement your way of painting. It will teach you how to fix mistakes and adjust the painting to your liking. Finally, several post-processing techniques and adjustments will push the painting to an even higher level.

PAGE 208

LEARN HOW TO :

▶ Use clipping masks.

▶ Use Alpha Lock.

▶ Use layer blend modes.

▶ Create custom brushes.

▶ Use various adjustment tools.

01

First, scour the depths of the internet to find a wide range of photos of the subject matter you wish to paint. This is a great way to enter the creative mindset. Don't just look for reference images; search for information on the formation of the types of landmasses you wish to appear in your fantasy landscape. By knowing how they naturally form, you can apply this knowledge to your painting to add extra detail and a sprinkle of realism. When creating your initial sketches, try using the Technical Pencil brush or the HB Pencil brush to achieve a hand-drawn look.

▶ Begin by taking notes and creating reference sketches from photos found online

02

Next, draw your thumbnails. Start by creating a rectangular canvas as a base. Add new layers for the background, middle ground, jellyfish, and foreground. Start experimenting with shapes resembling the kinds of landmasses you want to paint. Add each new layer as a clipping mask to keep everything inside of the frame. Use Alpha Lock to add smaller shapes to suggest details inside the bigger base shapes. Add smaller shapes and more contrast to create a clear focal point.

Continue to explore the designs you like, and mix and match elements to create new thumbnails. Keep things simple; don't get carried away by zooming in and adding too much detail, as you will be selecting only one of these thumbnails.

▶ Start to brainstorm the composition and value structure with small, simple thumbnail sketches

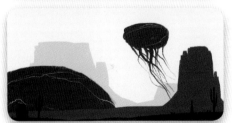

03

Select the thumbnail you feel is the most interesting and that looks clear even when zoomed out. Next, start experimenting with different color palettes. Duplicate your thumbnail layers a few times and use the filters found in **Adjustments > Color Balance** and **Hue, Saturation, Brightness** to add color. If the adjustment filters aren't enough, don't be afraid to repaint sections of the thumbnail. Use the soft brush to add sweeping color gradients and paint a slight glow around the jellyfish, then use a hard brush to give more definition and detail to the landscape.

▲ Use Color Balance and the Hue, Saturation, Brightness adjustment filters to experiment with different color schemes

04

Start to refine your chosen colorized thumbnail. Divide the larger areas of color into smaller shapes by painting on a new layer with a hard brush and erasing parts out. Use the Eyedropper to color-pick the lightest color of the sky, then streak the selected color across the sky to create simple clouds. At this point it is a good idea to consider the story of the painting and how you can better communicate it. Add the shape of a cloaked character to the foreground and dot tiny specks of light along the lower section of the midground to resemble small jellyfish emerging from the ground. This thumbnail will be used as a guide to create your final image.

▼ Start to refine your chosen colorized thumbnail by adding more detail and complexity

05

Create a larger canvas and add the thumbnail layer from the thumbnail file to the new canvas. Drag the layer with one finger and, with another finger, navigate to the newly created file and drop the thumbnail layer into the layer hierarchy. To achieve a cleaner look, start over by painting clean shapes using the thumbnail as your guide. (Another way of creating the final image would be to clean up and refine the thumbnail.) Work more carefully as opposed to the fast and spontaneous experimenting of the thumbnailing phase. Use the Eyedropper to pick colors from the thumbnail and add a gradient to the sky with a soft brush.

▲ Using the thumbnail as your guide, start by painting a gradient for the sky

06

Using a sharp-edged brush, such as Opaque Oil, create the base shapes for the foreground, middle ground, background, and jellyfish on separate layers. Keeping these layers separate means you don't need to worry about controlling your edges in the future. You can use the base layers to quickly make selections, Alpha Lock them, and use them as a base for clipping masks.

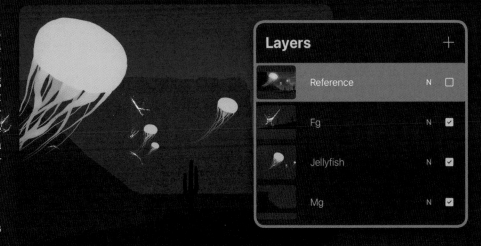

▶ Create clear silhouettes for the main objects in the painting using a sharp-edged brush

07

Use Alpha Lock to add base colors to all of the different objects. You will add highlights and shadows later on, so don't make the colors too dark or too light just yet. Since the air contains dust particles and moisture which prevents perfect vision over long distances, make sure the objects furthest away have the least contrast and saturation. This is called atmospheric perspective. Keep your base colors dark and muted to give the glowing and saturated jellyfish more emphasis.

▶ Separate different materials and objects by adding areas of local color

08

Create a new layer on top of the base shape layer and select Clipping Mask. Use clipping mask layers to add the sides of the cliff faces, the top planes for the rocks in the foreground, and any major places light would hit.

▼ Use clipping masks to define the main planes that receive light

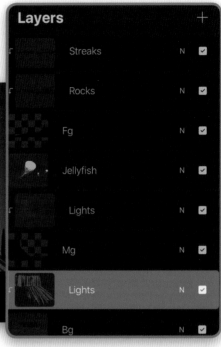

09

To blend the cliff faces into the painting and refine their form, Alpha Lock the clipping mask layer and apply a gradient fading from the color of the setting sun to the color of the layer below using a soft brush. Choose the direction of the sun and keep it in mind to ensure the lighting is consistent. Add a bit of flare to your colors by color-picking the transition color between light and dark and increasing its saturation. Lightly brush the saturated color on the transitional area with a soft brush, but keep the effect subtle.

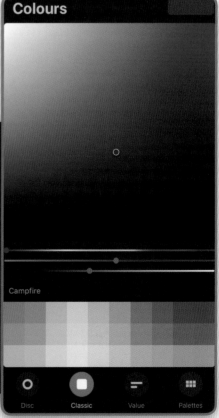

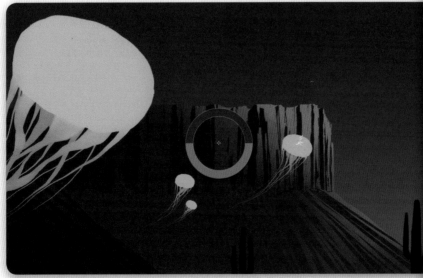

▲ Use Alpha Lock to add color gradients to the light planes

10

If some of your colors aren't working, use the Selection tool to select an area you want to adjust, then select **Adjustments > Hue, Saturation, Brightness** to change the color. This is where starting with crisp shapes and simple areas of color proves useful, as it allows for quick and easy selections.

Another way to adjust colors is by using the various layer blend modes. Experiment with the different blend modes to see what they do. (The most useful ones tend to be Multiply, Add, Color Dodge, Overlay, Soft Light, and Color.) Brush some fog on the background layer using a soft brush, add a shape of a red cloaked character to the foreground sitting on top of a log, and add an oval shape as a base for a firepit.

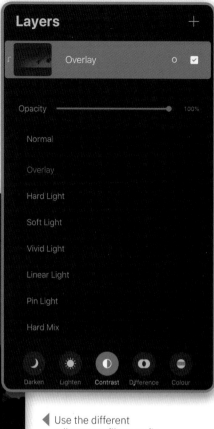

◀ Use the different adjustment filters to fix mistakes and unify colors

11

If you aren't happy with the shape of an object, the Liquify tool lets you fix minor mistakes without having to repaint the whole area. Use **Liquify > Push** to move areas of your painting around. Experiment with the different tools and settings to see what kind of effects they create. Add a road to the middle ground and create a campfire using the **Elements > Fire** brush

with a dark and saturated orange color. On a new layer, use a soft brush to add a warm light around the flame and to the middle ground where the sun would shine its last rays. Use the Eraser tool with a hard brush to create shadows.

▼ Use the Liquify tool to mold shapes you are not happy with

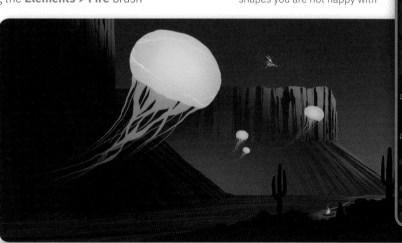

12

Add darker crevices to the cliff faces to give the shadow side more definition. Control your values and try to avoid using pure black. Merge unnecessary layers by pinching them together to speed up your workflow. Add indications of small shrubs in the middle ground to enhance the sense of scale. Keep them small and dot them in horizontal clusters, making them smaller the further away they get.

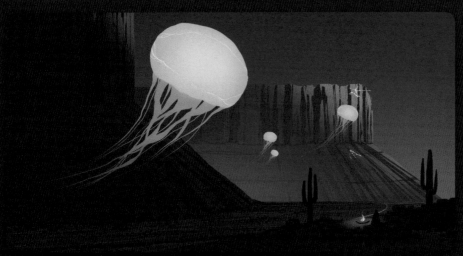

ARTIST'S TIP

It's easy to become blind to your own mistakes. Try flipping your canvas to provide a fresh perspective on your work using **Actions > Canvas > Flip canvas horizontally**. Don't be discouraged if you don't get the shapes and colors right the first time. Painting is an iterative process and you are bound to make mistakes. Don't rush and make sure to take small breaks to give your eyes a rest from the screen.

◀ Add small shrubs to the middle ground and darker crevices to the cliff's shadow sides

13

Start to define more of the planes that receive light and use a layer set to Overlay to warm and lighten up the parts of the cliffs hit by light using a saturated orange color. To determine the color of an object that is affected by a colored light (like the flame from the campfire), color-pick the color of the light source, then paint this color very lightly on the surface the light is affecting. (Use a brush that has the Brush Opacity control set to Pen Pressure, such as the Soft brush.) Color-pick the resulting mix, and this will be the color of the light on that specific surface.

▼ Define the planes that face different light sources, such as the rocks by the campfire

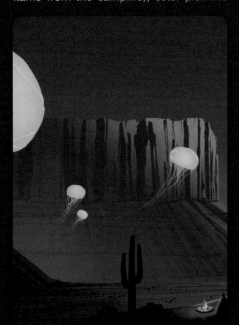

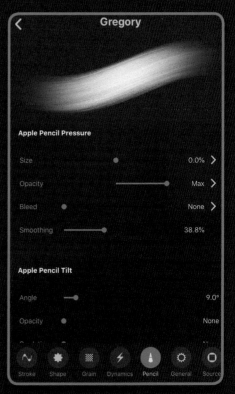

14

To push the sense of scale and distance, use the Soft Airbrush to gently brush some fog between the layers. This will lighten the background and simulate atmospheric perspective, increasing the value difference between the layers while making the image more readable. You can also use an Overlay or a Multiply layer to darken the shadow side with cold blue tones to give the warm sunlight more emphasis. Use the Smudge tool with a hard round brush to mold the fog into more interesting shapes. The sharp edge of the round brush allows it to create hard edges, which can create a nice visual contrast to the naturally soft edges of the Soft Airbrush.

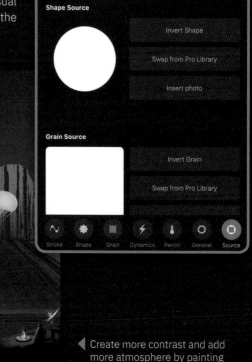

Create more contrast and add more atmosphere by painting a misty fog between the layers

15

Using a hard-edged brush, begin to add clouds by designing interesting shapes that complement your composition. Use the Smudge tool to blend edges together to create wispy sections and produce a more cloud-like look. Don't forget that clouds are a key part of the composition and offer a fun opportunity to design some very graphic shapes. Not many other natural elements can take so many different and interesting forms. The use of a hard-edged brush allows you to more clearly focus on the shape design and make the clouds as interesting as possible.

Add clouds using a hard-edged brush and soften parts using the Smudge tool

16

Add more faces and highlights to the rocks in the foreground, considering how the ambient sky light and the light from the campfire will affect them. Add a small backpack on the ground next to the character, plus a landmass in the foreground to create overlap with the tentacles of the jellyfish, enhancing the sense of scale. Create a glow effect for the jellyfish by duplicating the jellyfish layer and adding 35% Gaussian Blur to the duplicated layer. Change the layer's blend mode to Lighten and reduce its opacity to 60%. Duplicate the jellyfish layer again and apply approximately 50% Gaussian Blur to it, set its opacity to 45%, and drag both newly created layers below the original layer.

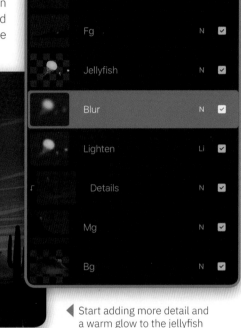

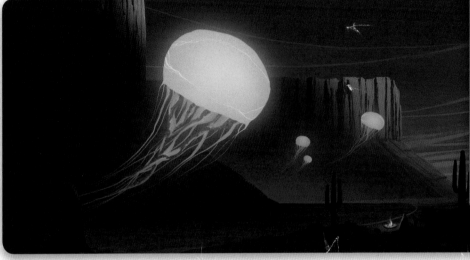

◀ Start adding more detail and a warm glow to the jellyfish

17

Next, add some foliage to the foreground. You could do this by hand, but creating a new brush for this purpose will save time. Create a new canvas that is 1000 x 1000 pixels. Use the Selection tool with the rectangle option to create one leaf of the bush and fill it with black. Duplicate the leaf and use the Transform tool to create the rest. Merge all of the leaves by pinching the layers together. Using the soft eraser, erase a small amount from the bottom to allow the bush to blend with the painting. Save the image as a JPEG.

▶ Create a simple brush to use as a bush shape for the foliage

18

Tap + in the brush palette to add a new brush. Add a blank grain from the Pro Library to the Grain Source. On the Stroke tab, set your Spacing to 45% and Jitter to 25%. On the Shape tab, add 10% Scatter to add more randomness to the direction of the brush. Skip the Grain tab, since the brush doesn't need any texture. On the Dynamics tab, add 45% Jitter to the Size Dynamics to create more of an uneven size to the brush. Lastly, set the Pressure size to 35% on the Pencil tab to gain some control over the size of the brush.

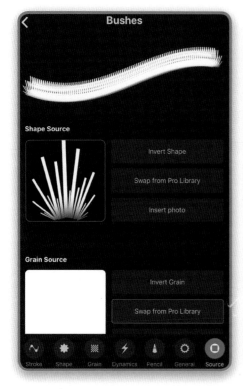

▶ Adjust the different brush settings to create your desired effect

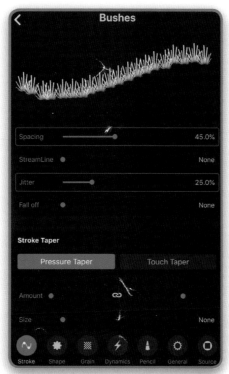

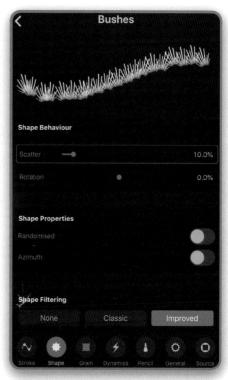

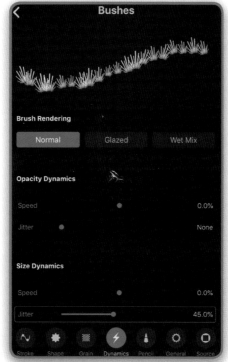

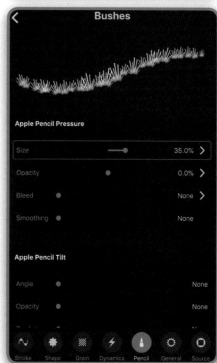

20

Continue adjusting colors and defining more details around the focal points. Add suggestions of baby jellyfish emerging from the ground using the Speckle brush. At this stage you can stop using separate layers and instead merge everything into one to reduce the time spent jumping between them. If you feel uncomfortable with merging all of the layers together, simply duplicate your file to ensure you have a backup in case something goes wrong. Add a glow to the baby jellyfish using the same technique of duplicating and blurring the layer. In addition, add a rim light to the foreground objects in front of the giant jellyfish, but don't overdo it.

ARTIST'S TIP

The time for big sweeping changes is over. Once you have a solid foundation and the image works as a whole, it's time to work on the details. Put some music on and paint away. This is the slowest and perhaps least exciting part of the painting process, but it's important you don't try to rush through it.

Layers +

Fg — N ☑

Jellyfish — N ☑

Fog — N ☑

Baby Jellyfish — N ☑

Bg — N ☑

Bg Backup — N ☑

Background colour — ☑

▲ Merge your layers together and zoom in to define more details

21

Using the soft brush, make full use of the layer blend modes. Use Overlay to adjust values and colors, Color Dodge to add a bit more punch to the light sources, Multiply to darken areas, and Soft Light for subtle color adjustments. Continue your detailing process and fix any mistakes. Add more small jellyfish and smoke to the firepit, and create wispy cloud-like mist that catches the light from the big jellyfish. Focus your detail work on areas close to the focal points and leave the less important areas a little rougher to emphasize the focal points even more. Once you have nothing more to add, let your painting rest for a day or two, then come back to it and do a final pass on the image.

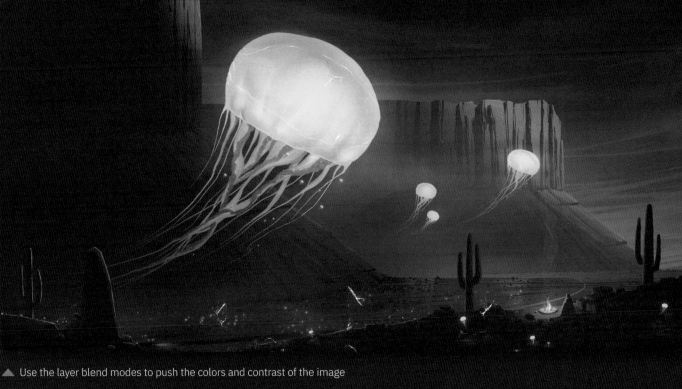

▲ Use the layer blend modes to push the colors and contrast of the image

22

To add the finishing touches, merge all of the layers together. Use **Adjustments > Sharpen** to create crisper edges. (Tip: if you do this to a duplicated layer, you can erase out the parts you don't want to be affected.) Add some grain by creating a new layer and filling it with middle gray. Use the Noise filter at 100% on Overlay and reduce its opacity to around 20%. Use the Hue, Saturation, and Value sliders to reduce the layer saturation to 0, creating a subtle monochrome grain effect. Finish by exporting and sharing your image (see page 18).

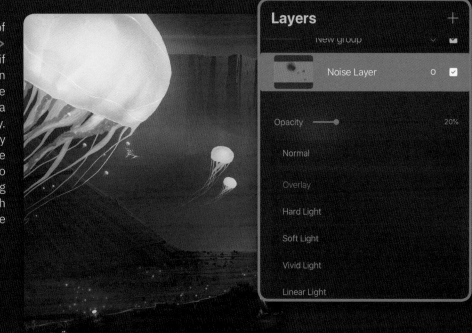

▶ Add Noise and Sharpen filters to the painting as a final touch

Layers	+
New group	
Noise Layer	0 ☑

Opacity ———●——— 20%

Normal

Overlay

Hard Light

Soft Light

Vivid Light

Linear Light

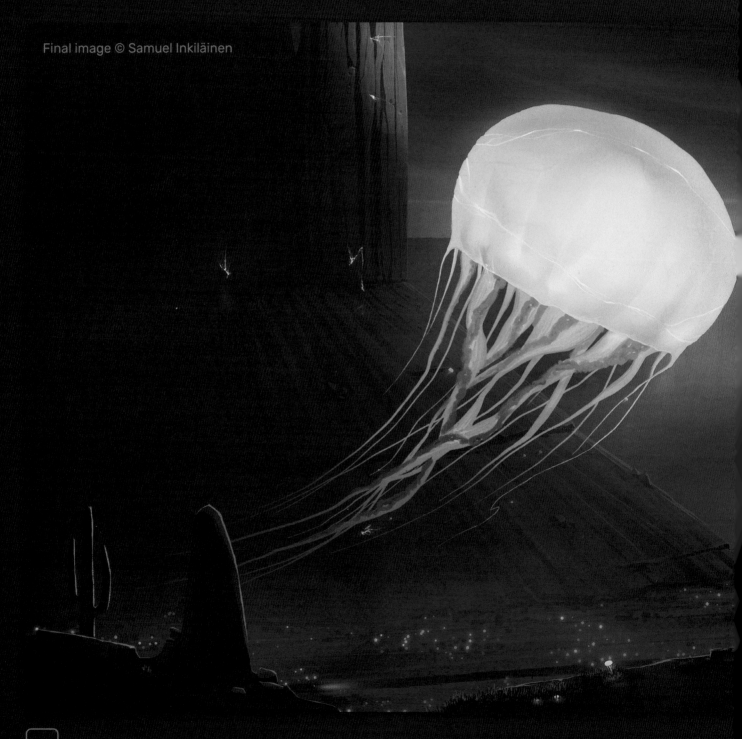

Final image © Samuel Inkiläinen

FINAL IMAGE

The finished painting tells a story of a mystical fantasy landscape. The warm yet dimly lit color palette and supernatural mood complement it well.

Planning the painting with rough sketches first can keep you from feeling lost, which can sometimes happen when using a more spontaneous approach. Much of the process was spent trying to create an accurate sense of scale using visual cues the viewer would be familiar with. Without these visual clues, the floating jellyfish could look as if they are just normal-sized jellyfish closer to the camera.

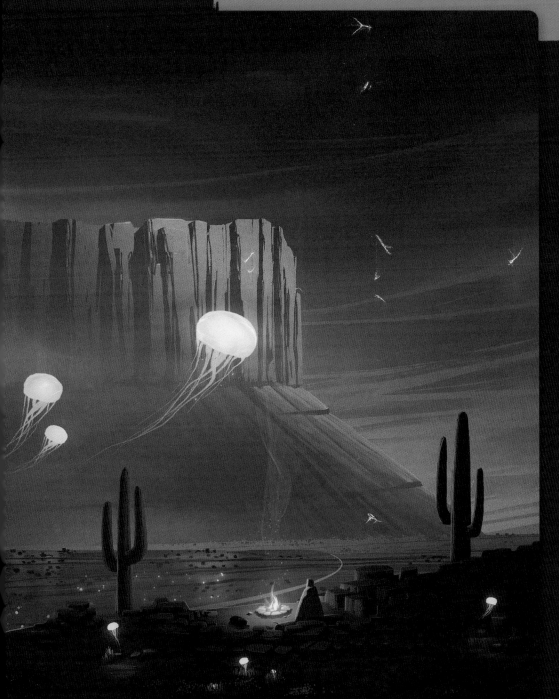

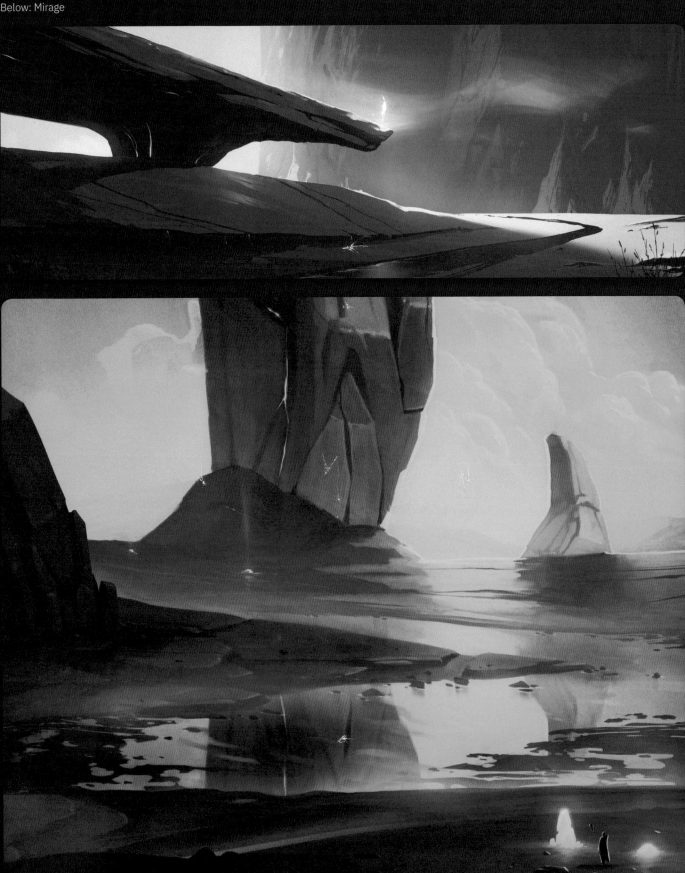

Below: Mirage

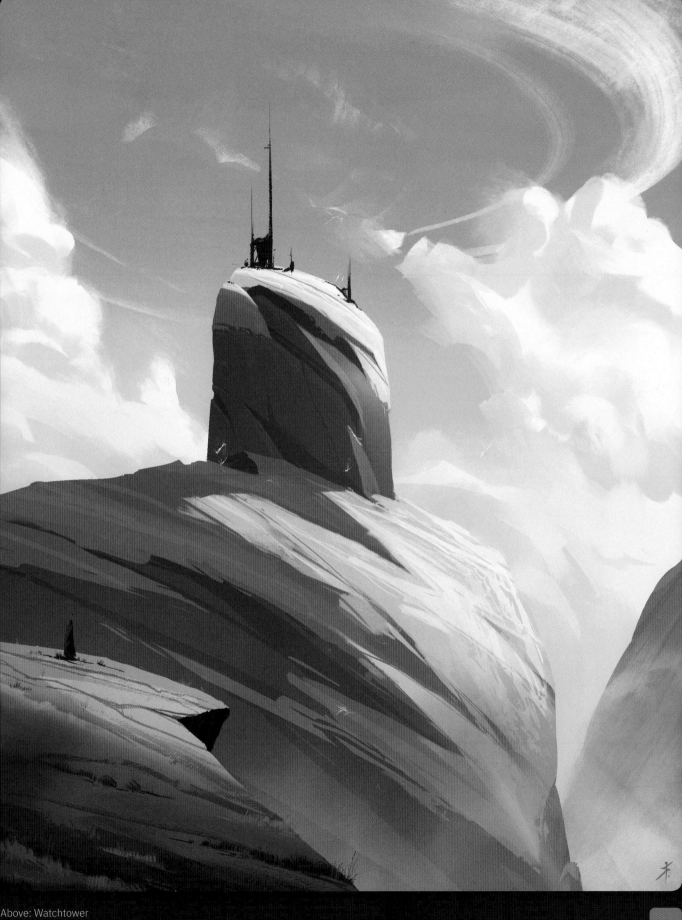

Above: Watchtower

FANTASY CREATURE

Nicholas Kole

This tutorial will guide you step-by-step through the process of creating a fantasy creature in Procreate. When starting an assignment, base your initial explorations on the context and prompt. If creating a fantasy creature for a video game, for example, you may want to ask questions about gameplay. Where will the character be used? What functions do they need to perform? Is there lore involved that might influence the design?

Start by making a list of a few of your favorite animals and think about what traits you can borrow from each to create your monster. Creatures that live under the sea can make for excellent alien inspiration, since the needs and designs suited to an aquatic environment are about as different from our own as it gets. For example, what kind of fantasy creature could you create by mixing a bit of sea lion, some orca, a touch of axolotl, and the teeth of a prehistoric dunkleosteus...?

PAGE 208

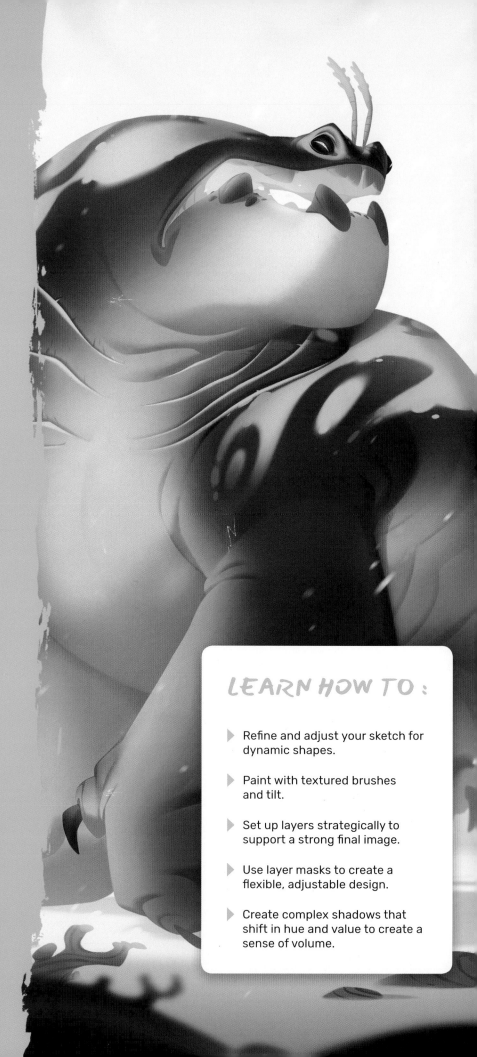

LEARN HOW TO :

▶ Refine and adjust your sketch for dynamic shapes.

▶ Paint with textured brushes and tilt.

▶ Set up layers strategically to support a strong final image.

▶ Use layer masks to create a flexible, adjustable design.

▶ Create complex shadows that shift in hue and value to create a sense of volume.

01

Begin by drawing some loose sketches. If you start working with too much detail or control too soon, your work can feel stiff and progress can be slow. Select Tara's Oval Sketch NK brush and set it to a medium or large brush size to remove the temptation to go into detail. (Details of how to download Tara's Oval Sketch NK brush can be found on page 208.) Look for shapes you like and take inspiration from nature. Consider what unique physical traits in animals you're drawn to, or that you rarely see represented in character designs. See if you can integrate those into your sketches in different ways.

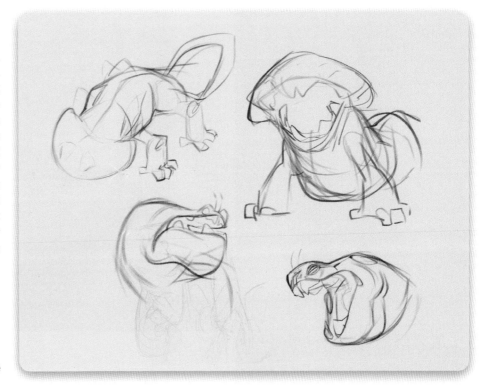

▷ Create a selection of loose sketches – it can take a few tries to find a design you like

02

If you find that part of your sketch is working especially well (in step 01 it was the head), duplicate the layer and use each new version to try something new in the pose or body composition. Emphasize exploration – with fantastical creatures you can introduce new and unexpected anatomy to a design if it feels overly familiar. Aim for bold, simple shapes as you sketch, and don't overcrowd the design with unnecessary detail. Streamlined designs with a balance of detail are easier for a viewer to understand and you can leverage that clarity to draw their attention to areas of the creature you especially want them to notice.

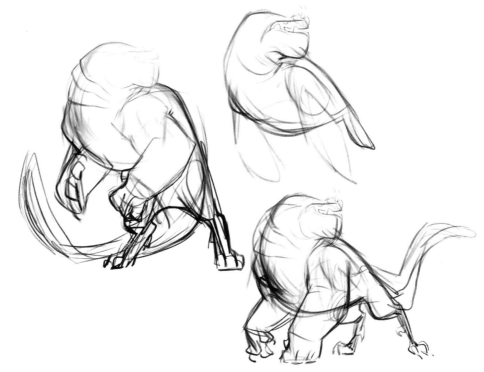

▷ Trying different bodies and poses with the preferred head design

03

When drawing loosely at the start, it can help to work quickly so you don't lose steam and start detailing instead of exploring new ideas. One way to speed up the sketch phase is to make use of the Liquify tool. If a design looks too wonky and uneven, or you want to push a tricky line into shape quickly without redrawing it numerous times, use **Adjustments > Liquify**. There are a variety of useful modes to experiment with. Push will allow you to nudge your sketch back and forth to try out new shapes before you commit to a design.

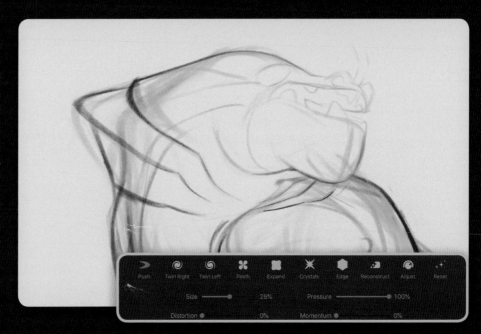

▶ An extreme example of what Liquify's Push tool can do to a sketch

04

Once you have scribbled and liquified your way to a sketch with strong shapes and a good pose, reduce the layer opacity to a low level so it's still visible, but not obtrusive. Next, create a new layer above it and use that layer to sketch cleaner, more detailed lines over the rough sketch beneath. This is the stage where you can begin to tighten the design up and get specific with details like fingernails and wrinkles.

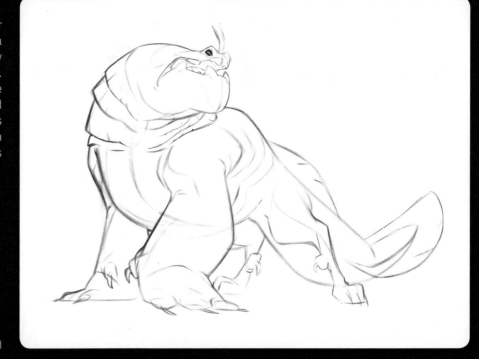

▶ The cleaned sketch, with the loose sketch faintly visible underneath – arms and tail were adjusted to drive attention to the head

05

Before moving on to color, flip your canvas. This will allow you to see the drawing from a new angle and spot weaknesses before you become too invested in painting and rendering. To flip, select **Actions > Canvas > Flip Canvas Horizontally**. It's common to notice issues with asymmetry in the eyes or uneven perspective in the limbs, and while it can be painful, it's good to get into the habit of flipping your canvas early and often. You can redraw errors or use Liquify to push them back into place, then flip the canvas back.

▶ Flipping revealed that the gills and mouth were slightly out of proportion – these were then subtly adjusted

06

You can now use your new clean sketch as a guide for painting. To set this up, set the blend mode to Multiply to make it translucent, then lower the opacity a little. Create a new layer underneath the lines, which will act as your base for the colored character. Choose a strong midtone color to start.

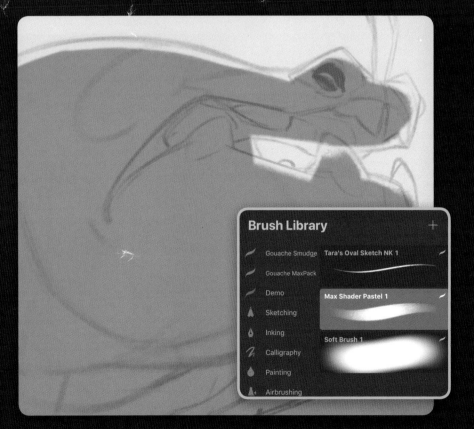

▶ Begin blocking color using the Max Shader Pastel brush to cover ground quickly

07

On this new blank layer, neatly fill in the character's silhouette with the midtone color. Use the Max Shader Pastel brush to start, as it's broad and can cover the large shapes quickly. (Details of how to download the Max Shader Pastel brush can be found on page 208.) Switch back to Tara's Oval Sketch NK brush to ensure the edges are nice and clean. This can take some time, so be patient – if you do this tidily and well, it will make things much easier later on.

▶ Create a crisp silhouette, or experiment with loose, textured shapes for a looser style

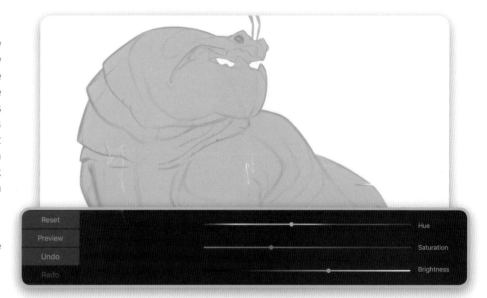

08

The silhouette you have created can now be used as a mask to help keep each new color you add to your character within the lines of the design. First, turn the base color to the pale tone of the creature's underbelly. To do this, select **Adjustments > Hue, Saturation, Brightness** and adjust the sliders to adjust your base color to a medium flesh tone. Next, use the mask shape to add the dark color of its back on a separate layer.

▶ Adjusting the color on the go is one of the main benefits of working in masked layers – everything can be changed during the process

09

Open the Layers menu and tap Select. Faint diagonal lines will appear around the silhouette, indicating the shape on the base layer has been selected. With the selection active, create a new layer, tap the new layer to summon the options menu, and select Mask.

▶ If you are new to masks, it's best to experiment before attempting a large piece

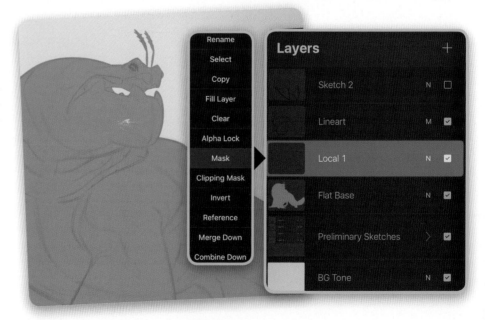

10

A black and white layer mask will appear above the new layer in the Layers popover, showing the white shape of your character's silhouette surrounded by black. Duplicate it (paired with its mask) several times. These will become the layers of color on your creature. The function of masks is to keep each new color you add within the lines of the design, while also flexibly keeping each on its separate, adjustable layer. (These masks can also be individually edited.)

ARTIST'S TIP

Thinking in masks and layers can be complicated if you're not used to it. Be patient with yourself. If you take the time to learn the basics, masks can be a powerful and versatile tool. The flexibility they offer will come in useful when a client suddenly wants something in blue instead of red.

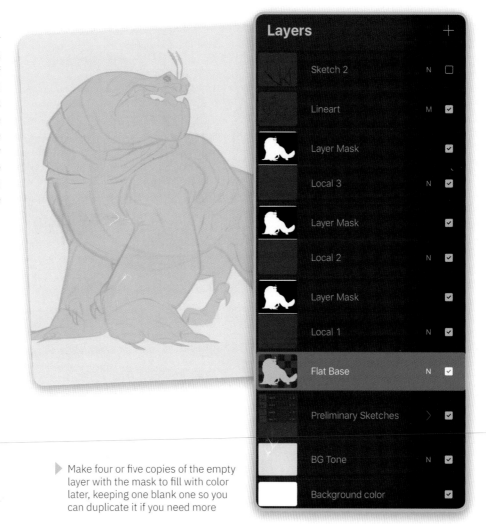

▷ Make four or five copies of the empty layer with the mask to fill with color later, keeping one blank one so you can duplicate it if you need more

11

Use the Soft Airbrush to paint your first color into the masked layer. Make sure you avoid selecting and painting into the mask itself. Use red to block in the color of the creature's back, noticing how the red never strays beyond the crisp silhouette of the design. The mask allows you to paint freely within those bounds. Use the Hue, Saturation, and Brightness sliders to adjust the red color, lowering the saturation and brightness to create a charcoal color. Notice how the base underbelly layer is unaffected and only the red changes.

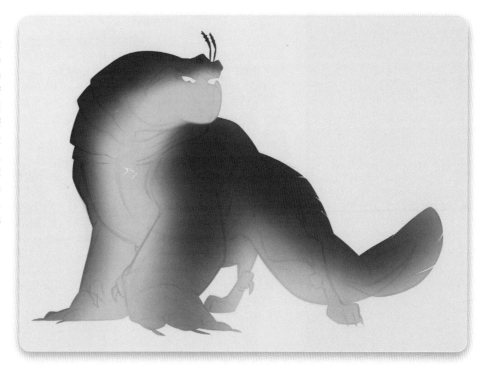

▷ The red color here is arbitrary – it just helps to demonstrate how colors can be adjusted afterward

12

Using the same technique, select a new layer from the set of masked layers you duplicated in step 10. Generally, zones of local color can be broken into separate layers like these. Local color is a term used to mean the true color of an object without any light or shadow affecting it. Your hair isn't the same local color as your skin, and your shirt is distinct from your hair, so you would break each of these into separate layers. This layer structure will prove useful if you want to make changes to the individual colors later without changing the surrounding colors. Using a light gray, paint the orca-inspired pattern on the creature's back into a masked layer.

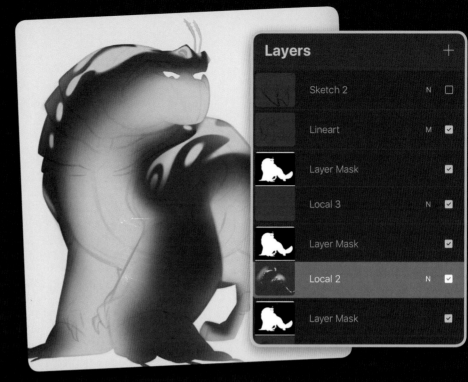

▶ The more textures and patterns used, the more fun it is later to see the effect of light and shadow across the form

13

Continuing in the same vein, use new masked layers to paint eyes, hair, fingernails, layers of clothing, or anything that requires a color break from the rest of the design. For this step, use masked layers and Tara's Oval Sketch NK brush to paint the eye, teal fins down the back and tail, and the glowing turquoise interior of the creature's mouth.

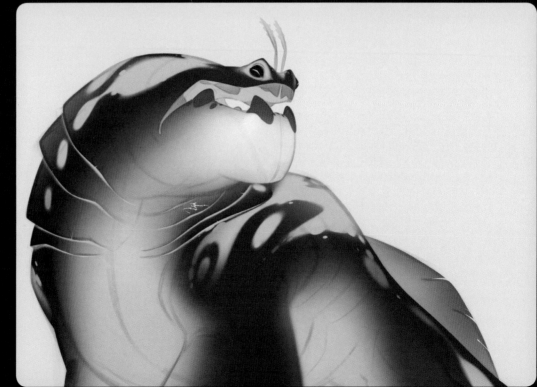

▶ Your sketch lines act as a guide for the color and development that follows – precise lines will lead to a better result

14

Each local color layer can start as a single flat color, but some areas call for added color complexity. To create a glow or gradient within a shape you have painted, Alpha Lock the pixels on that layer. A checkerboard pattern will fill the small layer preview image. This indicates that the pixels of that layer are now locked and anything new you paint into this layer will stay within the bounds of the pixels you have already painted on it.

▶ Notice the checkerboard pattern on the layer thumbnail – always check to see if the pixels are locked

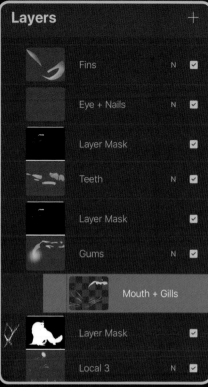

15

With the pixels locked, select a new color in the Color menu and use the Soft Airbrush set to a small brush size to begin painting. Paint a brighter turquoise color at the back of the creature's mouth to indicate that light is coming from deep inside its body. With the layer's pixels Alpha Locked, the bright color won't stray beyond the shape of the mouth you have already painted.

▶ Use Alpha Lock to paint a glow or gradient within a shape you have already painted

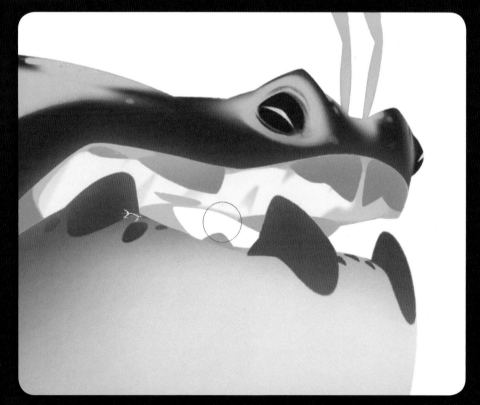

16

Setting up all of the local colors, adjusting them, and adding complexity can take a while, so find a good podcast or audiobook to listen to if you don't mind the mild distraction. It's worth doing a tidy and thorough job, as you will find the rest of the process much smoother if the local base colors are in good shape. Remember to turn the sketch layer off occasionally to check how clearly the design reads without the lines.

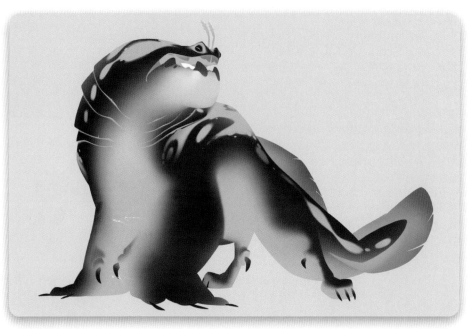

▶ At this stage the shapes and colors should feel strong, without telling the whole story – rendering will fill in the rest

17

Once you have set up the local colors, you can start to add form with light and shadow. Above your local colors, but below the sketch layer (which still acts as a guide throughout), create a new layer and set it to Multiply. Scroll down to the base layer you started coloring with, tap it once, tap Select, then with the selection active, return to your new Multiply layer, tap it once, and select Mask.

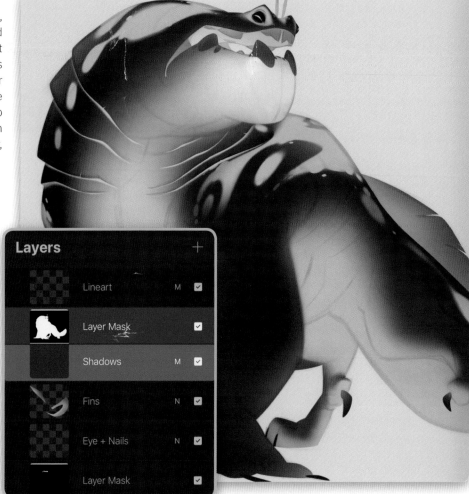

▶ This masked layer will be the one that carries the bulk of the rendering – try layering multiple shadows for extra complexity

18

This Multiply layer will act as the primary layer of shadows for your design. Since Multiply makes the pixels on the layer translucent, everything you paint into this layer will lie semi-transparently across the local colors underneath. Select a pale blue color (or experiment with a variety of shadow tones) and begin to paint where the shadows would pool. Consider the direction of your light source, the dimensional forms of the creature's anatomy, and how bright or dim the light source is.

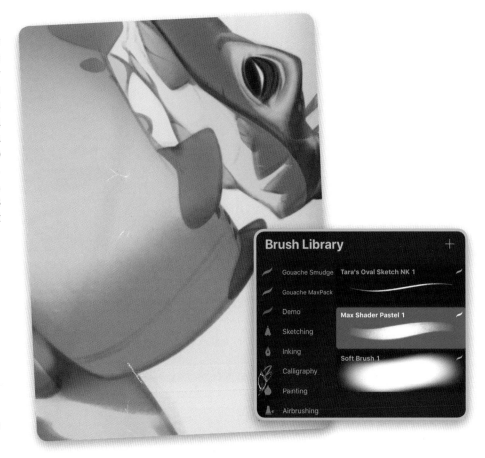

▶ As you paint the shadows, think about the softness or crispness of the edge – soft edges imply round shapes, whereas sharp edges imply hard creases

19

One of the chief advantages of this layered approach is that your shadows can be painted without permanently changing the colored layers below, which means you can add, smudge, and erase shadows fearlessly. Use the Max Shader Pastel brush to block in large textured areas of soft shadow, and Tara's Oval Sketch NK brush to paint tighter wrinkles and precise turns in the form. With the Smudge tool set to the Max Shader Pastel brush, use this sparingly to soften hard shadows.

▶ Aim for a mix of crisp edges where the form turns sharply, and soft gradients where the volumes are rounder

As with the local color layers, paint your shadows with a single color at first, focusing on shape and the impression of form, then add color and complexity. To add color to your shadows, lock the pixels on the layer then use the Soft Airbrush to gently shift the shadow color in areas. Softly brush reds and golds where you want bright light to bleed. Brush bright blues and teals where you want cool light to reflect. And paint darker blues and purples where you wish to show deep folds and pits.

▶ This is the finished shadow layer with all the local colors and base layer turned off – note the shifts in color and brightness

on point

on tilt

Max Shader Pastel

Soft Brush

Tara's Oval Sketch NK

ARTIST'S TIP

Mastering soft and hard edges takes practice. Tara's Oval Sketch NK brush has a crisp line when you use the stylus on its tip. Try tilting the stylus to produce a softer edge. Mix this with the Max Shader Pastel brush and the Soft Airbrush for a wide variety of edge qualities.

21

In this approach, the shadows define the shape of the light (similar to most watercolor techniques). Consider where some highlights or glowing effects might be useful to clarify the form. To set this up, create a new layer and set it to Overlay. Next, use the Soft Airbrush set to a large brush size with bright colors to lightly brush areas of glowing light across the creature on this new layer. But use this sparingly, as too much can make a piece look overcooked.

▶ The effect here is subtle, but the glow at the mouth and on the hump of the neck add believability to the light

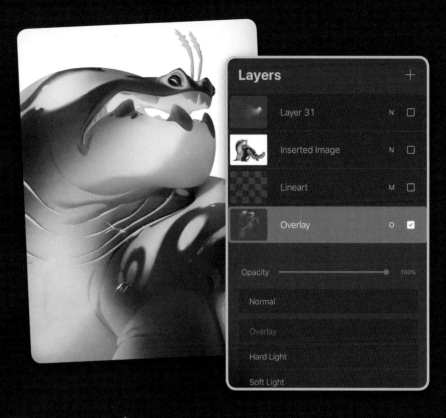

22

Lastly, create a new layer and leave its blend mode set to Normal. Use this layer to paint opaque adjustments on top of the whole piece. Create ridges of light, special highlights or shine marks; small clarifying details in areas of the anatomy that haven't been clearly rendered. Depending on your preference and the time involved, you can spend a long time painting over the top. The strong base of local color, light, and shadow you created beneath will set you up for success.

▶ Small additions – highlights on the teeth, a pupil for the eye, some light on the jaw

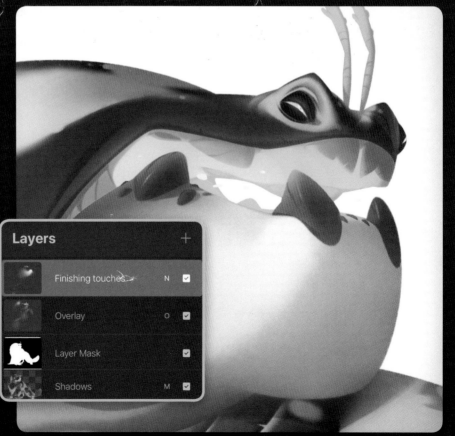

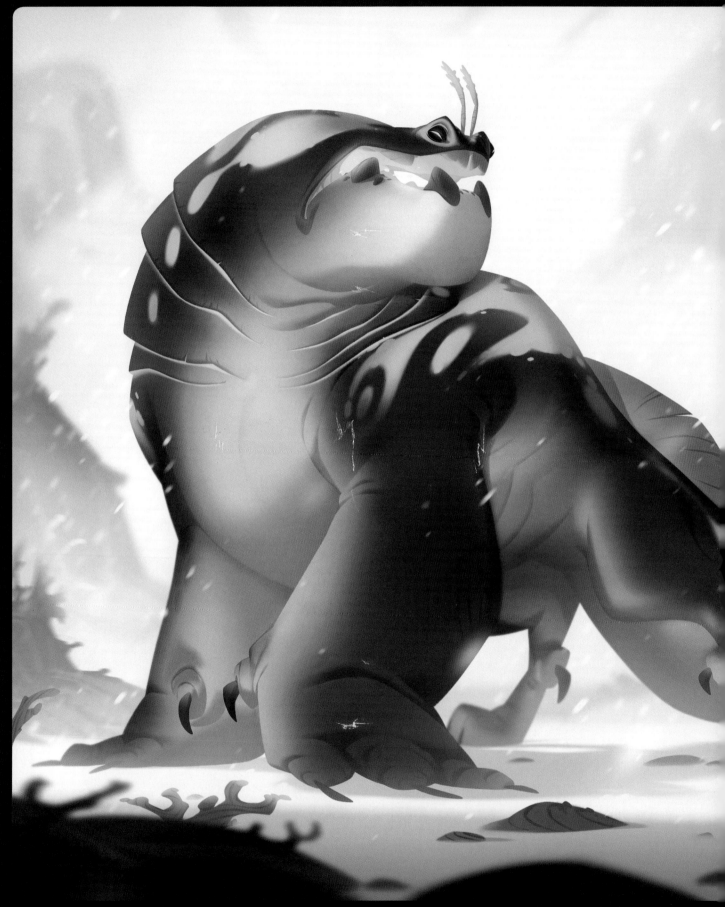

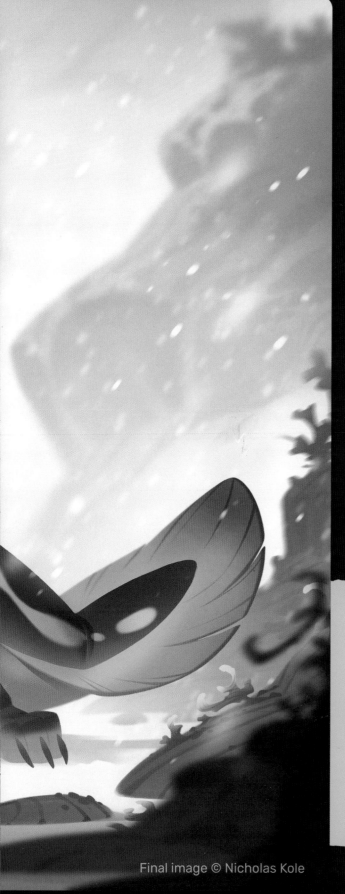

23

A background can help provide context and a sense of scale. Less is more, so be careful not to add too much contrast or high-frequency detail that will take focus away from your creature design. An otherworldly, snowy tundra is a good fit for this creature, as it was inspired by animals from cold climates. Keep the values bright and contrast low behind the character to ensure it pops. Blur layers increasingly according to their distance from the creature to create a sense of a shallow depth of field, which will also help to drive focus. A cast shadow, soft haze, and snowflakes all help to ground the design, and the result has just enough visual interest without distracting from the monster. Once you're happy with the image, it is ready to be exported (see page 18).

 The background sets the creature in its environment, enhancing without distracting

FINAL IMAGE

On completing this tutorial you will have a robust, flexible layered file with a fantasy creature that can now be adjusted as you see fit. You will also have grown more comfortable with the system of masks and layer blend modes in Procreate as a result. Next time, try adjusting the individual masks themselves to see what nuances you can achieve. Try working with a roughly textured base, or layering multiple shadow layers on top of each other. Masking can be hard to get your head around at first, but once you master it there is a lot of room to expand and create complex professional-level work.

Final image © Nicholas Kole

All images © Nicholas Kole

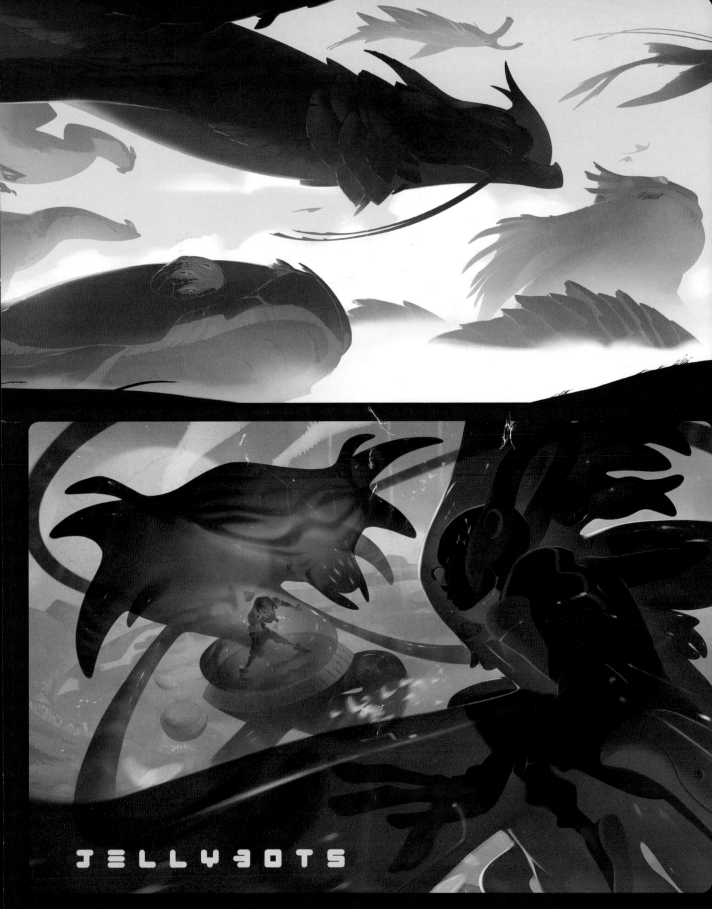

JELLYBOTS

Above: Jack Versus Duncan - Jellybots

TRADITIONAL MEDIA

Max Ulichney

Artists are often taught to focus on design and technique, but it's also important to consider character motivations and storytelling. Characters deserve an inner monologue and desires of their own. This tutorial will teach you how to create a fun, nostalgic scene of a boy listening to his older brother's records in the warm, late afternoon light after school when he should really be doing his homework or cleaning his messy room. The image will also include good storytelling details such as his cat and a poster of his idol.

The tutorial will cover basic brush techniques, as well as the creation of a new gouache brush. You will learn how to paint in Procreate in an expressive way that reinforces the subject's playful energy, using a combination of analog-influenced techniques and digital flexibility to create an image that looks rich, warm, and traditionally painted, while embracing the strengths of Procreate.

In addition, the tutorial will guide you through some complex perspective tricks using Procreate's drawing guides, which make scene construction easier than it has ever been in digital painting.

PAGE 208

LEARN HOW TO:

▶ Create thumbnails.

▶ Manipulate color using Curves, Color Balance, and Hue & Saturation.

▶ Construct a scene using drawing guides and Drawing Assist for perspective, and QuickShape for geometric objects.

▶ Create a custom brush.

▶ Approach digital painting using a traditional style.

01

A piece this complex needs thumbnails, so begin by making frames. To mimic the artwork proportions, use QuickShape to draw straight lines from corner to corner, creating an X as a guide (see page 36). Next, use **Options > Canvas > Drawing Guide** to create your frames. Enable the drawing guide and tap Edit Drawing Guide below that. The 2D Grid settings are perfect. You can enable Assisted Drawing by clicking on a layer and selecting Drawing Assist. Draw vertical and horizontal lines for your frames using the diagonal lines as guides to keep your proportions on point.

▶ Use QuickShape and drawing guides to create thumbnail frames

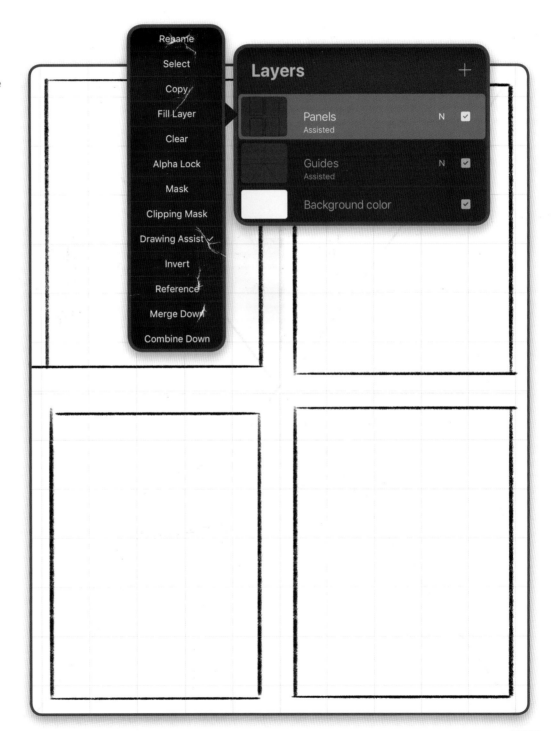

02

Take some time to consider your composition and the story you wish to tell, then on a new layer below the frames, start sketching using the Sketchy Sarmento Pencil. As shown in the top left thumbnail, the idea for this image started as a boy sitting on the floor calmly lost in the music; however, this was lacking emotion and storytelling. To iterate on your first thumbnail idea, duplicate the layer, then use the Transform tool to move the new layer to the next frame. Sketching the boy jamming along on his air guitar makes him more active, which led to the idea of adding the cat swiping at his fingers.

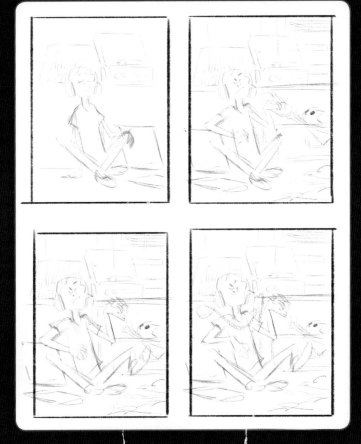

 With each iteration the concept develops and the poses are refined

03

Next, create the color roughs. First, copy the last thumbnail sketch to all of the frames and flatten them into one sketch by pinching all four layers together. Make the Background color layer gray by tapping on the thumbnail to bring up the Color Picker.

On a new layer, start painting the local color of the objects in the room. On a new layer above that, darken the room by painting the whole frame a light blue color and setting the layer blend mode to Multiply. This is all that needs doing here, as the room is dark and backlit, but in most other cases you could paint the shadows more selectively, such as under a character or cast across objects.

Additionally at this point, use a light color to paint the window light and a rim light on the character and effected surfaces, which can be tackled in separate layers.

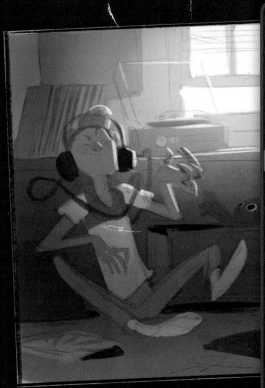

 Create layers that allow for lots of color variations and flexibility

04

To create the haze, fill a layer with orange, tap on the layer to add a mask, tap on the mask thumbnail, and invert the mask to make it black. Then, using the Grain Cloud brush, softly paint white in the mask to reveal the orange. Set the orange layer's blend mode to Screen.

To make the character's hand and face look like they're in front of the haze, create a new layer over the haze layer and create a clipping mask. This makes whatever you do to this layer act only on the layers it's clipped to. As the Screen blend mode treats black as transparent, paint black where the face and hand are to hide the effect of the haze there. Alternatively, you could paint this directly in the mask, but this method offers more flexibility if you need it later. Add the bright window color on a separate layer to provide better control of that color independent of the haze color.

▷ The isolated haze layers shown without local color – note clipping layer holdouts / silhouettes

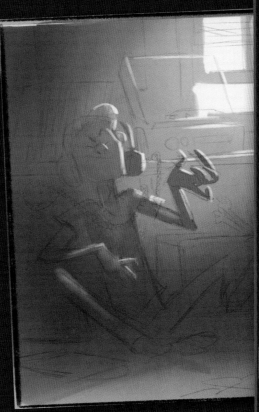

05

Group all of these layers together. This will allow you to duplicate the group and make variations to the time of day and color palette. Use **Filters > Hue, Saturation, Brightness** to alter the colors of the shadow and haze to find a color scheme that evokes a vintage, nostalgic mood using shades you might see in a Polaroid or 8mm camera. If the colors in your frames feel slightly drab, as with the top four frames shown on the right, flatten those groups then use **Filters > Color Balance** to push the colors even further until you find something you're happy with.

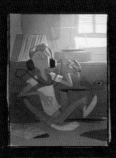

△ Possible color variations, before selecting the bottom right frame

143

ARTIST'S TIP

Good references are crucial to good storytelling. As this piece is 1980s themed, it's important to ensure every object and piece of clothing is accurate for the time, especially the record player. The human brain is great at simplifying the world, but not so good at remembering what a real hand-me-down record player from the '70s or '80s looks like. Ground your piece in reality and your audience will relate to it in a much deeper way.

06

Now to begin refining the sketch. Establishing your perspective early on will help as you start work on your character to ensure they feel grounded. Select **Options > Canvas > Edit Drawing Guide** and switch the mode to Perspective. Zoom out and tap once to the side of your canvas at the height of the horizon. Tap again to establish a second vanishing point farther off the canvas. This is a good time to flip your canvas, using **Options > Flip Canvas Horizontally,** to check if there are any weird distortions you might have missed.

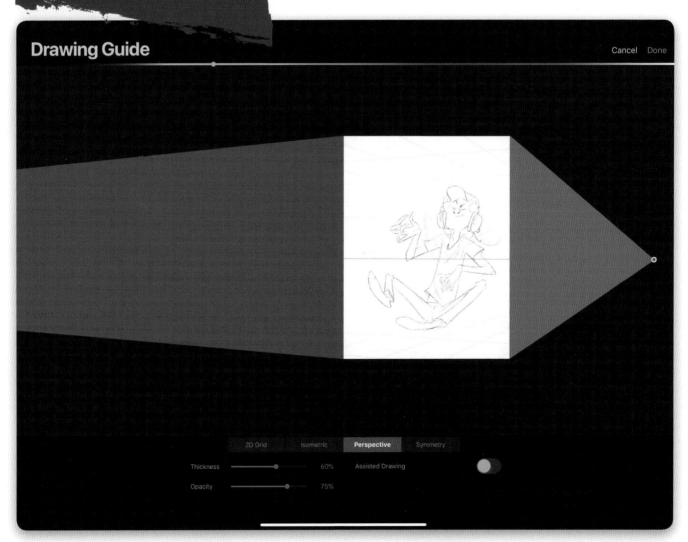

▲ Set two-point perspective using drawing guides

07

On a new layer, begin constructing your scene in perspective, allowing Drawing Assist to guide your lines toward the vanishing points without the need for a ruler. Use QuickShape for circular records or speakers, which is invoked by drawing a circle and holding the stylus down until it snaps into a clean shape (see page 36). Still holding the stylus on the canvas, touch the canvas with a finger on your other hand to snap it into a perfect circle where needed.

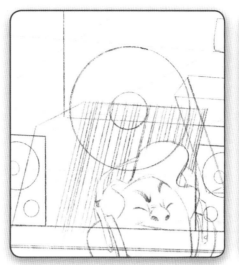
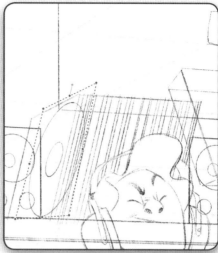

▶ A record drawn using QuickShape, then transformed into perspective

08

In the case of the speakers and album covers, you may find it easier to draw them flat then distort them into perspective using the Transform tool. Tap-holding on the corners allows you to warp them to the corners of the albums. Do this for the speakers too, so they are identical to each other. Once you have sufficiently distorted the records on the ground, make a selection using the Freehand Selection tool and swipe three fingers down on the canvas to invoke the Copy & Paste menu. A quick Transform then moves the record into place.

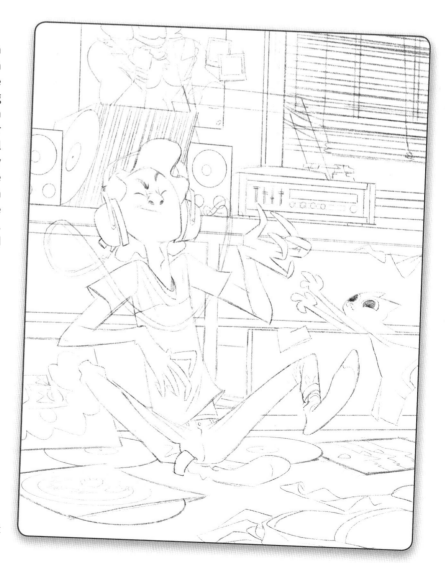

▶ Finished line art

09

Before beginning painting, you may wish to create a custom brush for the piece. To create a new brush, tap the + at the top of the Brush Library menu. This will open a blank tab for your new brush, where you can add a Shape Source for the brush tip and Grain Source for paper texture, or bristle texture in this case, which will be explained in later steps. In each case, tap Swap from Pro Library to use shapes and textures from Procreate's existing brushes. The built-in assets are great for creating a wide variety of effects. You could also Insert Photo or tap on Select Shape to open a file browser to load your own custom images.

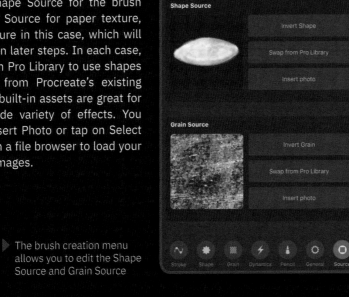

▶ The brush creation menu allows you to edit the Shape Source and Grain Source

ARTIST'S TIP

Brush creation is a huge topic. You can do a lot using the basics covered here, but the best way to learn is simply to experiment. In the process of creating one specific brush, you might find that you create numerous other brushes accidentally along the way. Branch off, experiment, and develop them if they seem interesting, even if they weren't quite what you were trying to create originally. Swipe left on a brush to duplicate it and play around with settings until it creates the desired effect.

10

One of the most versatile settings is Grain > Grain Behavior > Movement. At the default 100% Rolling setting you can create effects like a pencil on paper grain. As you drag the slider left, it stretches the grain out along the stroke, creating longer streaky textures needed to create a bristle effect. In this palette, Scale determines the size of the grain, while Zoom acts like a multiplier on your brush size. At the lowest Zoom level is the Cropped option, which means the grain remains the same size independent of your brush size, like you might want for a pencil. At the highest level of Zoom is the Follow Size option, which keeps the grain size relative to your brush size, more like the bristles of a brush. In between those two extremes, you can use the slider to select more subtle levels of zoom for your grain.

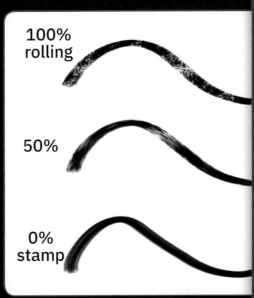

▶ A breakdown of the effects of Grain Behavior and settings for the brush

11

Now look at **Pencil > Apple Pencil Pressure**. Size controls the thick and thin action of pressing harder and making the brush larger. This is seen most notably in paintbrushes and fountain pens. Opacity controls how transparent the mark is, like with an airbrush. Bleed is almost like a high-contrast version of Opacity, ignoring the more delicate pressure and leaving you with bolder, more textural marks. It's perfect for creating a strong dry brush effect. For more detail, examine the settings in the MaxU Gouache Thick brush that has been created for this tutorial.

▶ The effects of pressure on a brush and the settings for the MaxU Gouache Thick brush

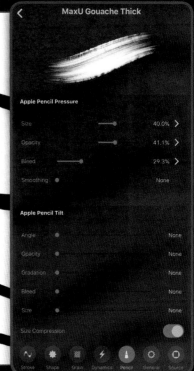

Default

Size

Opacity

Bleed

12

After carefully lining your image with a pencil-like brush, it is now time to loosen up and start painting. A tight drawing provides a good foundation for a more expressive painting style. It's easy to lose shapes in the painting stage if they have not been well defined leading up to this point. With a strong drawing and your colors mostly worked out already, you can begin to work more intuitively. Import your color study from your other file using Copy & Paste.

▶ Finished line art with color thumbnail imported

13

Toning the canvas is a common traditional technique. Lay down a base of orange midtones to create the hint of a warm glow early on. This will allow you to paint loosely and transparently without feeling the need to carefully cover up a white background. A good texture can help when allowing the canvas to show through. Paint this using the MaxU Gouache Bristle Gritty.

▶ Traditional style underpainting, with texture from the MaxU Gouache Bristle Gritty

14

Lay down some loose midtones, sampling colors from the color thumbnail using the Eyedropper tool. To create bounce light from the window, paint warmer tones near the window and cooler tones further away from it. It's OK to work a little messily at this stage and layer in detail as you go.

▶ Lay down loose and expressive midtones

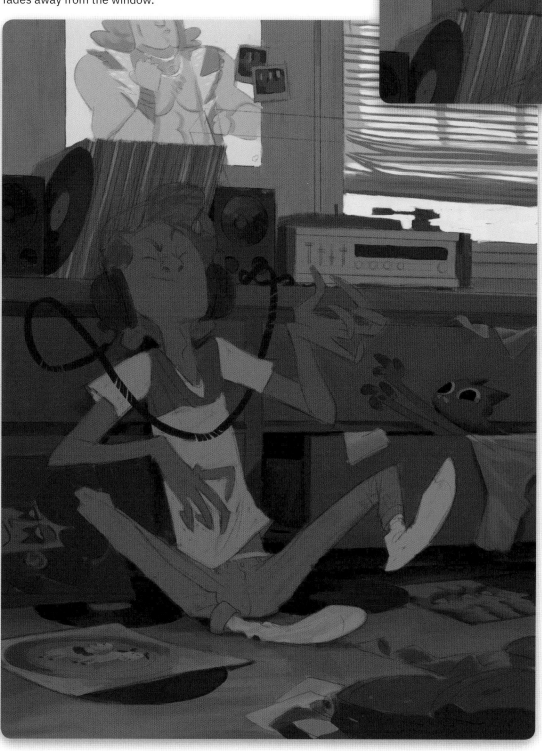

15

Details such as album covers and posters are fun to paint. Most of the time you can paint opaque colors sampled from the study, but in the case of the poster above the boy's head, paint it unlit and set the blend mode to Multiply, as it's on a white wall that blends from warm to cool as it fades away from the window.

▲ Add details like the poster, which is painted unlit and then multiplied

16

To create the hazy atmosphere, take an approach similar to the color roughs. However, something about the colors looks a little chalky and flat as the haze fades out. This is most noticeable around the cat's paws. Rebuild the layers, painting white haze on a black layer set to Screen blend mode, then clipping the silhouettes of the hand, face, cord, and cat out of the haze using Multiply layers (called "hold out" layers here). Now the orange color comes from two layers clipped on top of this stack; one set to Overlay to warm up the grays, and the top one set to Multiply to tint the whole thing. The result is easier to work with and adjust, and has a much more pleasing falloff.

▷ Comparison of the old haze setup and the new richer setup with a warmer falloff

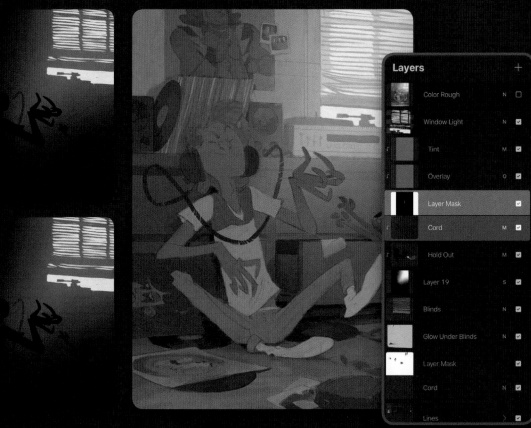

17

The blinds and window frames sit under the haze layer, so benefit from the warm light. Paint the yellow light coming through the blinds on top of the haze to allow you to work more predictably, without the artificial influence of the haze. Mix in a little warm and cool on this layer to imply the sky and neighborhood outside, which you would not be able to do if there were a big orange layer on top. To give the painting a more traditional feel, embrace imperfections and don't worry about creating perfectly straight lines.

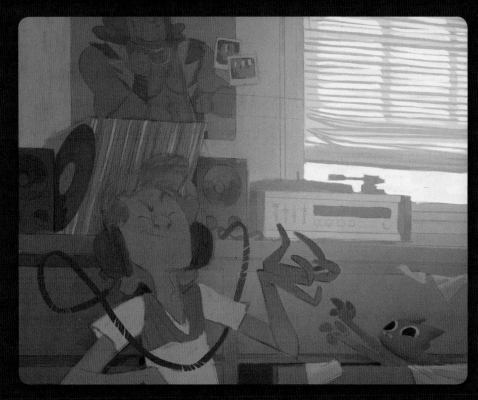

▷ The result of the window layers on top of the haze layers

18

You can use a concept called simultaneous contrast, which means putting two different colors of matching brightness next to each other. This can create a feeling of vibrancy and energy. When the warm underpainting pops through the cool walls and carpet, it creates a lovely visual interest. The effect is especially visible in the bright yellow and blues of the window. It is perfect for very hot light sources, reflected light, rich skin tones, and translucency. It's easy to create by eyedropping the color you wish to match, then in the color picker, moving the Hue or Saturation sliders and refining the brightness slider until you find the color that matches the brightness and feels like it enhances the first color in the upper right swatches.

▲ An example of simultaneous contrast used on the windows – notice the color swatches at the top right of the Color Picker

19

Details like the poster on the wall are a great way to add story to an image. When the man on the poster was just a funny-haired musician in a goofy vest, he was not adding much to the story. However, when redrawn so he is playing a guitar in a posture that mirrors the boy's, it suggests that the boy idolizes him and is enjoying the very same song. The fact that the guitarist is heavily muscled, while the boy is scrawny, adds to the narrative further.

▶ Use details to further the storytelling in an image

20

The headphone cord is easy to over-detail, so opt for a stylized approach. Create a mask and paint black in some areas, then repaint white loops back in. Break up the shading in the cord by setting the layer to Alpha Lock, ensuring you can't paint outside what is already opaque. The checkerboard background in the thumbnail tells you that it's locked. Next, paint in some warm and cool strokes on the cord layer with similar spiral marks.

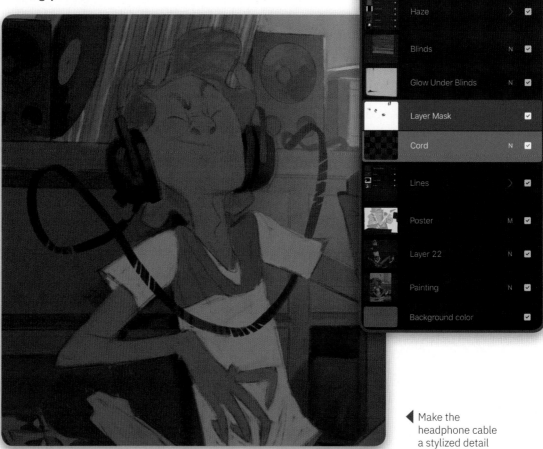

◀ Make the headphone cable a stylized detail

21

As you sample colors around the painting, turn the haze layers off so your colors aren't diluted by the orange if painting under it. The more layers you have, the more difficult they can be to manage, so at this point you may wish to flatten the layers of your painting. Once flattened, you can begin painting details on top of the painting instead. This saves space and still allows some flexibility in case you make a mistake.

▶ Flatten your layers, then begin detail work on top of them

22

Working on top of the flattened image, focus on cleaning up edges by sampling colors directly rather than flipping back and forth between layers. Begin to refine the face and hands; clean up edges but take care not to zoom in too much or scale your brush down too small. Overly clean and sharp brushstrokes are a dead giveaway that a painting is digital, so keep brushstrokes expressive when trying to create an image that looks like it's been created with more traditional media.

23

The last major element to add is the rim light. This is what draws the viewer's eye to the focal point, so reserve your darkest darks and lightest lights for the boy's face. Similarly, the face and hands should contain the most detail, falling off to the more loosely rendered, lower-contrast room surrounding the character.

▲ Focus on refining the face

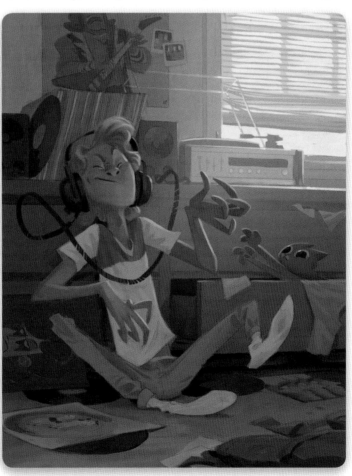

◀ The rim light is crucial for the composition to pick the boy off the background

153

24

Adding a slight vignette to the room will help to draw the viewer in, plus the cool tones will complement the warm haze. Do this by painting some soft dark blue shadows in the corners on a new layer set to Overlay. To add a bit more heat to the rim light, use the MaxU Gouache Bristle Gritty on a new layer set to Lighter Color, dry brush in some warm orange around the brightest highlights. Finally, add a little grain by filling a new layer with 50% gray, setting it to Overlay, and using **Filters > Noise** to add some noise. Using Gaussian Blur, blur the noise a couple of pixels then reduce the layer opacity to around 25% so it's very subtle. Once you feel your image is finished, you can export it (see page 18).

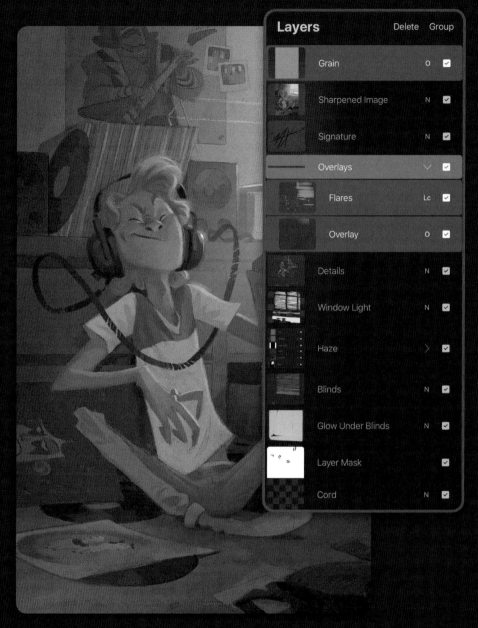

▶ The vignette, flares, and grain layer

Layers Delete Group

	Grain	O	☑
	Sharpened Image	N	☑
	Signature	N	☑
	Overlays	⌄	☑
	Flares	Lc	☑
	Overlay	O	☑
	Details	N	☑
	Window Light	N	☑
	Haze	›	☑
	Blinds	N	☑
	Glow Under Blinds	N	☑
	Layer Mask		☑
	Cord	N	☑

FINAL IMAGE

This is a highly complex piece with a lot of elements at play, but at the heart of it all is the story of a boy lost in a relatable moment. Now you are equipped with the knowledge of how to use Procreate's tools and techniques, always be asking yourself "why?" in your work. Consider also how the character design, color, lighting, and mark-making support your concept? These are meaningful tools at your disposal. Now it's up to you to make thoughtful choices.

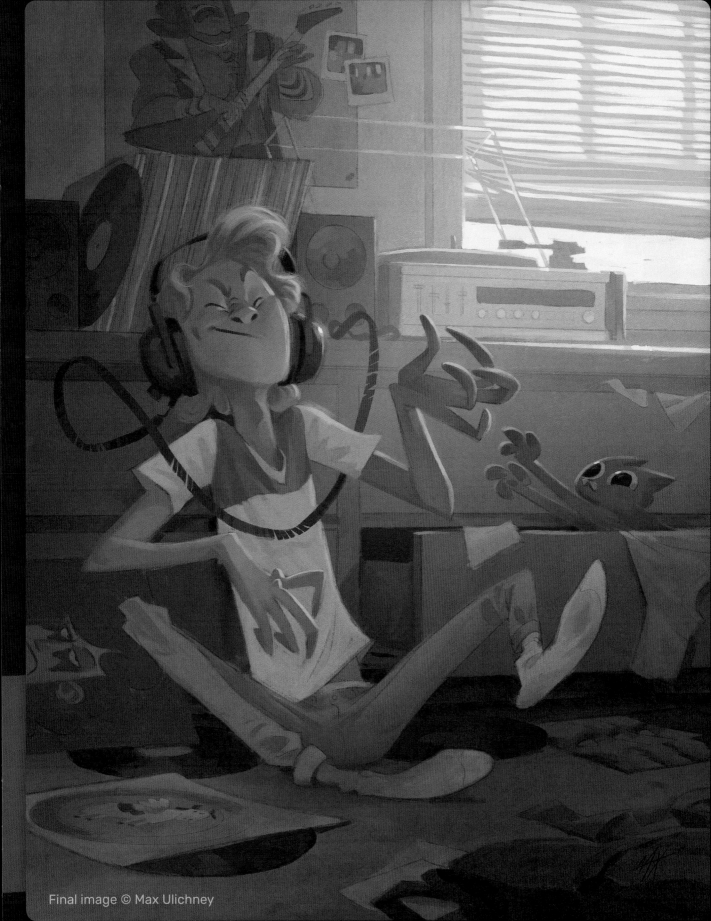

Final image © Max Ulichney

All images © Max Ulichney

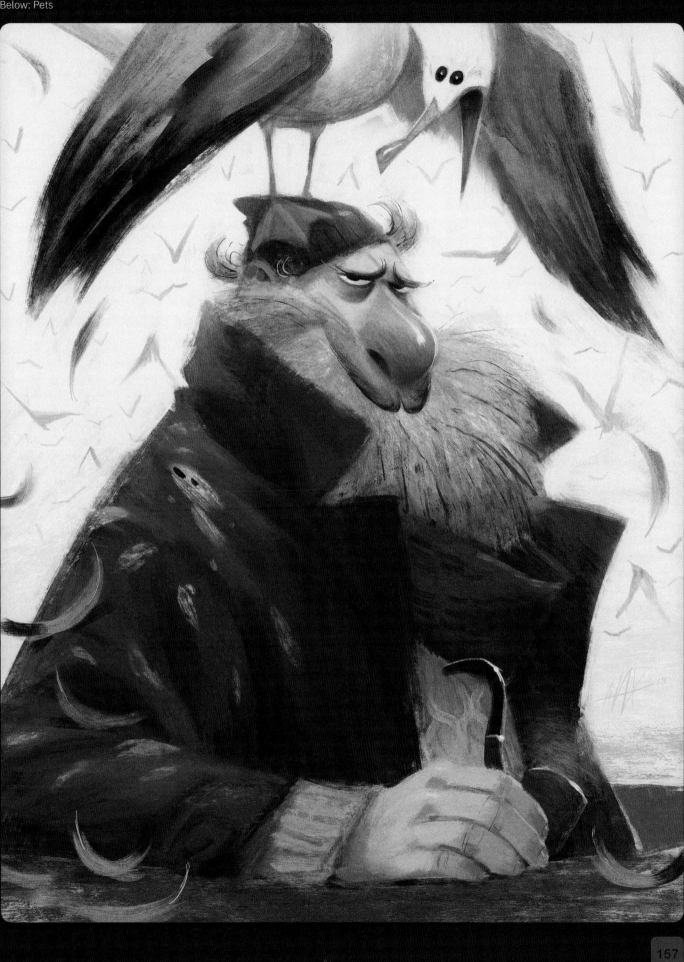

SPACESHIP

Dominik Mayer

This step-by-step tutorial will teach you how to create a dynamic spaceship painting using Procreate's tools and default brushes. Beginners will be guided through the start-to-finish creation of sci-fi artwork, while advanced artists will discover interesting tips and tricks.

The tutorial will show you how to set up a canvas, plus all of the basic settings. It will demonstrate the power of the Symmetry tool and how this can be used to start your design process. It will cover the importance of good layer management and how to use the various layer blend modes. As well as the technical aspects, you will also learn how to create a good composition, how to begin a painting, and how to build it up step-by-step to a finished artwork.

Showing you how to paint a small, agile fighter ship, speeding over a golden landscape with the rising sun in the background, the tutorial will explore how to create epic lighting effects and add movement and speed to the image. It will cover how to use a painterly approach for the background and a slightly cleaner one for the ship itself to create a strong contrast for good readability. Plus, it will use several default brushes and teach you how to create a striking and realistic-looking image using very simple methods.

PAGE 208

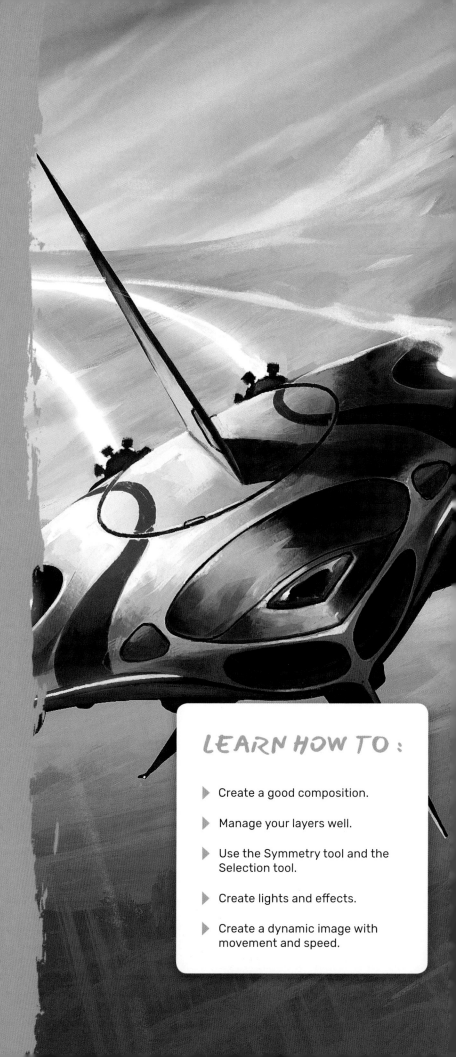

LEARN HOW TO :

▶ Create a good composition.

▶ Manage your layers well.

▶ Use the Symmetry tool and the Selection tool.

▶ Create lights and effects.

▶ Create a dynamic image with movement and speed.

01

Start by creating and setting up a new file. Choose Create Custom Size and enter 4,000 pixel width, 2,151 pixel height, 300 dpi and sRGB as the Color mode. If you experiment with the canvas size you will notice that the number of layers available in the file will change. The larger the file, the lower the number of layers allowed.

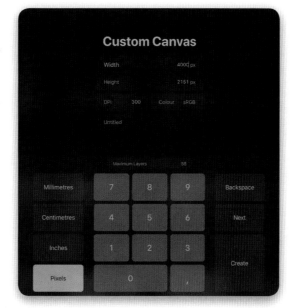

Set up the canvas settings

02

Coming up with new ideas is always a challenge, therefore it's important to have a large library of images to use as inspiration and references during your creative process. These images can be artworks and/or photos from other artists, or photos you have taken yourself. Starting to store such images on your device will help you to build up a visual library in your head, which is essential for your design process. Browse through your image library to find inspiration for interesting spaceship designs.

Set up Symmetry

03

The Symmetry tool can prove incredibly helpful when creating first sketches. Select **Actions > Canvas** and enable the Drawing Guide. Next, select **Edit Drawing Guide > Symmetry > Vertical > Done**. This enables you to mirror every line from one side to the other. Use this to create some initial spaceship sketches. Some of your layers may have the small Assisted tag, meaning the layer uses your symmetry settings. If you want to disable this, tap on the layer then tap Drawing Assist. This tool is useful when creating man-made structures, leading to happy accidents that can help you find interesting shapes.

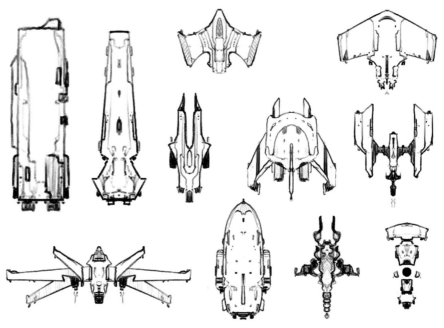

 Initial spaceship designs

159

04

Another useful method to create interesting designs is to draw small black and white sketches. Using a black brush with 100% opacity, start to sketch random shapes, but don't go into detail. Try using the Erase tool to edit the shapes. When you draw a shape you like, create a more detailed sketch based on that. Try to create a variety of different designs so you have a good selection to choose from.

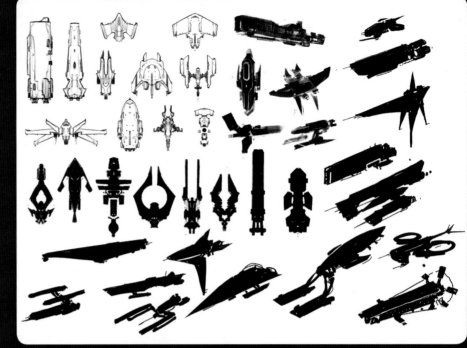

▶ Spaceship sketches

05

Once you have a number of possible ideas for your spaceship design, consider how to present it. For example, decide whether you wish to use a landscape or portrait format. Landscape formats often create energy toward the sides, whereas portrait formats do this in a vertical direction. Landscape images tend to create a more cinematic feeling and are a perfect fit for large or wide subjects, while portrait is perfect for illustrating height or extremely tilted horizon lines.

▶ Landscape and portrait
format thumbnails

06

Take your chosen thumbnail and start to draw a more refined sketch. This is the time to think about details for your spaceship design. Additionally, consider what you plan to show in the background and how that can support your spaceship design. Landscape thumbnail five has been selected here. For a dynamic scene like this, a tilted horizon is essential to illustrate speed and movement. It breaks the peaceful harmony and grounded atmosphere a straight horizon line creates. Tilt from the bottom left to the upper right to convey a positive feeling, or the opposite way for a slightly negative one.

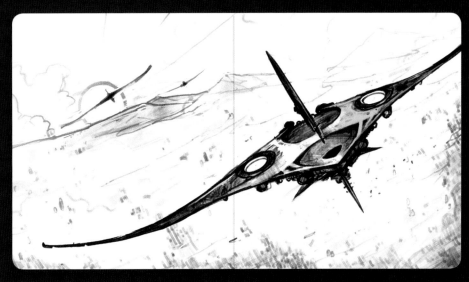

▲ Final sketch

07

Once your sketch is finished, the next step is to create some basic layers for painting the different elements in your image. Use the Selection tool to select the shape of the spaceship. If you tap from a point A to a point B, this will create a straight selection line between those two points, whereas if you draw a line, this will create a freehand, organic selection line. Create a new layer, then select Fill Layer. This will fill your selection with the currently selected color. Repeat this for all of the background elements.

▼ Select Fill Layer to fill your selection

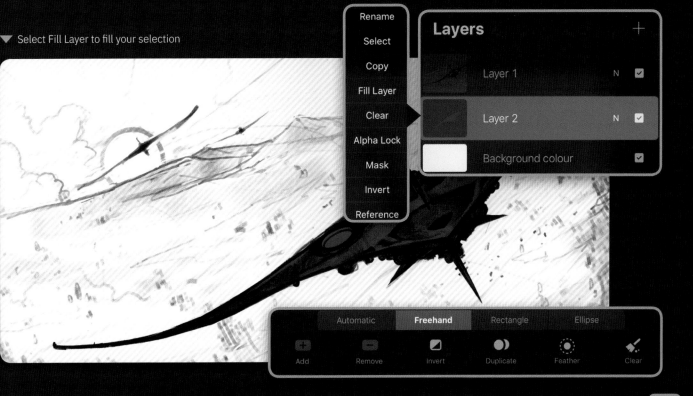

08

Next, create a perfect circle for the sun using QuickShape (see page 36). Select **Brushes > Round Brush** with a white color. Draw a closed circle and hold the stylus on the canvas for a few seconds until it snaps to a precise round shape. Tap **Edit Shape > Circle** and your round shape will transform into a perfect circle. Fill the circle by dragging the color dot from the upper right-hand corner into your circle.

▲ Create a perfect circle using QuickShape

▲ Fill the circle by dragging the color from the top right corner into your circle

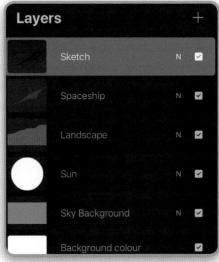

▲ Layer structure

09

With these layers set up, you can begin painting. Create a new layer on top of each of your base layers, tap them once, then select Clipping Mask. Now everything you paint on these new layers will only be visible on the layer below. Start with the sky. Select the Soft brush and start painting a bright blue gradient on the bottom part of the sky background. Use the left-hand slider to toggle the brush size and the same brush to color the landscape with yellows and browns. Add a subtle blue gradient to the mountains, then fill the spaceship layer with dark gray.

▼ Use clipping masks to paint in basic colors

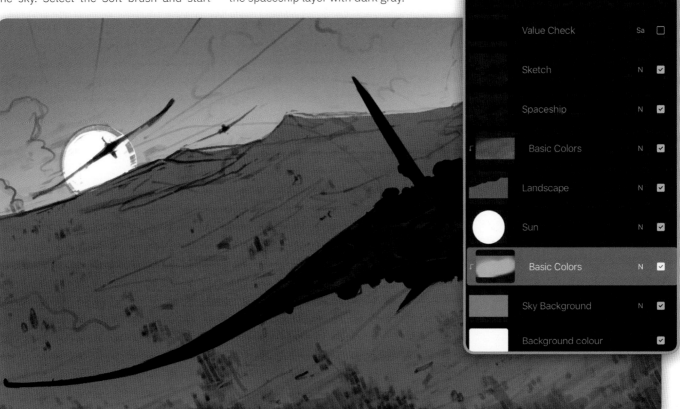

10

Ensure your values are correct. Values are the brightness information of the pixels from pure white, to gray tones, to pure black. If an element is further away in the background, make sure the darkest parts of that element are brighter than the corresponding dark parts of a similar object in the foreground. Elements in the background are brighter than in the foreground. To check this at regular intervals, create a new layer on top of everything else and fill it with pure black. Change the layer blend mode from Normal to **Color > Saturation**. The small N will change to Sa. When this layer is active, you can see what your values look like. You can hide and unhide this layer throughout the design process.

▼ Create a value check layer

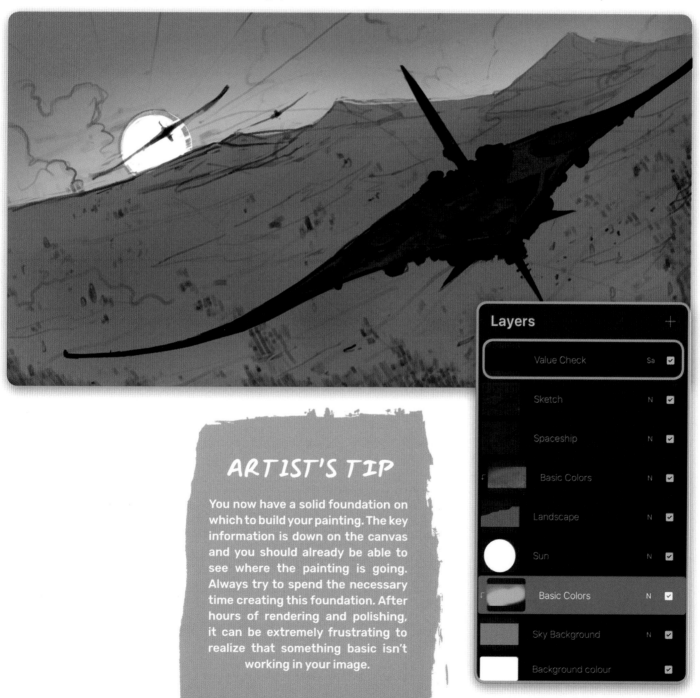

ARTIST'S TIP

You now have a solid foundation on which to build your painting. The key information is down on the canvas and you should already be able to see where the painting is going. Always try to spend the necessary time creating this foundation. After hours of rendering and polishing, it can be extremely frustrating to realize that something basic isn't working in your image.

163

11

Use the layer blend modes to create an epic sunlight effect. Create a new layer, then use the Round Brush to paint a blurred orange triangle around the sun. The long side of the triangle is aligned to the horizon line. Set the layer blend mode to Hard Light with 40% opacity. Next, create a new layer. Paint a blurred orange circle that is slightly bigger than the sun and set the blend mode to Add with 50% opacity. Again, create a new layer. Paint a much blurrier circle that is also slightly bigger than the sun, using a darker orange this time. Set the blend mode to Add with 50% opacity. Group all of the new layers. This will allow you to enable and disable the effect from time to time. Continue painting with the sun effect hidden.

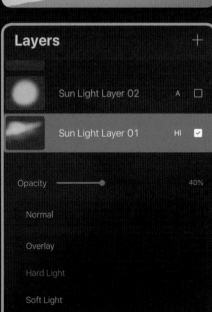

▲ Create sunlight layer

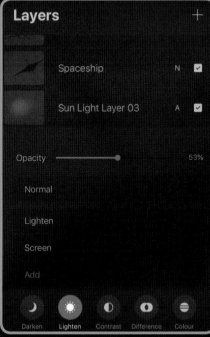

▲ Create additional sunlight layers

▼ Select all of the sunlight layers by swiping them to the right

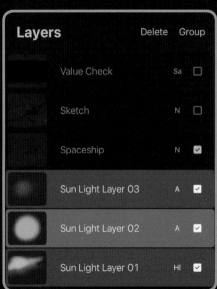

▼ Group all of the sunlight layers and rename the group

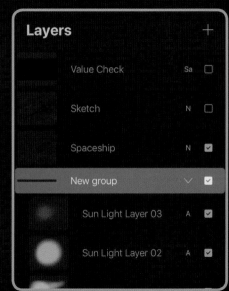

12

The next step is to add clouds to the sky. Using the Wet Acrylic brush, paint spots of dark blues and oranges into the sky background layer. Next, use the Smudge tool with the Oil Paint brush to mix the colors in horizontal strokes. Feel free to paint in more colors and smudge them again until you are happy with the result.

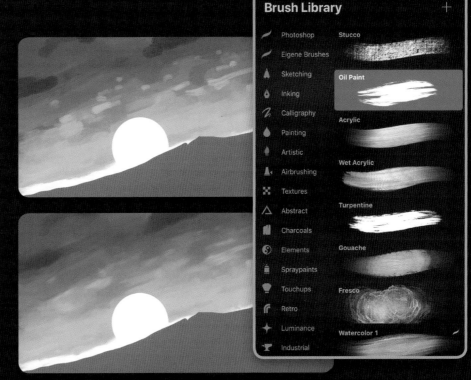

▶ Add spots of color

▶ Mix them together using the Smudge tool

13

Now add details to the landscape layer. Create a new layer over the basic color layer for your landscape and set it as a clipping mask. Add bright yellows and browns to the sides of the mountains that face the sun using the Wet Acrylic brush. To do this, select a color using the Eyedropper tool and paint a stroke in a certain direction. Next, pick the color right beside the first stroke and paint another stroke slightly angled in the opposite direction, while painting over the first stroke. This technique will create a nice painterly look that forms triangle-shaped brushstrokes with which you can sculpt your landscape.

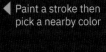

◀ Paint a stroke then pick a nearby color

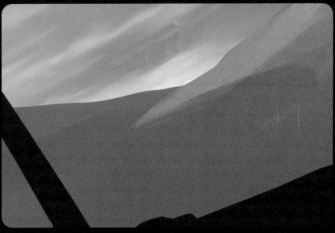

◀ Paint a second stroke, slightly angled over the first one

14

Select the Oil Paint brush and use the same painting technique (outlined in the previous step) to add more details and color to your landscape. Next, use the Turpentine brush and Oriental brush to paint in small trees. Decrease the size of the trees toward the horizon to add depth to your landscape. Add some blues to the shadow areas, such as under the trees and the sides of the mountains that are not facing the sun.

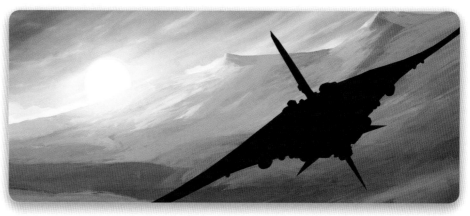

▲ Add details to the landscape using the Oil Paint brush

▲ Add small trees

▲ Add more trees

▲ Add blue shadows underneath trees and to the sides of the mountain that will be in shadow

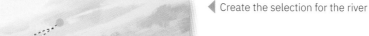

◀ Create the selection for the river

15

Next, create a river. Use the Selection tool to draw a snake shape where you want the river to be. Close the selection by connecting the start and end point of your selection path and create a new layer. Select a very bright yellow and Fill Layer, then set the layer to Alpha Lock. This will only let you paint on the pixels that already exist on that layer. Add some subtle white or yellow gradients to the river.

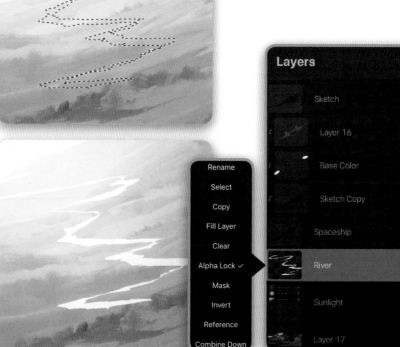

▶ Fill the river selection

16

With the background almost finished, it's time to start rendering the spaceship. Set the sketch layer as a clipping mask over the spaceship base layer you created at the start. Set the opacity to 20% so you can see some of the details. Create a new layer and use QuickShape to add the two round turbines by drawing the circle then holding your stylus on the screen (see page 36). Use the same method to create the upper shell of the spaceship. Set the shell layer to Alpha Lock and use the Round Brush to add some basic shading. (Enable the sunlight to get a better sense of this.) Next, use the Nikko Rull brush to add more details to the spaceship.

▲ Create clean lines using QuickShape

▲ Add basic shading using the Round Brush

▲ Add sharp details and material using the Nikko Rull brush

17

Use color to add visually interesting details to the spaceship. Create a new layer and set the blend mode to Multiply. Using a bright red, add striking patterns to the body of the ship. Start with rough strokes, refining them once you have found a good shape. Next, polish the spaceship and connect the upper shell with the lower part of the ship, then add a stripe of light to the front edge of the wings.

▲ Add color for more interesting visual detail

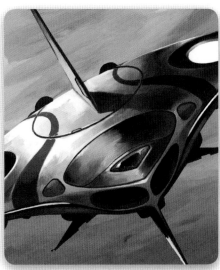
▲ Add more features to the spaceship, then polish

18

Currently the image doesn't create a strong feeling of motion. To change that, create a white trail left by the spaceship in the sky, showing where the ship has come from and where it's going: toward the viewer. Speed lines are another useful effect, enhancing the feeling of action by adding lines or streaks around the moving subject. First, reorganize your layers. Unhide the sunlight effect group. Select all of your layers, group them, duplicate the group, then flatten the new group. Now you have a merged version of everything, and all the other layers are saved in your backup group below. Next, use the Smudge tool with the Oil Paint brush and gently paint in the speed lines following the ship's movement. Use the Soft Brush to add some additional spaceships in the background.

▲ Add the trail in the sky to show where the ship has come from

▲ Add speed lines

▲ Add more speed lines by following the ship's flying direction

19

It's now time to add some light effects to the spaceship. Create a new layer and use the Soft Brush with a bright blue to paint over the parts of the spaceship you wish to glow. In this case, it's the trail behind the spaceship, the round turbines, and the thin light stripes on the edge of the wings. Set the layer blend mode to Screen to create a striking blue glow.

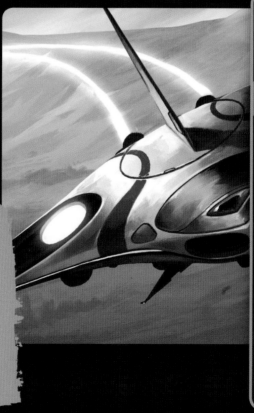

ARTIST'S TIP

Don't give up if you're not happy with your image. Drawing and painting are crafts that require a lot of practice. It's completely normal if your painting is not a brilliant masterpiece after the first attempt. Be patient and start again and after some time you will earn the rewarding fruits of your hard work.

20

Next, tweak the whole image with a small color correction. To affect the whole image you need to place everything on one layer. Select all of the layers and layer groups and group them into one new group. Duplicate it then select Flatten. Next, select **Adjustments > Color Balance** and use the sliders to tweak the image with a reddish/violet tone.

▶ Use Color Balance to apply a color correction

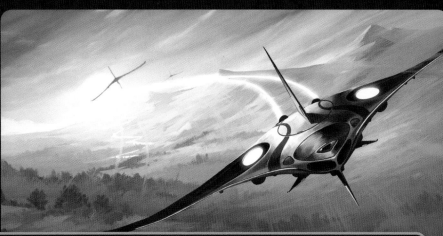

Reset			
Preview	Cyan ——————●—————— Red	Highlights	
Undo	Magenta —————●————— Green	Midtones	
Redo	Yellow —————————●——— Blue	Shadows	

21

Create a new layer and add final details, such as smoke trails emitted by the spaceship's turbines and some more speed lines. Once you are happy with the result, select all of the layers, group them, duplicate the group, and flatten it. Add a Sharpen effect to the new merged layer using **Adjustments > Sharpen**, setting the strength to around 80%.

▶ Add finishing touches to your image

Layers +

	Value Check	Sa	☐
	Blue light	S	☑
	Final Details	N	☑
	Color Correction	>	☑
	Painting With Speedlines	>	☐

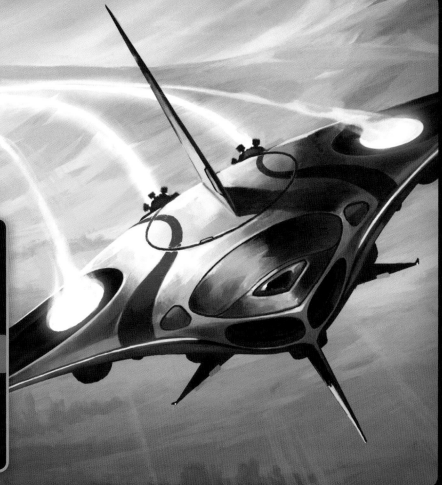

169

Now your artwork is finished, you can export it and share it with the world (see page 18).

FINAL IMAGE

This tutorial shares valuable advice, not just about how to use Procreate, but how to create a digital painting in general. Feel free to follow every step and use this tutorial as a base for your future artworks, but don't get stuck in rules and advice. Experiment with the software and see where it takes you. Happy accidents are a huge part of the creative process, so don't be scared of taking risks, and have fun playing around with new ideas. Always try to push the storytelling and overall dynamic of your images further.

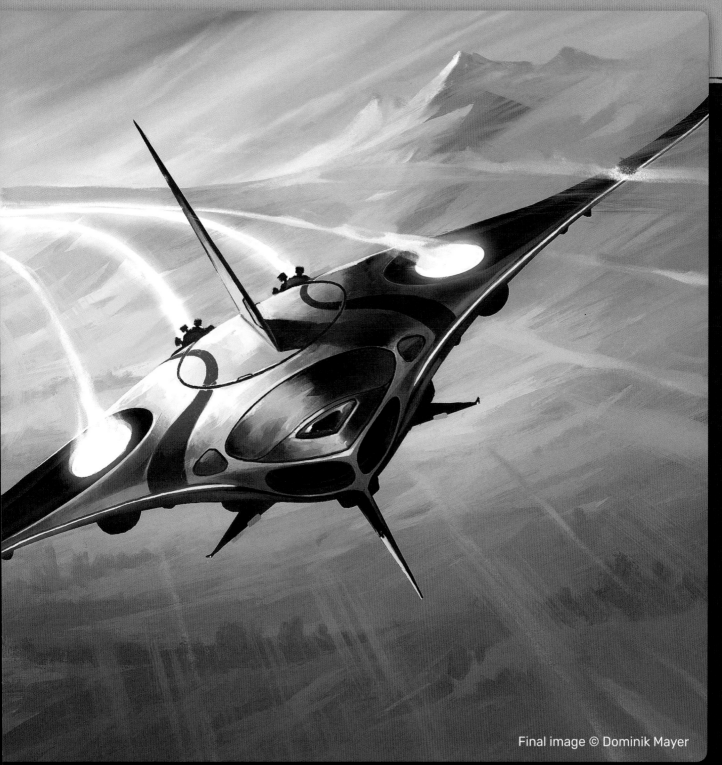

Final image © Dominik Mayer

 All images © Dominik Mayer

PLEIN AIR

Simone Grünewald

Drawing in Procreate on an iPad has many advantages, the greatest being that it allows you to paint digitally anywhere you choose. You can take it out and about with you and create quick sketches of whatever catches your eye. It's much quicker and easier to simply pop the iPad in your bag than lug around a large quantity of art supplies. Nevertheless, there are some considerations that need to be made, such as choosing your sketching spot when settling down for a longer session.

This step-by-step tutorial will show you how to sketch on location and capture a beautifully lit outdoor scene, using only one, slightly modified, standard Procreate brush. It will cover how to use the brush in a versatile manner to capture the lighting of a scene, utilizing various layer blend modes and tools that make painting in Procreate a lot easier. The tutorial will also show you certain techniques to create more vibrant and lively colors, especially when painting a lot of greenery.

PAGE 208

LEARN HOW TO :

▶ **Edit a standard brush.**

▶ **Use layer blend modes.**

▶ **Use clipping masks.**

▶ **Use Alpha Lock.**

▶ **Paint in masks.**

01

When painting outside it's important to dress appropriately, as you could be sat there for a while. A little foam sitting mat can be easily carried around for such occasions. A small folding chair might be a more comfortable option, but it depends on the view you want. When choosing your spot, avoid sitting in the middle of a path and make sure no direct sunlight will shine on your iPad while you're working, as it can be hard to see what you're drawing when this happens.

▶ A little mat is very useful when drawing outside

02

This tutorial was created using a modified standard HB Pencil brush, which is found in **Brushes > Sketching**. The HB Pencil originally has very small size limits, but tapping HB Pencil will allow you to access the brush editing menus. Select **General tab > Size Limits** and change the Max slider to about 140%. If you still want to keep your original HB Pencil brush, then duplicate it.

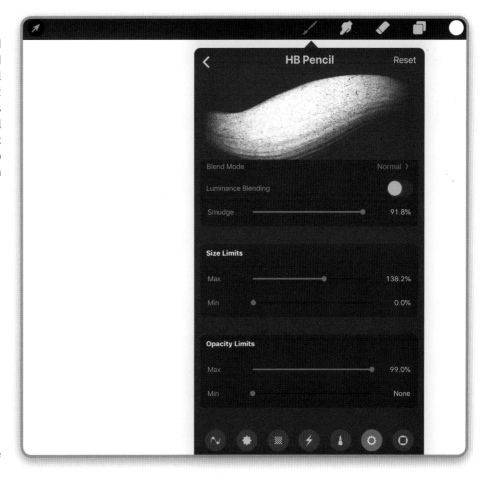

▶ Modify your HB Pencil to produce an all-rounder brush with a great texture

03

Explore your chosen location in search of a good view to paint. You can find a nicely framed scene by making a window with your hands and looking through it. Once you have your scene, start by drawing rough perspective guidelines, then draw a quick first sketch. At this stage in digital drawing you can move elements around the canvas to improve the composition. Make a selection of your drawing using **Selection > Freehand,** then draw around your selection.

▶ Choose your scene and create a rough sketch

04

Tap Transform to finish editing the selection, then tap and drag to reposition it elsewhere on the canvas. As well as moving the selection, you can also edit it in multiple ways, including flipping or warping it if necessary. Try to get the composition right at this early stage. Balance your elements and ensure the spacing is right, but make sure it isn't too regular. Positioning the focal point slightly off-centre, rather than in the middle, will make the image more interesting.

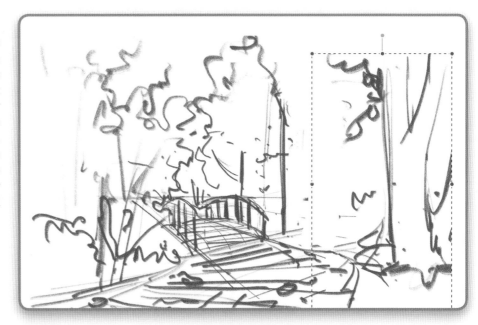

▶ Edit the composition of your sketch

05

Once you have finished editing your rough sketch, start to refine it and add more detail, laying out the light and shadow areas too. It can help to sketch in some volume and perspective lines, such as on the path leading to the bridge. This stage is allowed to be messy, as you won't need this line art later. Keep your composition in mind and work this sketch into the painting.

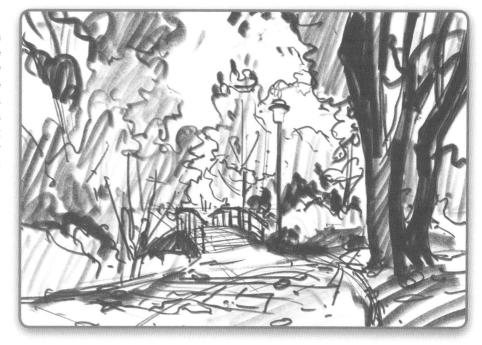

▶ Refine the rough sketch just enough that it has all the information you need

06

When you start sketching in Procreate, you will automatically sketch on a new layer on top of the background layer. Each layer can be set to a different layer blend mode, the most basic of which is **Darken > Multiply**. Everything on this layer will be multiplied, mixed in visually with the layer underneath. Set the sketch layer to Multiply.

▼ Multiply is one of the most essential layer blend modes in digital painting

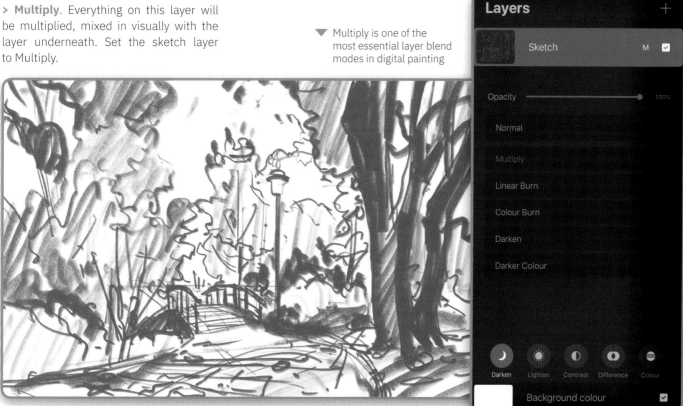

07

Before starting a color sketch, consider changing the color of the background layer. As green will be the dominant color in this outdoor scene, red is a good choice for the background as it is the complementary color to green. Setting the background color to red will allow it to peek through here and there in your painting, which will provide warmth and make the green shine brighter. To change the background color, tap the layer to summon the Color Picker.

▼ Changing the background color can provide the colors you layer on top with extra life

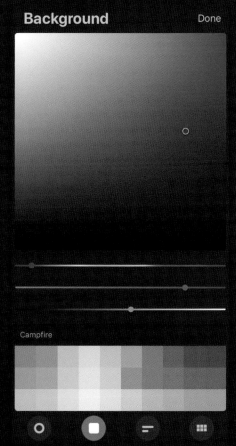

08

Create your color sketch on a layer under the rough sketch. The color sketch is important in deciding on your overall color scheme. Producing a color sketch first will prevent you from realizing that you dislike your chosen colors halfway through the painting. Create a couple of color sketches, experimenting until you are happy with the colors and can see the direction you wish the painting to take in terms of color. By setting a fairly big brush size, you will avoid falling into the trap of over-detailing the sketch.

▶ Create color sketches to decide on the right colors for your painting

Color sketch

Color sketch with rough sketch visible

09

Create a new layer under the sketch, set to Normal, and start painting the colors at the back of your scene. Starting from the back will ensure you have the right colors shining through underneath the layers you gradually layer on top. Since this scene is backlit, with the light coming through the trees, this layer will contain some of the brightest and most saturated colors in the painting. Remember to turn the sketch layer off every now and then in order to view the colors on their own.

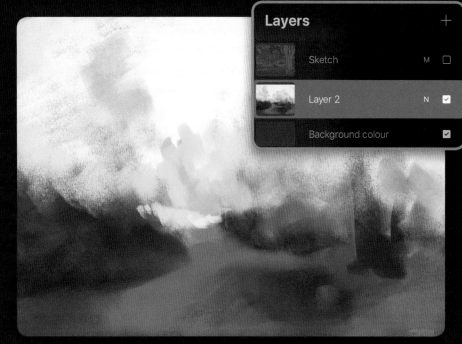

▶ Paint the background colors first

10

After setting the background colors in place, start to paint the trees on new layers. Divide the big tree into two layers; one for the front and one for the back branches that are overlapped by the front branches. The background trees can be drawn on a single layer, since they don't overlap. Keeping objects on separate layers makes it easier to control your edges and will make shading easier later. It will allow you to erase parts of the trees later, without damaging other parts of the painting. But don't put every single object on a new layer – that will get too confusing – just the ones that overlap.

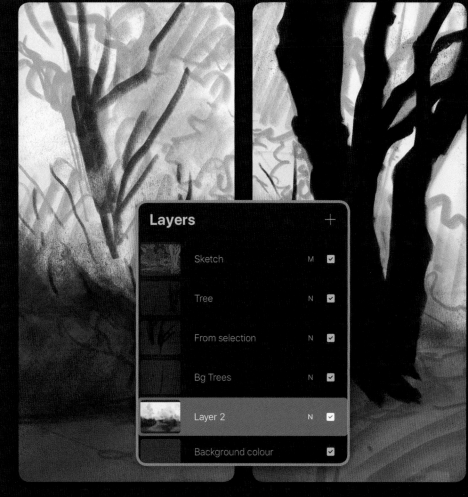

▶ Keep overlapping elements on separate layers for easy rendering and crisp shapes

11

Next, block in the background greenery, tilting your stylus to create a broad, grainy stroke. Experiment with the angle you hold the stylus at. The HB Pencil's stroke is quite precise when held straight, but when tilted it becomes more translucent and grainy. Block in the greens in different shades to create variation. Different trees have different shades of green, and even within one tree the shades can look different. For example, leaves at a certain angle reflect the blue of the sky, and they can look bright and closer to yellow in color when sunlight shines through them.

ARTIST'S TIP

When looking at a scene or a photograph, try separating it into practical layers in your mind. Think about how you would separate a scene with as few layers as possible, but with as many as are needed. With practice, you will start to get an idea of what makes sense to group and what needs to be separated.

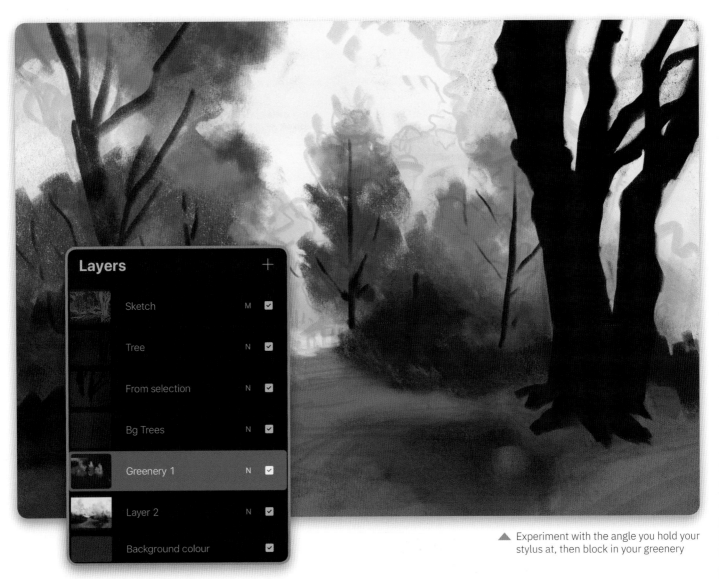

▲ Experiment with the angle you hold your stylus at, then block in your greenery

12

In order to add some color variation to the leaves at the front and to lighten and brighten them toward the edges, it helps to put them on a separate layer, again because of the overlap. You want to avoid having to keep track of the edges of the front tree against the other green. The easiest way to achieve this is to Alpha Lock the layer.

▶ Alpha Lock is the easiest and cleanest way to paint color variation

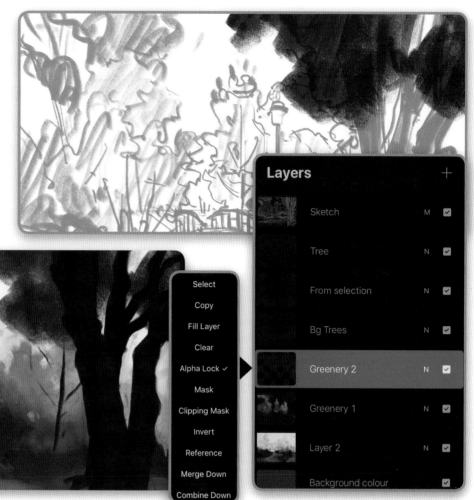

13

When you use Alpha Lock on a layer, it locks the pixels that already exist on the layer. As a result, when you paint on an Alpha Locked layer, you are only able to paint on the existing pixels. Everything else stays transparent; even half-transparent pixels retain the same transparency. This is very useful when you want to shade a shape with large brushstrokes to create a smooth gradient, but don't want to damage the shape and the edges you have already painted.

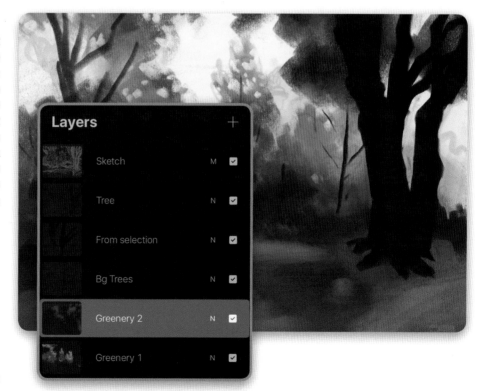

▶ Alpha Lock is the easiest and cleanest way to paint color variation

14

Once almost all of the elements are in place, start to refine them a little. For example, refine the blocked-in greenery to create more intricate shapes and edges by erasing parts of the layers. Erase holes in the leafy shapes to allow the background colors to shine through. This instantly gives them a leafy quality. For the eraser, use the same brush set to 100% opacity to create crisp shapes.

◀ Turn Alpha Lock off, then refine shapes by erasing parts of the blocked-in shapes

15

Everything leading up to this stage may have felt quite technical, as if you were setting up, sorting, and preparing to start painting; but this preparation is essential. A good base is key to creating a good painting. Once this is sorted, the painterly fun can begin: refining the shapes, and adding details and delicate colors that are close to the existing ones, but with fine nuances. Lower the opacity of the brush; this will give you more control and will make the strokes less harsh. Add a new layer and begin to gently paint all over, keeping mainly to the background.

▶ Refine the painting using finer brushstrokes with lowered opacity

16

One of the most important details is still missing: the bridge, the focal point of the painting. Block in the bridge on a new layer and paint it in its darkest shade. Setting the brush to 100% opacity, keep the edges crisp and opt for a fairly clean and solid shape. The initial sketch should still be set to Multiply and the opacity set low to help with the perspective and position of the bridge.

▼ Add the bridge on a new layer and block it in as a solid shape

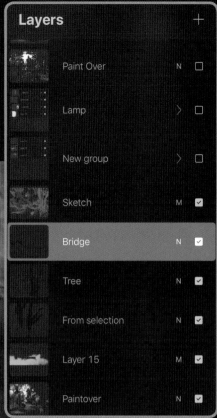

17

Add some additional layers on top of the bridge layer on which to detail the bridge. Paint a gradient on one layer using a big soft brushstroke and add more detailed lighting on the others. Set these layers as clipping masks. These will use the pixels of the bottom layer as a shape within which you are allowed to paint. They work similarly to layers set to Alpha Lock, but their virtue is that you can use more than one and layer them on top of each other. It is also easier to edit the bottom shape without damaging the painting on top.

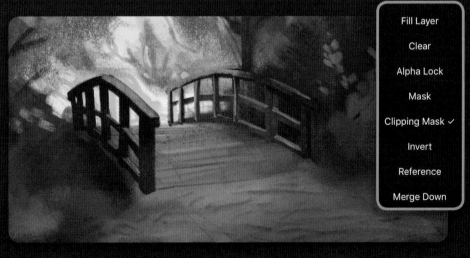

▲ Clipping masks use the shape of the layer below as a stencil within which you can paint

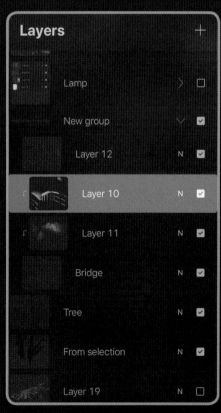

18

At this stage you can start to see the painting coming together, though it still feels a little blurry and flat and lacks depth. There are still some details missing too. Try to paint and refine all parts equally. If you need to leave your location, one of the advantages of today's digital age is that you can take a photo of the scene to use to finish the details later. It's always best to draw on location, as a photo is rarely able to capture the mood completely, but if necessary the final touches can be carried out from home since you have already captured the atmosphere.

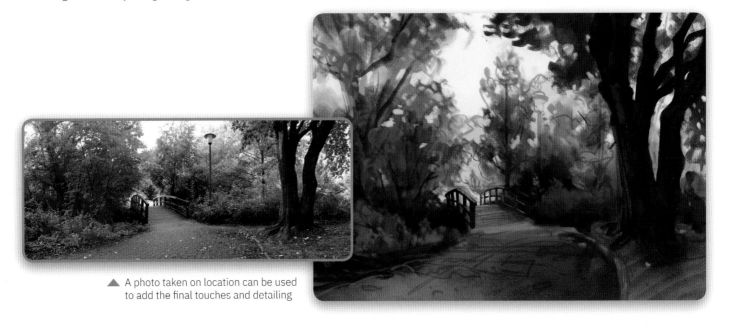

▲ A photo taken on location can be used to add the final touches and detailing

19

The lamppost is one of the last elements to add. This can be created in a similar manner to the bridge. Paint the light bulb and the post on separate layers, using each as the shapes for the shading layers set to clipping masks on top. After finalizing the lamppost, continue layering details on new layers in areas where you feel this is needed.

▶ Add further details and more all-over painting on new layers created on top of everything else

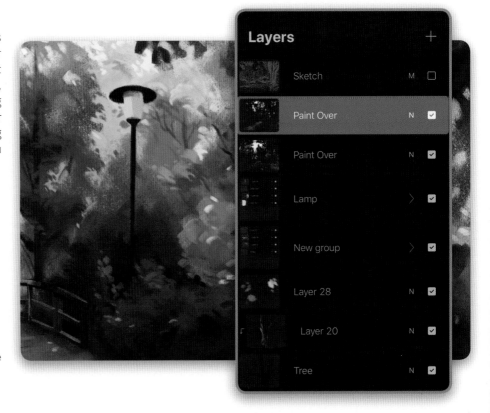

ARTIST'S TIP

Remember to zoom out from time to time when you are working. This will provide you with a thumbnail view to check whether the painting still reads well and you are still on track. Zoom out by pinching two fingers together on the image.

20

At the end of a painting, make a copy of the whole image. Swipe down with three fingers over the image, then select Copy All from the menu. Repeat the same action and select Paste. This is like taking a picture of everything you have painted. Move this flattened painting layer called Inserted Image to the top.

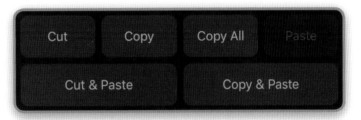

▲ Take a picture of everything that has been painted

21

Experiment with the various layer blend modes to achieve different effects. Soft Light, for instance, will saturate and add more contrast to your painting, which can give your painting a final tweak. By adding a mask to the layer, you can partly erase this effect without damaging the actual pixels on the layer. Paint within the layer mask, which will use grayscale tones automatically. Use black to hide the layer's contents and white or gray to reveal them.

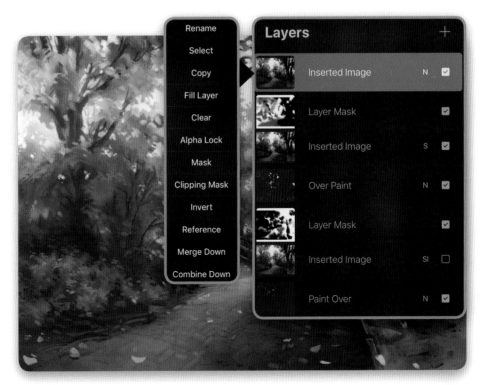

▶ Masks can be used to selectively tweak the colors and contrasts

After adding more depth and color to the image with as many different blend modes as you find helpful, give your image a final evaluation and some finishing touches on a new layer. If you find yourself getting annoyed with the number of layers, you can merge them at any time – you just need to feel confident that you don't want to change anything about them. Layer blend modes used to create this image include Multiply, Soft Light, and Screen. Once finished, export and share your image (see page 18).

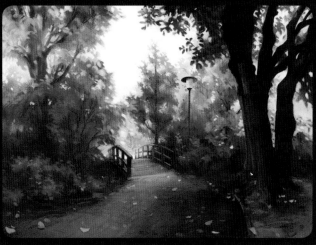

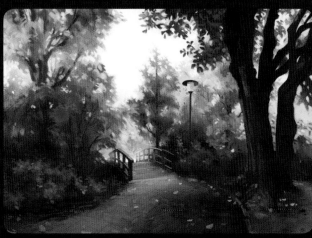

◀ Add a final layer for the finishing touches

FINAL IMAGE

This plein air painting sought to capture the peaceful atmosphere of a leafy outdoor scene. It was important to balance the softness and the noise from the leafy shapes. Hard and soft edges were experimented with, as were color and light, to balance and hint at details. When you can't draw every leaf, learn to stylize instead. This will become easier with practice as you grow more familiar with the various tools and techniques covered in this tutorial.

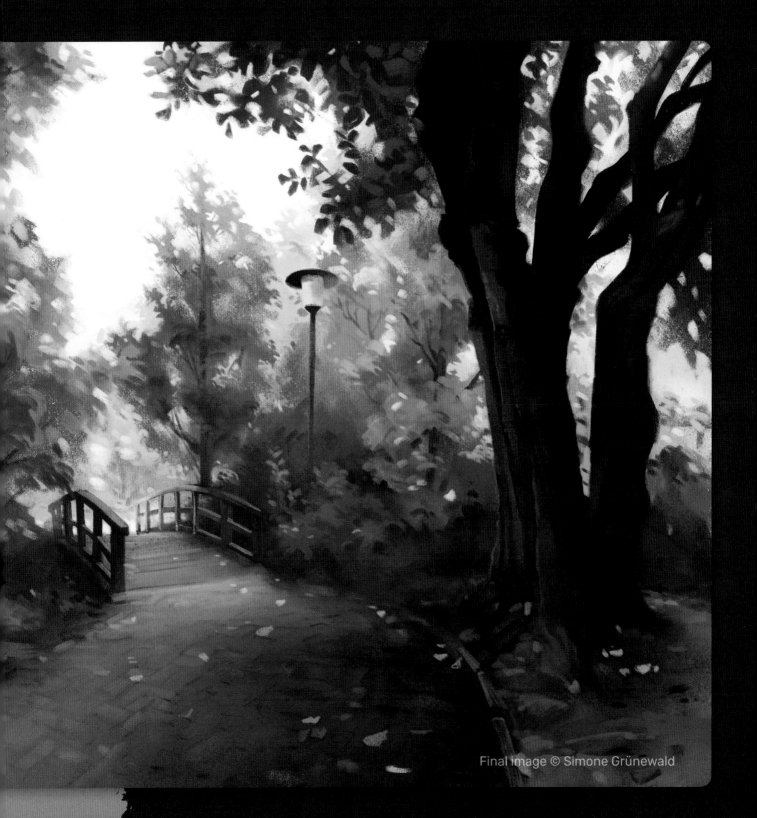
Final image © Simone Grünewald

 All images © Simone Grünewald

Above: In a Nutshell

Below: Bathing in Autumn

SCI-FI CREATURES

Sam Nassour

Creating artwork on the go with Procreate can feel like drawing on a traditional sketchpad, but with all the magic that digital tools can offer. This tutorial will show you how to create a stylized image featuring two science-fiction creatures set in an edgy spacecraft scene.

Right from the beginning, this painting demonstrates that Procreate makes every stage of painting easy, including the initial exploratory sketches and line art. Using the Clipping Mask tool allows you to accurately paint within the detailed outlines of the creatures' silhouettes, while blend modes add the effects of a light source, bringing the character to life. During the process you will see the various layers individually and the effect when merged.

To create the background, the tutorial guides you through the process step-by-step, including how to create two-point perspective and use Drawing Assist to ensure your lines snap to the grid for a realistic effect. The last section of the tutorial involves creating lighting effects, textures, and depth of field to ensure the background complements the sci-fi creatures.

PAGE 208

LEARN HOW TO:

▶ Sketch rough ideas.

▶ Use layer techniques for efficient lighting.

▶ Use drawing guides to create effective perspective grids.

▶ Create light glow effects.

01

Create a new file and choose the A4 size from the templates. Select the **Sketching > HB Pencil** brush and, with the sci-fi creature theme in mind, begin to make loose exploratory creature sketches. This tutorial will show you how to create a tough alien character with a silly lizard-type pet. This type of contrast in character design is always fun to play around with. Create at least three rough sketches, all on the default layer. At this stage there is no need to add any extra layers.

▼ Start exploring your design with at least three thumbnail sketches

02

Choose which sketch you prefer (here sketch A has been chosen), then start to clean up that sketch to create a refined line art version. Use **Selection > Freehand** to draw a selection line around your rough sketch, then summon the menu and choose Cut & Paste. This will paste your preferred sketch onto its own new layer. You can now hide or delete the original layer containing the other rough sketches. Select the Transform tool and use the pinch gesture to scale up or center your sketch within the canvas to get the best out of the file's resolution. Next, adjust the Layer Opacity slider to around 50%.

▶ Summon the Copy Paste menu by swiping down with three fingers

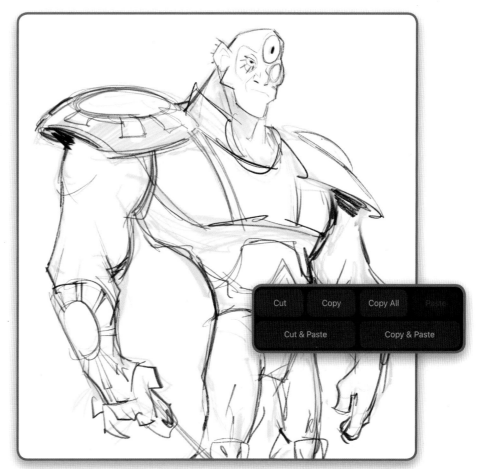

03

Create a new layer on top of the rough sketch layer and rename it Line Art. Always name layers in a way that will make sense to you later – this way you're less likely to work on the wrong layer when there are lots of them. Use the same HB Pencil brush to draw the creatures with cleaner lines. Work slowly and think about each design element as you draw. It's good practice to include a variety of straight lines, S curves, and arches. Aim for interesting proportions overall and an easy-to-read silhouette. Feel free to tweak the initial rough sketch. Here an intimidating soap bubble gun has been added.

▲ Contrast curved and straight lines in your design to create a nice dynamic rhythm

▲ Refined line art doesn't have to be really clean – just clear enough to start painting

04

After creating a refined line art design of your creatures, create a solid base color layer which will support the lighting work to come later. Lighting can enhance the way your creatures look and help bring a sense of mood to the scene. What follows is a simple and straightforward way to create lighting with the help of layer blend modes. Create a new layer, hold and drag it down below the line layer, and rename it Flats. Use the Freehand Selection tool to define the overall silhouette, then fill it with a solid color by dragging the color circle from the top right-hand corner into the selected area.

▶ Solid fill layer – this will be used for the base (local) colors

05

Lower the layer opacity of the Line Art layer and Alpha Lock the Flats layer. Locking this layer will then not allow you to draw beyond what is already on the layer. Next, block in the main colors using a solid round brush, such as the Hard Blob brush. Try painting large areas with solid colors.

▶ Line art plus flat color

06

Once you have the local colors blocked in, create a new layer and rename it Ambient Occlusion. Activate the Clipping Mask tool, so that when you paint on this new layer you will always be confined to the borders of the layer below it. Change the blend mode to **Darken > Multiply**. Multiply mode is good for adding shadows, as it darkens the colors on the layers underneath.

Next, select the Practical Strokes brush or the Simple Gouache brush. Fill the layer with white and, keeping the sketch layer visible, paint with black and levels of gray to depict the form in a subtle way, with low -intensity diffused light coming from the top right. Areas where light can't or can barely reach, such as corners and deep crevices, can be almost black. This will help give a 3D look to your creatures. Switch the blend mode back and forth between Normal and Multiply to check the result. Use **Airbrushing > Soft brush** for painting softer transitions.

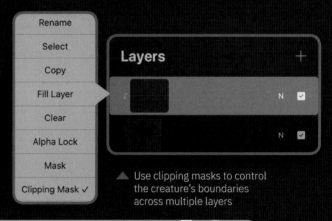

▲ Use clipping masks to control the creature's boundaries across multiple layers

▶ Ambient Occlusion layer with the line art visibility turned off

07

Create a new layer above the Ambient Occlusion layer, rename it Light Pass, and change the blend mode to Add. Here the light source is coming from the top right. Keeping this in mind, block in simple light shapes using the Sam's Roller brush or the Practical Strokes brush. Take care not to make it look too soft at this stage.

▶ The Light Pass layer mixed with the Ambient Occlusion layer, with the Line Art layer switched off

08

Turn on the visibility for all of the layers to see how they work together. Adjust the opacity levels of each as needed. The key is not to exaggerate the lighting too much, as this is only a starting point for painting.

▼ The result of the four basic layers together

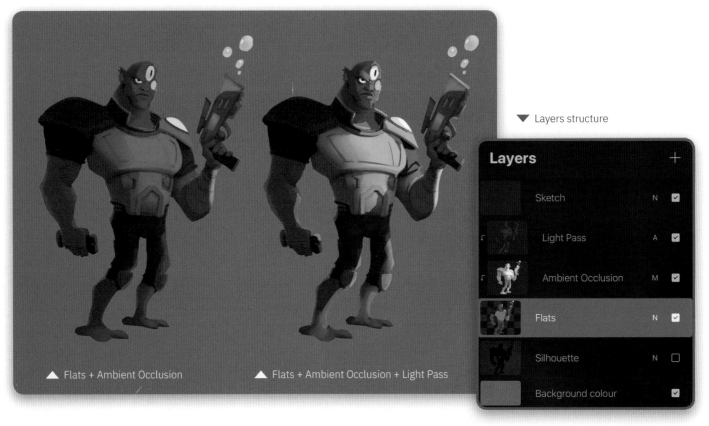

▲ Flats + Ambient Occlusion

▲ Flats + Ambient Occlusion + Light Pass

▼ Layers structure

Layers +

Sketch N ☑

Light Pass A ☑

Ambient Occlusion M ☑

Flats N ☑

Silhouette N ☐

Background colour ☑

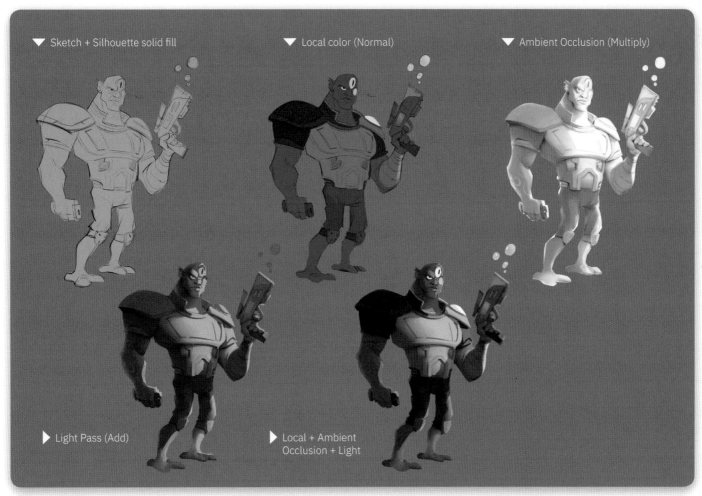

▲ Layer breakdown

Sketch + Silhouette solid fill

Local color (Normal)

Ambient Occlusion (Multiply)

▶ Light Pass (Add)

▶ Local + Ambient Occlusion + Light

09

Next, merge all of the individual layers into one using the pinch gesture and continue to paint directly onto it. This enables the process to be more about painting and less about layer management. Lock the transparency of this layer, then paint in details and enhance the lighting effect. Use the Flat Painterly brush to do most of the work here. Use the same process for the lizard pet, keeping it on its own separate layer.

▶ Merge all of the basic lighting layers of the main character into one and paint in details and lighting

10

Use **Adjustments > Curves** to adjust the color contrast. Select Composite and adjust the curve points slightly to increase the contrast and push the colors a little. Aim to create a subtle S shape with the curve, producing slightly darker darks and lighter lights.

▶ Use the Curves tool to increase the contrast

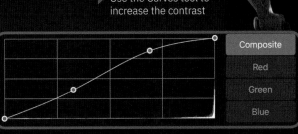

ARTIST'S TIP

Using Procreate effectively is all about mastering gestures. The more you get used to the gestures, the faster your workflow will become. A useful shortcut is to tap the Modify button. This will summon the Quick Menu, which consists of six frequently used actions, including creating new layers, deleting, Alpha Lock, and more. You can customize what actions appear on this menu by holding any of the six buttons and choosing a different option from the list.

11

Use the Liquify tool to push proportions further and to carry out some overall shape corrections. Liquify is a very powerful tool, so be careful not to overdo it and distort your image too much – you might end up deviating too far from your original drawing and what made it a strong idea in the first place. Experiment with the Momentum slider if you want the effect to be more dynamic and fluid. Momentum is useful for pushing the design a bit further without having to redraw or paint anything, but again, be careful not to go over the top – find a balance between adjusting the image manually and letting the tool do its own thing.

▶ The Liquify tool is useful for adjusting form and proportions slightly when needed

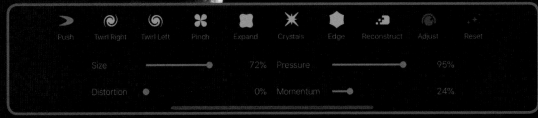

12

Continue adding small details, such as scratches and textures, on the alien creature using the Flat Painterly brush set to about 75% opacity. You can also use texture overlays by importing any black and white image texture. Select **Actions > Add > Insert a Photo**, then navigate to your iPad's photo gallery (where you will have saved the black and white texture) and confirm the import. Turn the blend mode of the imported photo to Overlay. This is a good blend mode to choose when working with textures.

▲ Consider adding textures to overlay in a subtle way

13

Use **Transform > Warp** to manipulate the texture and place it on a round surface, such as the shoulder piece of the armor. Adjust the corner handles to bend the texture into the fitting curvature. Switch back and forth between Freeform and Warp modes to position the texture into place. For the main chest piece, use the **Textures > Halftone** brush to paint a simple consistent texture.

▶ Use texture brushes to add patterned overlays – here a simple hexagon pattern texture has been added

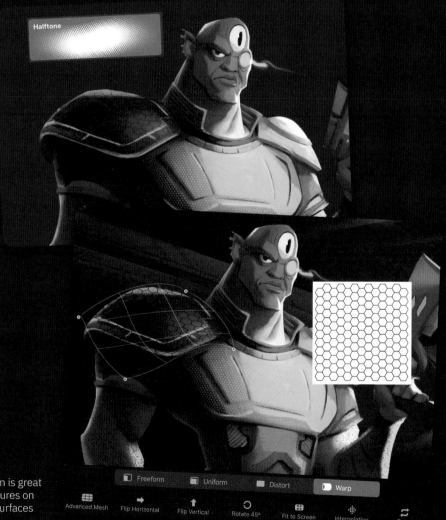

▶ Warp Transform is great for placing textures on top of curved surfaces

14

For the background, create something simple that won't distract too much from the creatures. Make use of Procreate's drawing guides to draw accurate perspective. Select **Options > Canvas**, enable the Drawing Guide, and tap Edit Drawing Guide. You can now create vanishing points by tapping anywhere on the image.

◀ Turn on Drawing Guide and choose the perspective option

15

When creating two-point perspective, it's good practice to keep the points further apart and to ensure the horizon line is not tilted. You can also adjust the thickness of the guides by adjusting the Thickness slider below. Tap Done once you're happy with the perspective grid. Now you can see the grid while sketching your background.

▶ Make sure the creatures sit well within the perspective grid, and keep the horizon line straight

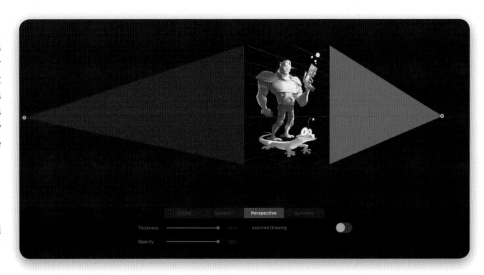

16

To make your lines snap naturally to the grid lines, as if you were using a ruler, enable the Drawing Assist option on any layer you want to draw straight lines on. This tool is layer dependent. Create a new layer for the background sketch and enable Drawing Assist. You can turn this on and off while sketching your background. This comes in very useful when you're drawing straight lines, then wish to sketch freely.

▶ Turn on Drawing Assist to make your lines automatically snap to the grid you set up with the Drawing Guide

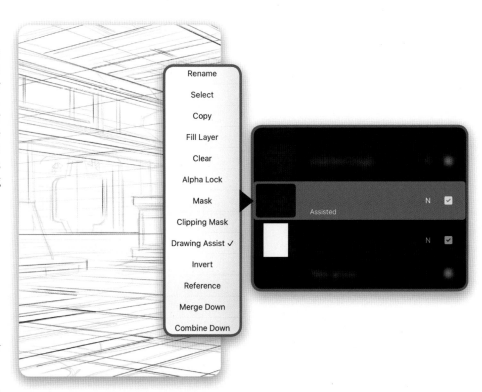

17

Continue refining the background sketch. Create a layer underneath the sketch and fill it with gray. Use the Selection tool to block where the main elements are and maintain some hard edges. Set the layer blend mode to Multiply.

▶ Block the background's main elements using the Selection tool

18

Once you are happy with the overall background sketch, create a new layer and drag it underneath the sketch blocking layer. Since the background contains minimal detail, you can paint it all on one layer. To speed up the process, fill the new empty layer with a solid dark blue color.

19

Use the Flat Painterly brush to paint in some details, choosing colors that are similar to the main dark blue base color. Use the Selection tool to create clean edge selections and paint within them. While in Selection mode, switch between the Freehand and Polygonal modes by tapping instead of dragging the selection to combine the two modes together. Painting directly within selection borders is a good technique to use to achieve precise edge control in your work.

▲ Keep the background colors mainly monochrome – here it is dark blue, making the creatures stand out without distractions

▲ Painting within selections is a great technique for controlling hard edges

ARTIST'S TIP

Procreate's intuitive tools make it easy to jump right in and create artwork. You can learn fast – it just takes practice. Remember to keep your layers organized in the best way possible.

20

At this stage it's a good idea to turn the visibility of your creature layers back on. This will prevent you from spending too much time detailing anything that will be blocked by the creatures anyway.

▶ Background work in progress

21

To create the glow effect for the background lights, first create a new layer and paint in some solid shapes. Use the Polygonal Selection to create clean rectangular shapes and fill them with solid colors. Next, duplicate the layer and set this duplicated layer's blend mode to Add.

▶ Make polygonal selections using the Freehand Selection tool to tap corner points instead of dragging

22

Select **Adjustments > Gaussian Blur** and slide your finger left and right to adjust the strength of the blur effect. Once you are happy with how it looks, select **Adjustments > Noise** and add some noise to the glow.

▼ Use the Add layer blend mode with the Gaussian Blur filter to create a glow effect

Adjustments

Opacity

Gaussian Blur

Motion Blur

Perspective Blur

Sharpen

Noise

Liquify

Clone

Hue, Saturation, Brightness

Colour Balance

Curves

23

Use **Transform > Distort** to overlay texture on the ground. This is a good mode to use when transforming flat textures onto a flat surface in perspective. It's important not to add too many distracting details, since the focus is on the creatures. Some subtle hints of unified sci-fi texture are all that is needed here.

▶ Transform > Distort is useful for overlaying textures in perspective

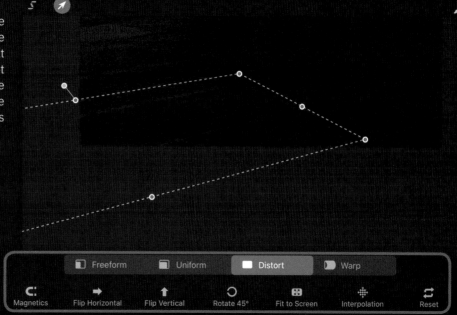

| Freeform | Uniform | Distort | Warp |

Magnetics · Flip Horizontal · Flip Vertical · Rotate 45° · Fit to Screen · Interpolation · Reset

24

To create a sense of camera depth of field, duplicate the background layer and use **Adjustments > Gaussian Blur** to create an out-of-focus effect, adding depth to the scene. You can also use **Adjustments > Noise** to create a film grain effect. Next, use the Soft Airbrush to erase the ground part from the blurry layer, as you only want the areas furthest away in the background to be a little blurry, not the foreground. Unhide your creature layers to add them back into the scene. Now the artwork is complete, you can export it to share it with the world (see page 18).

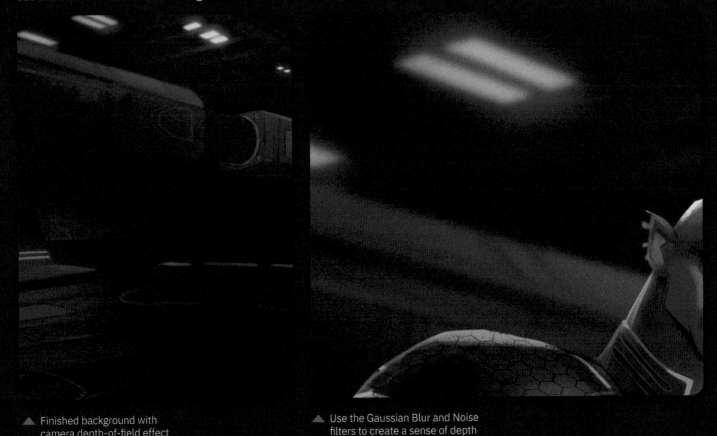

▲ Finished background with camera depth-of-field effect

▲ Use the Gaussian Blur and Noise filters to create a sense of depth

FINAL IMAGE

On completing this tutorial you will have learned how to use some of the most fundamental tools and techniques in Procreate to create your own sci-fi creatures in a scene. Explore further on your own and apply these techniques to any art style or genre you enjoy making. Embrace the discovery process – there are always new things to learn and implement in your work. Creative play and experimentation are always beneficial to your art, so allow yourself to have fun and enjoy the process.

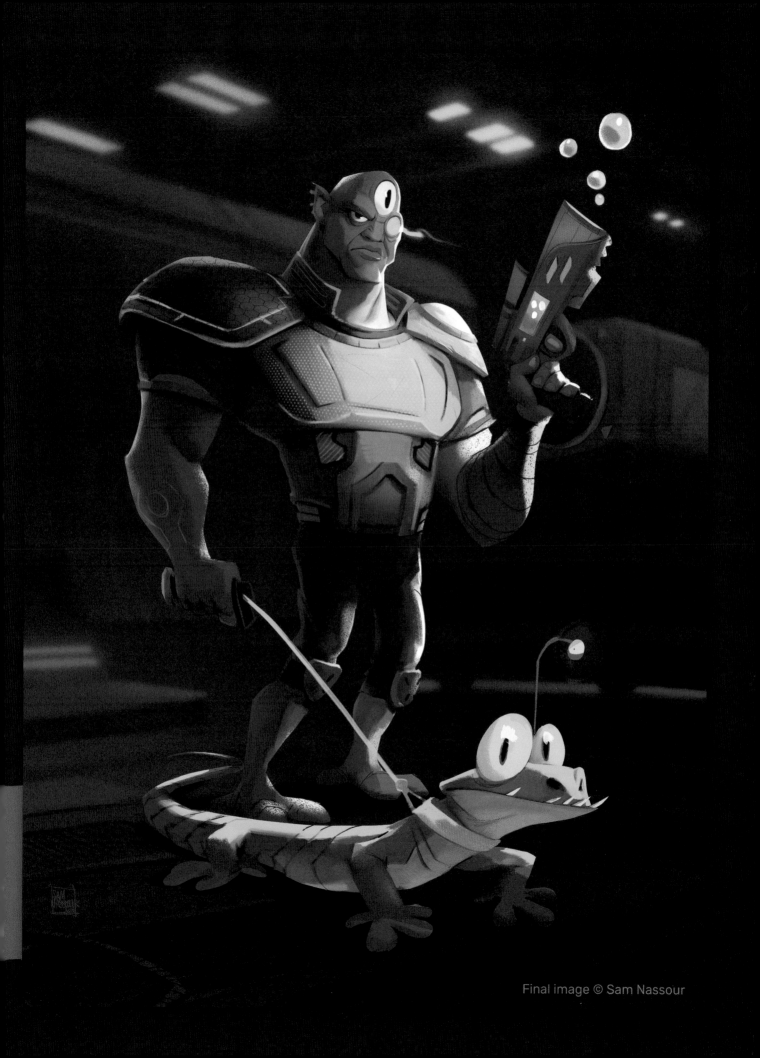

Final image © Sam Nassour

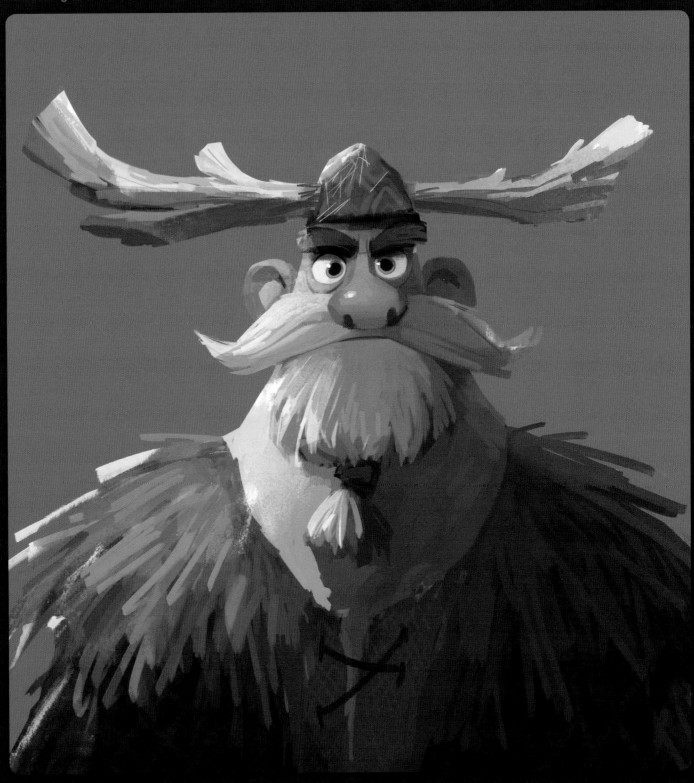

 All images © Sam Nassour

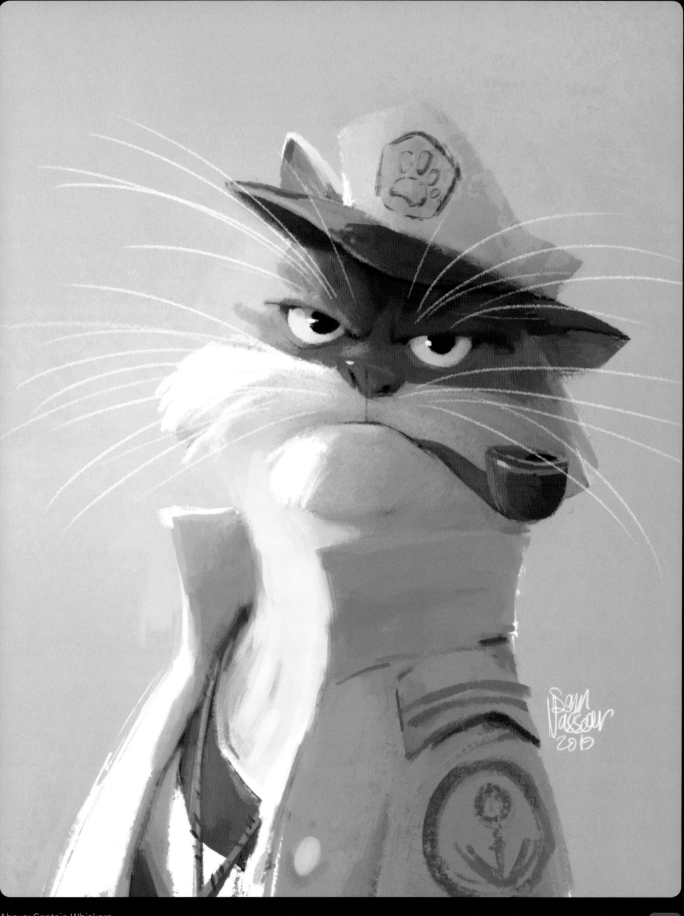

Above: Captain Whiskers

GLOSSARY

Ambient occlusion
Ambient occlusion refers to the shadows created as if by an ambient, non-directional light, as if the subject is lit on an overcast day. This shades mainly the crevices where ambient light cannot reach.

Apple Pencil
An advanced stylus developed by Apple to work exclusively with the iPad. It is the recommended tool for Procreate users, with features including tilt recognition, pressure sensitivity, and side buttons.

Background color layer
Specific to Procreate, this is a non-deletable layer created automatically with each new file.

Back-up
To create a copy of your digital artwork to avoid losing it.

Brush library
The collection of brushes included with Procreate. You can expand this collection by creating your own custom brushes, or downloading brushes created by other artists.

Brush set
A group or category of brushes used to paint.

Canvas
Your painting surface, used in both analog/traditional and digital artwork.

Dock
A quick access menu containing the most recently used apps on your iPad, summoned by swiping up from the bottom of your iPad screen.

Export
To save your artwork out of Procreate. You can export files to your own device, or to other apps.

File
Used as a synonym of canvas or artwork, every artwork is treated as a single file inside your gallery.

Gallery
The home screen in Procreate that showcases all of your files. Here you can create new canvases, as well as preview, delete, or reorganize the existing ones.

Gestures
In the context of Procreate, gestures are commands triggered by finger motions on your iPad screen.

Import
To add a file into Procreate. You can import flat images, brushes, or even files from other software (such as Photoshop's native PSD format).

Image format
To transform the digital data of your images into an actual picture, the file must be stored in a determined format that your device can interpret. There are several major formats, but the most common are JPEG for images without transparency, PNG for images with transparency, GIF for animated images, or PSD and PROCREATE for files composed of layers.

Layers
In digital painting software, layers emulate a stack of transparent sheets. You can create, rearrange, and erase them, plus paint on or manipulate them separately. Layers are one of the most important tools in digital painting.

Line art
A technique where you create an artwork through lines instead of painting. It may be an objective in itself, but some artists may also refine a rough sketch into clean line art that can be used as a base for a painting.

Opacity
How opaque or transparent something is. In the context of digital painting, it refers to the transparency of your brushstrokes or layers.

Popover
A popover is a dropdown menu or list, containing additional content, settings, or options.

Perspective
In the context of drawing and painting, perspective is the representation of three-dimensional depth on a flat surface such as a screen or page.

Prefs
An abbreviation of Preferences, Prefs is a menu under Actions that contains Procreate's general settings.

Pressure Sensitivity
The capacity of the software to interpret the pressure of your brushstrokes and reproduce them digitally.

RGB
This is a color mode that allows you to control a color by the amount of red, green, and blue.

Stacks
Specific to Procreate, a stack is a group of files in your gallery.

Stylus
A pen-shaped instrument that lets you navigate a touch-sensitive device, such as the iPad.

Tab
One section of a menu. There may be multiple tabs per menu, each tab listing a different category of options.

Thumbnails
Small preliminary or draft versions of your artwork, or previews of an artwork in a software.

Tilt Sensitivity
The capacity of software to interpret the tilt of the stylus tip on your screen and reproduce it digitally.

Time-lapse video
Unique to Procreate, this is a sped up reproduction of the creation of your artwork, stroke by stroke.

Workflow
How you approach the development of a project from start to finish. Some artists may create rough sketches and color roughs, then cleaned-up line art with finished colors. Every experienced artist develops their own unique workflow over time.

Value
In painting, value refers to the lightness or darkness of a color.

◼TOOL DIRECTORY

Alpha Lock 44
A setting that allows you to lock transparent pixels on a layer, only letting you paint on the already visible pixels.

Layer blend modes 46-47
A setting that determines the interaction between two or more layers. The default mode is Normal, which interacts as if two pieces of paper were stacked. Other mode simulate various brightening, darkening, and other interactions between colors.

Blur 58-59
An adjustment that lets you diffuse the pixels of a layer. The opposite effect is Sharpen.

Paintbrush 28-35
The main tool used in digital painting. Procreate's brush library contains a wide range of different brushes that let you simulate different media and effects.

Clipping mask 49
An interaction between several layers, it sets one layer as the parent and the rest as children. The children cannot paint outside of the pixels of the parent.

Color Balance 63
A setting that controls the color by the amount of red, green, and blue in the image.

ColorDrop 40
A tool specific to Procreate, used to fill enclosed areas with a flat color by dragging and dropping the color swatch onto the canvas.

Color popover 38-41
The menu opened by tapping on the color swatch in the top right-hand corner of your interface. The Color popover lets you select and manipulate color through different modes including Disc, Classic, Value, and Palettes.

Color swatch 38, 41
The round circle in the top right-hand corner of the interface that tells you what color is currently selected. Color swatches are also the small squares of color that make up palettes in the various Color modes.

Crop 68
A tool that lets you cut and manipulate the size of your canvas.

Curves 64
A setting used to manipulate the colors of your image through a histogram, primarily used to control the amount of darkness and lightness in your image.

Custom brush 33-35
A brush that is made from scratch by a Procreate user, or tweaked from an existing default one.

Drawing Guide 69
In the context of Procreate, this is a tool to create and edit grids on your canvas to use as guides when drawing.

Drawing Assist 69
This tool snaps your lines to the last used Drawing Guide. You can switch it on or off for each of your layers.

Eraser 28, 30
A tool that lets you delete pixels from your canvas.

Hue, Saturation, Brightness (HSB) 63
This is a color model that allows you to control color by its Hue, Saturation, and Brightness. In Procreate and other digital painting software, it is also an adjustment for your image.

Liquify 62
A tool that lets you manipulate, distort, and re-shape the pixels of your canvas.

Lock 44
Locking a layer stops you from manipulating or painting on it.

Magnetics 57
Specific to Procreate, this setting allows you to move objects along the horizontal, vertical, or diagonal axis in fixed increments.

Mask 48
A non-destructive workflow tool that enables you to hide the content of a layer without erasing it.

Noise 61
A setting that creates noise on your layer, similar to the look of a photograph or video recording. This is useful when you want to create texture.

Pressure Curve 70
In the context of Procreate, Pressure Curve is a setting that lets you tweak how the software interprets the strength of your strokes.

QuickMenu 71
Specific to Procreate, this menu contains six customizable options that you can summon through custom gestures.

QuickShape 36-37
Specific to Procreate, QuickShape is a feature that makes it easy to draw perfect lines and basic geometric shapes by automatically smoothing your freehand lines.

Recolor 65
An adjustment that lets you select areas of color and change them to a preselected one.

Selection 50-53
A tool found in most digital painting software that allows you to isolate specific areas to edit or manipulate. An area of content isolated in this way is the active selection.

Smudge 28, 30
A tool in Procreate that lets you move and smear paint instead of creating or erasing it.

Transform 54-57
A tool in Procreate that lets you modify the position, proportions, and scale of the elements in your artwork. You can move, distort, or warp them.

Undo/Redo 25
Undo lets you go back a step, and Redo forward a step, in your painting.

DOWNLOADABLE RESOURCES

The following resources are available to download at www.3dtotalpublishing.com/resources to experiment with as you work through *Getting Started*, and to help you complete each project. We recommend that you download the resources before starting a project.

Getting started

▶ Sample image with layers

Illustration – Izzy Burton

▶ Time-lapse video

▶ Line art

Character Design – Aveline Stokart

▶ Time-lapse video

▶ Character exploration time-lapse video

▶ Line art

Fantasy Landscape – Samuel Inkiläinen

▶ Time-lapse video

▶ Samuel Inkiläinen Brush Set

 • Technical Pencil
 • Sketch
 • Opaque Oil
 • Oval Hard
 • Soft Airbrush
 • Gregory
 • Chalk
 • Bushes
 • Jellyfish Stamp
 • Speckle
 • Hard Smudge
 • Smudge

Fantasy Creature – Nicholas Kole

▶ Time-lapse video

▶ Line art

▶ MaxU Shader Pastel Brush
(Max Shader Pastel © Max Ulichney. This brush is from the Essential MaxPack. You can buy Max's brushes at MaxPacks.art)

▶ Tara's Oval Sketch NK brush © Tara Jauregui has also been used for this tutorial. You can buy Tara's Oval Sketch NK brush from gumroad.com/dizzytara

Traditional Media – Max Ulichney

▶ Time-lapse video

▶ Line art

▶ MaxPack Brush Set

• MaxU Gouache Bristle Gritty
• MaxU Gouache Grain Cloud
• MaxU Gouache Thick
• MaxU Sketchy Sarmento

Find more of Max's brushes at MaxPacks.art

Spaceship – Dominik Mayer

▶ Time-lapse video

▶ Line art

Plein Air – Simone Grünewald

▶ Time-lapse video

Sci-Fi Creature – Sam Nassour

▶ Time-lapse video

▶ Line art

▶ Sam Nassour's Painterly Miniset Brush Set

• Sam's Practical Strokes brush
• Sam's Roller brush
• Sam's Flat Painterly brush
• Sam's Simple Gouache brush
• Sam's Hard Blob brush

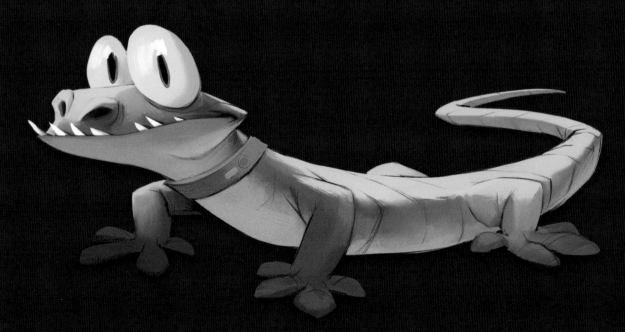

Image © Sam Nassour

CONTRIBUTORS

Izzy Burton
izzyburton.co.uk

Izzy Burton is a UK-based freelance director and artist working in animation and illustration. She is the director of the award-winning short animated film *Via* and is now repped by Troublemakers and Passion Pictures' Greenhouse Initiative as a director, and Bright Agency as an illustrator.

▲ Freelance Director & Artist

Samuel Inkiläinen
samuelinkilainen.com

Samuel Inkiläinen is a digital 2D artist based in Tornio, a city in Finnish Lapland. His passion lies in digital landscape painting with a hint of traditional watercolor mixed in.

▲ Freelance 2D Artist

Simone Grünewald
instagram.com/ schmoedraws

Simone Grünewald is a freelance illustrator and character designer from Germany. You might know her as Schmoedraws from Instagram, YouTube, or Patreon. Simone worked in the game industry for over ten years as an artist and Head of Art, and has helped to shape the look of many games.

▲ Freelance Illustrator & Character Designer

Nicholas Kole
nicholaskole.art

A ten-year veteran of the entertainment industry, Nicholas Kole now draws dragons and wizards full-time on his iPad in Procreate. You may recognize his most recent character design work from the *Spyro Reignited* Trilogy, while his other clients include Disney, DreamWorks, Blizzard, Nintendo, Warner Brothers, Riot, and more. He lives in Vancouver.

▲ Freelance Character Designer & Illustrator

Dominik Mayer
artstation.com/dtmayer

Dominik Mayer lives in Nuremberg, Germany, working as a professional concept artist and illustrator for several video/board/card games and movies. His passion is exploring new universes, unique worlds, fascinating stories and designs, and being part of their creation.

▲ Freelance Concept Artist & Illustrator

Lucas Peinador
lucaspeinador.com

Originally from Costa Rica, Lucas Peinador is an illustrator and concept artist working in the video game industry. He is a passionate content creator, dedicated to facilitating knowledge for aspiring artists and inspiring others to create. He is also a very good salsa dancer.

▲ Illustrator & Concept Artist

Sam Nassour
samnassour.com

Sam Nassour is an art director and visual development artist based in London, UK, working in the entertainment and animation industries for studios including Cartoon Network, DreamWorks TV, Disney TV, Netflix, and others. He recently worked on the new *Paddington* TV series at Blue Zoo and teaches a character design course at Escape Studios.

▲ Art Director & Visual Development Artist

Aveline Stokart
avelinestokart.com

Aveline Stokart is a Belgian character designer and comicbook artist. Passionate about character design and creating universes, she studied 3D animation at the Haute Ecole Albert Jacquard and continues her own self-taught learning. Aveline currently works as a freelancer for various clients in the publishing and animation field.

▲ Character Designer & Comic Artist

◀ Illustrator, Art Director, & MaxPacks Brushmancer

Max Ulichney
maxulichney.com

Max Ulichney is an illustrator and animation art director based in Los Angeles. His MaxPacks Procreate brushes are used worldwide by professionals and beginners alike. On the horizon he is looking forward to creating his first children's book.

INDEX

Image © Ignacio Bazan Lazcano

3dtotalPublishing

beginner's guides

Start a new artistic adventure with our ever-popular *Beginner's Guide* series,
which teaches you all you need to know to get started in sketching, clay
sculpting, digital painting in Adobe Photoshop, and more!

Visit shop.3dtotal.com to see more in the series.

3dtotalPublishing

3dtotal Publishing is a trailblazing, creative publisher specializing in inspirational and educational resources for artists.

Our titles feature top industry professionals from around the globe who share their experience in skillfully written step-by-step tutorials and fascinating, detailed guides. Illustrated throughout with stunning artwork, these best-selling publications offer creative insight, expert advice, and essential motivation. Fans of digital art will find our comprehensive volumes covering Adobe Photoshop, Pixologic's ZBrush, Autodesk Maya, and Autodesk 3ds Max. The dedicated, high-quality blend of instruction and inspiration also extends to traditional art. Titles covering a range of techniques, genres, and abilities allow your creativity to flourish while building essential skills.

Well-established within the industry, we now offer over 60 titles and counting, many of which have been translated into multiple languages around the world. With something for every artist, we are proud to say that our books offer the 3dtotal package:

LEARN · CREATE · SHARE

Visit us at 3dtotalpublishing.com

3dtotal Publishing is part of 3dtotal.com, a leading website for CG artists founded by Tom Greenway in 1999.